AUSTRALIA

4th edition

A **WAVE**FINDER Publication

002 EDITORIAL

We send heart felt thanks to over 100 great surfers who gave their knowledge, sketches, photos, videos, sweat and time. Special thanks to Christo, Shaun, Matt Mackay, Dave Penkethman, Richard Evans, Gally, Mark Ogram, Len Dibben, Victor Tilley, Kim Wooldridge, Rod Hocker, Pam Burridge, Brenton Preece.

Editorial: Larry Blair, Adam Coxen, Jeremy Goring, Cheyne Horan, Wayne Deane, Stef Powell, Mark Lane, Frank Ederle, Barrie Sutherland.

Art: Stéphane Rouget, Nick Baron

Photography: Hilton, Tim McKenna Barrie Sutherland, JG, Bernie Baker, Sean Davey, Pete Adams.

Covershot: Narrabeen firing / Sean Davey. Frontispiece: NSW Beach-break / Sean Davey

We have set out to give you the most compact, easy to use tool for the travelling surfer. The Wave - Finder Icon System gives you a quick overview of the best conditions for each spot, saving you precious surfing time by getting you straight to the right spot for the conditions. Any break can be great on it's day, and banks can move around overnight to give all-time, but short lived perfection. Unlike your favourite chip shop, the ocean dishes up your surfing experience according to her mood - not your order. So be prepared for conditions to vary from what you expect. We have covered just about every good spot in this guide, but some secret spots must stay just that - they are for you to go and seek out. All we ask is that you respect the locals, and be merciful to the natural environment.

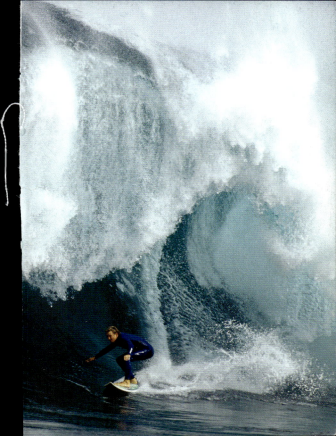

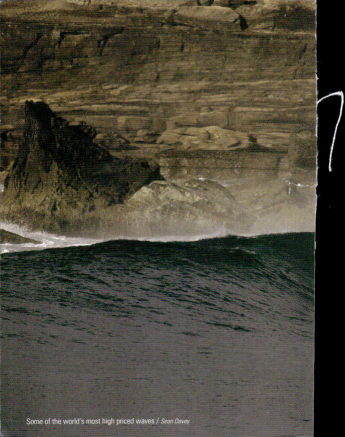

Some of the world's most high priced waves / *Sean Davey*

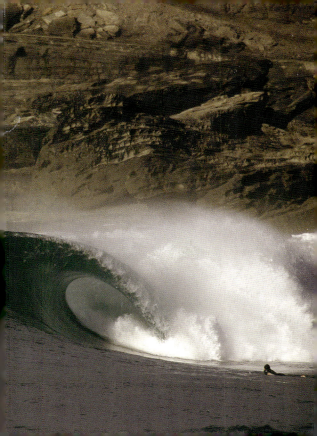

Some of the world's most remote waves / *Hilton Dawe*

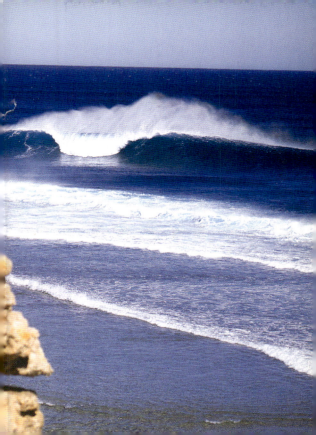

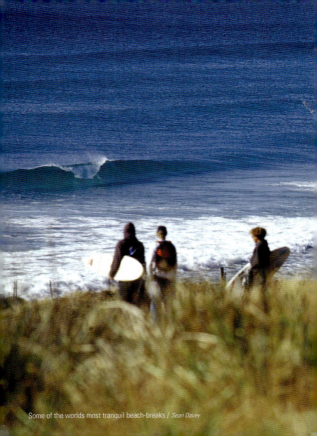

Some of the worlds most tranquil beach-breaks / *Sean Davey*

CONTENTS

015

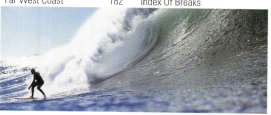

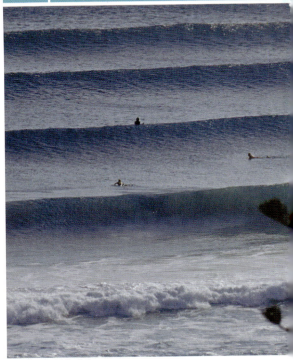

Kirra's Superbank / *Tim McKenna*

worldwide surfing holidays

break free...

...take a surfing holiday

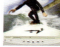

How does Wave-Finder Work?

Wave-Finder uses mini data-maps and icons to help you quickly identify the best conditions for each break. The icons also indicate wave type and direction; see opposite.

What do I look at first?

You can find your desired break by looking at the area map for each section. Find out what area you are in by looking at the contents pages overleaf. There's also a break index at the back.

How do I find the best spot for the conditions?

Each spot has its own data-map showing the main streets and landmarks nearest the break. Look for the icon box located in the corners. This contains info on Wave direction, bottom type, best swell direction, best tide, and best wind direction.

Wave locators: in each map show position and direction of wave. There may be more than 1 break per map; in this case you'll see 2 or more icon boxes, each relating to the nearest locator. If you know the current wind direction (or other conditions), you can flick through the maps and scan the icons.

Tides: Most maps show beach at low tide, with a black line for the high tide mark. This is why some waves appear on the rocks, because that's where they break on a higher tide.

Additional Info

Surf data-charts for each ocean zone show seasonal conditions and hazards etc. There's a forecasting page at the back, or check our website **www.wave-finder.com**

WAVE LOCATOR

 Peaks

Right Left R & L

 Points

Right Left

WAVE TYPE: show direction and bottom

Right Left R & L
Bottom: Reef

Right Left R & L
Bottom: Sand

Right Left R & L
Bottom: Rivermouth

OPTIMAL SWELL DIRECTION: Other directions may also work

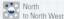 North
to North West

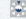 North

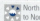 North
to North East

OPTIMAL WIND DIRECTION: Other directions may also work

 Northerly

 North
to Northeasterly

 Southwesterly

TIDES

Show optimal tide heights. Other tides may work, and sand movement may change situation

Low Mid L to M M to H High All tides

SCALE

Marked on the maps.
In Kilometers.

SPECIAL ICONS: Exceptional features about the break

 Swell Magnet

 World Class

 Crowds

 Best in Winter

 Best In Summer

Protected from
prevailing winds

 Car Park

 Handles
big swell

Sharks

Please forgive us for humbly repeating some of the unwritten rules of peaceful surfing.

The basic minimum
Invasion of personal space causes heightened levels of stress in all mammals: Give some leeway to other surfers.

Priority
Observe wave priority but don't snake around other surfers to get it.

Waves with a tight take-off zone
Don't bring an instant crowd.
Never paddle straight into pole position; wait around on the shoulder, and pick your moment before paddling into priority.

Housekeeping
Shut gates. Pick up your litter. Park mindfully.

Wavefinder Publications
Wave-finder publications prides its self on keeping quiet about the secret places to surf around the UK, although "secret" is generally a matter of opinion. You might stumble across such spots on your travels. If you do, the rules above are doubly important.

Surf rage
You will only experience this semi mythical affliction if you fail to use your people skills, or ignore the above.

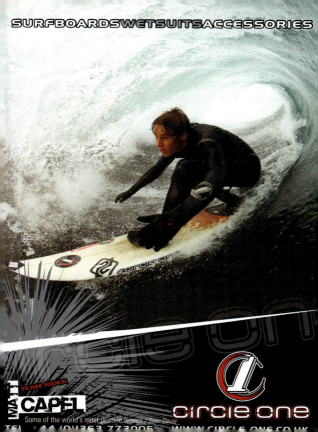

SURFBOARDSWETSUITSACCESSORIES

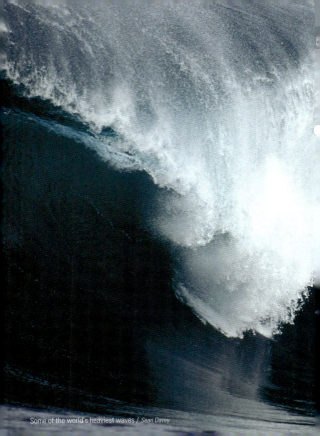

Some of the world's heaviest waves / *Sean Davey*

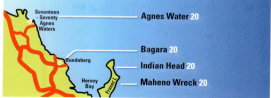

Seventeen - Seventy Agnes Waters — **Agnes Water** 20

Bundaberg — **Bagara** 20

Hervey Bay — **Indian Head** 20

Fraser I — **Maheno Wreck** 20

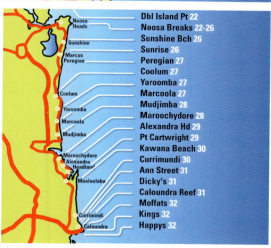

Noosa Heads — **Dbl Island Pt** 22

Noosa Breaks 22-26

Sunshine — **Sunshine Bch** 26

Sunrise 26

Marcus Peregian — **Peregian** 27

Coolum 27

Coolum — **Yaroomba** 27

Yaroomba — **Marcoola** 27

Marcoola — **Mudjimba** 28

Mudjimba — **Maroochydore** 28

Maroochydore — **Alexandra Hd** 29

Alexandra Headland — **Pt Cartwright** 29

Mooloolaba — **Kawana Beach** 30

Currimundi 30

Ann Street 31

Dicky's 31

Currimindi — **Caloundra Reef** 31

Caloundra — **Moffats** 32

Kings 32

Happys 32

QUEENSLAND

Agnes Water

On Bruce Hwy, go N from Bundaberg then R to Agnes Water. Go past surf shop & 2nd R to the end.

R hand point break off the rocks over sandy bottom. Can give long hollow walls up to 6ft NE-SE swells. Best in summer Dec-Jun. Nice beachies S in Nat Park and at **Farnborough** (10K N of Yeppoon). Sharky. If big cyclone swell, check **Bagara**, due east of Bundaberg; a fickle gem of th s coast.

Islands in this area also have secret spots for the adventurer.

Sleep: Agnes Water Caravan Pk, Jeffrey Ct, 4974 9193

Maheno Wreck (Fraser Island)

Sunshine Hwy N from Brisbane to Gympie. Inskip Point ferry. 4WD essential.

Best spot on the island, 60km up the beach. L & Rs work off the wreck hull, dependent on sand-banks. Best in 6ft E-SE swells. Go N 30km to try **Indian Head**, a wrapping point-break over sand bottom. Waddy Point, round the headland may have a R. Many secret spots and a few sharks.

Sleep: Cathedral Beach Camping, 4127 9177

Double Island Point

N of Noosa, ferry then all way up the 80km Teewah Beach. 4WD essential.

Nice sandy point produces a v long, peeling R. Can break all the way into Wide Bay. Needs big ground-swells. Walk back up the beach to avoid bad paddle out. Quite forgiving spot. Isolated. If wind is north to west, check **The Corner** just round to the South. On the drive up from the ferry you may have spotted the wreck of the **Cherry Venture**, which can accumulate good banks, and be hollow on W winds.

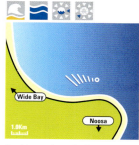

Sleep: Noosa North Shore Retreat Beach Rd Tewantin 07 5447 1225

QUEENSLAND

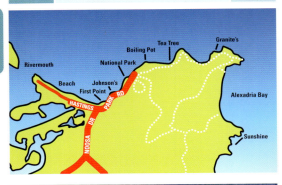

Rivermouth

Beach

Johnson's
First Point

National Park

Boiling Pot

Tea Tree

Granite's

Alexadria Bay

Sunshine

HASTINGS

NOOSA DR

PARK RD

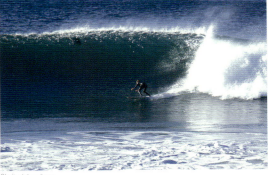

Clarity / Sean Davey

QUEENSLAND

First Point (Noosa)

At the east end of Hastings Street in Noosa.

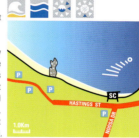

Mellow R inside point, breaking mostly over sand. Unless there is a massive cyclonic NE or E swell, First Point is a 2-3 ft wave. Otherwise maxes out at 4-5 ft. Forgiving wave, protected from southerly wind & close to town, so crowded. Other end of Hastings st thru caravan park, is the **Rivermouth**, good on a 2-6ft E swell & south winds, although banks shift.

Johnsons (Noosa)

From First Point in Noosa, head N on Park Rd to car park. Take a stroll through park to Little Cove.

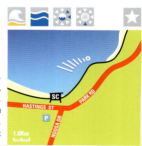

Second point heading NE out of Noosa. Slightly more powerful than first Point, breaking on sand and rocky bottom. In 2ft to solid 4ft E swells it forms a long peeling wave best at low tide. Any bigger can get rippy and break very wide. Crowds when going off, especially if wind is S. Longboarders Nirvana.

Sleep: Melaluka On The Ocean 7 Selene St 1800 003 663

QUEENSLAND

National Park (Noosa)

As for Johnsons, head N on Park Rd to car park.

The third R hand point out of Noosa. Holds a couple of ft more than Johnsons. Breaks over sand & rocky bottom. On a 4ft plus NE-E swell, you can pick the wave up a long way outside the point by Boiling Pot & link through to Johnsons.
Good novice or intermediate spot.

Sleep: Noosa River Caravan Pk, Munna Point, 5449 7050

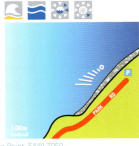

Boiling Pot (Noosa)

As for National Park, head N on Park Rd to car park. You'll see the "Boiling Pot".

A rocky takeoff to a barrelling wave breaking over a rocky bottom. Opening section can be fast & sizey, but the mid section may peter out. Best in 4-5ft NE-E swell, when it can link up through the National Park as far as Johnsons. Beware the rocks on takeoff. Good intermediate wave. Gets super-crowded.

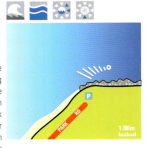

Tea Tree Bay (Noosa)

From National Park car park, obvious track 400m to Tea Tree Bay.

R point break, breaking on mainly sandy & patchy rock bottom. Jacking takeoff then barreling section. More intense than other Noosa points. Holds up to 10ft NE-E swells although these can break wide. Likes 4ft and a south wind. In perfect conditions a long 2-300m ride. Beautiful bush setting.

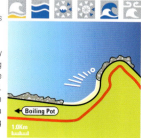

Boiling Pot

1.0Km

Granite's (Noosa)

From Tea Tree Bay, take the track another 400m to the next bay going E to Granite Bay.

Hollow R point break. Fast, steep takeoff, breaking over rocky & sandy bottom. Least consistent of the Noosa points, but holds more swell , best at 3-8ft NE-E swells. The long walk in makes it less crowded. Can be a heavy wave; big harsh drops and powerful sections.

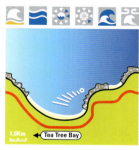

Tea Tree Bay

1.0Km

Alexandria Bay

From Sunshine Beach take McNally Dr, or walk from the Noosa nat. Park.

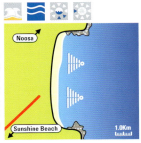

The bay faces to the E, and therefore holds all SE-E swells, although S lines up best. Selection of L & R beachies at either end, breaking over sandy bottom. Not big but can hold some power. Best in up to 6ft swells. Can get rippy. Scenic, less crowds, all levels.

Sleep: Irish Murphy's Noosa Junction Plaza, Sunshine Beach Rd Noosa Heads 07 5455 3344

Sunshine Beach

From Noosa, take David Low Way South, turn East at roundabout on Hill St. Follow it to the beach.

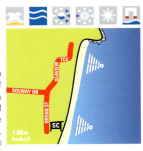

Long SE- E facing beach, picking up a lot of swell. Holds up to 6ft. Plenty of L & R beachies - punchy A-frames & often long walls. Good place to avoid crowds. Northern corner "Sunshine corner" is good in Northerly winds, and pulls swell. Also Try Sunrise to the S, and Castaway's Creek.

Sleep: Dolphins Beach House 14 Duke St 07 5473 5392

QUEENSLAND

Peregian & Coolum

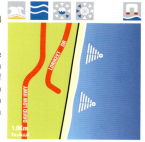

Peregian is the long beach running N from Coolum.

Pitta St and **Stumers Creek** are some of the more consistent spots on Peregian beach. **Coolum** beach itself also holds great banks. All hold up to 6ft. In Summer, go the early. Also worth checking **Marcoola**, & **Tanah St** to S..

Coolum Beach Budget Accomodation Cnr Ann St & David Low Way Coolum Beach 07 5471 6666

Yaroomba Beach (Pt Arkwright)

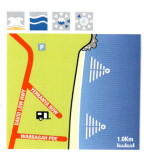

N on Hwy, turn off in Yaroomba on Yerranya Row or Warragah Pde.

Fairly consistent L & R beachies, breaking on sand and some on rock. Hold most swell (facing E-SE) up to 8ft in some spot. Nice ledgey shore dumps. Beware rips. Good place to avoid the crowds in a NE wind & swell. All standards.

Sleep: Maroochy Beach Park, David Low Way, 07 5446 1474

QUEENSLAND

Old Woman Island

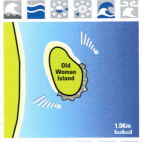

Head N of Maroochydore to Mudjimba. At the top end of Mudjimba beach you'll see The Island. It's a hefty paddle. Hardcore R breaks over shallow reef bottom on north side. Powerful with fast walls. Better still, a spitting L breaks on S side over rocky bottom. Shocking paddle-out. Gets crowded & a big local scene. In S winds take the R, in N winds take the L - simple! **Mudjimba Beach** itself worth a check, as well as **Waynes World** at north end of this, on the bend.

Old Woman Island

1.0Km

Sleep: Maroochy Beach Park, Cottonwood St, 07 5448 7157

Maroochydore Beach

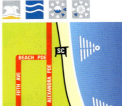

Turn off Hwy to Sunshine Hwy. Right in Maroochydore on 5th Ave to the beach.

Array of small but powerful beachies along this long beach. Sandy & patchy rock bottom. Quality depends on banks. Holds 6-8ft E & SE swells well. Rips & crowds. To escape, try **Pin Cushion** (behind Cotton Tree Caravan Park) or Memorial Ave, both N.

BEACH PDE
FIFTH AVE
ALEXANDRA PDE
SC
1.0Km

Sleep: Cotton Tree Backpackers 15 The Esplanade 07 5443 1755 Shaper: Beach Beat, 20 Fishermans Rd, 07 5491 4711

Alexandra Headland

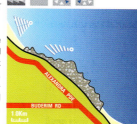

Go N on coast Rd from Mooloolaba for a few K, it's off Alexandra Parade.

S end of Maroochydore beach, opposite the rock wall just before the headland is a short, mellow L /R beach-break on sand & rock bottom (**The Corner**). The Headland itself hosts a nice mellow lined up R (**The Bluff**) frequented by long-boarders, holds big swells. Super-crowded. All levels.

Steep: Maroochydore Backpackers 24 Schirmann Drv Maroochydore, 07 5443 3151

Point Cartwright & Secrets

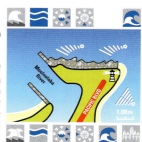

From Mooloolaba, get to La Balsa Park Car park.

Heavy R outside the E break wall of Mooloolaba Rivermouth. **Carties** is a steep takeoff with intense hollow ride that can close out on the rocky ledge or whack the wall itself. **Secrets**, further E along the head is a shorter & even gnarlier bodyboard spot. Both work in 3-8 ft+ SE-E swells and are protected from S winds. Expert surfers. In Northerly winds, check the **Pocket** on S side of point. Its a pretty consistent reef plus sand, often crowded and can get heavy and big.

QUEENSLAND

Kawana Beach

In Caloundra, North on Nicklin Way.
Left in Kawana on Koorin Dr, Left on
Pacific Blvd.

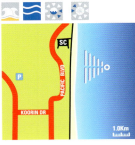

Reasonably consistent nice A-frame L
& R beach breaks. Works best on 3-5ft
swell. Quality depends on condition
of sandbanks. Maxes out in 6ft E-SE
swells and can get rippy. Good place
for avoiding the crowds. Also good as
White House & **Cross Roads** to the
N, as well as **Coffee Rock** to south.
Shaper: Bob Brown Surfboards, 16 Tandem Ave, 07 6554 7216

Currimundi Beach

From Caloundra, N on Nicklin, R at
Buderim St, L on CurrimUndi Rd.

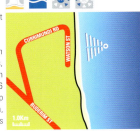

A creek mouth to Lake Currimundi can
sculpt the sand her to form quality banks,
generating peaky, lined up peaks. Often
powerful, but closes out at around 6
feet. There are peaks all the way up
the beach. For a bit more isolation,
try **Wurtulla** just N. All standards
beach-break.
Sleep: Dolphins Beach House 14 Duke St 07 5473 5392

Ann Street & Dicky's

Just S of Currimundi, at the end of Buderim Street.

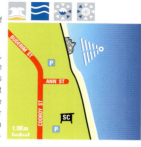

Heavy L & R reef and beach-break, especially in big SE swells. The wave jacks quickly to form long, hollow Ls & shorter Rs. Holds up to 8ft. Can get crowded but it's good, and there are plenty of beach-break peaks further up. Any tide is OK. Check **Dickys** to the south if Southerly winds. Intermediate spot.

Sleep: Dicky Beach Caravan Pk, Beerburrum St, 07 5491 3342

The Reef (Caloundra)

End of Neill Street at north end of Moffats Beach.

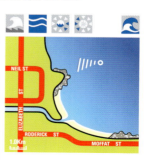

Long 20min paddle-out. Gnarly L over shallow reef bottom. Thick-lipped ledgey, hollow wave. Holds up to 12ft cyclone E-SE swells. Experts only. Inconsistent but worth checking in bigger swells. Further into Moffats is a nice little left reef.

Boards/Repairs: Caloundra Wind and Surf, 5A/4 Lynn St, Caloundra. 0754380674. K.Energy Boards, Wind / Kite Surf , Repairs.

Moffats Beach

Take the same directions as for Caloundra Reef.

Long, wrapping right-hand point at the southern end, good on southeast swells and any south wind. It's a pretty mellow wave good for long-boarding. Further into the bay, the shore-break is body-board central, and gets very dumpy. Also a left of the rocks at northern end, which is peaky and steep, with tight take-off zone. Shaper: Factory Surfboards, 17 Allen St, Caloundra. Custom short & longboards, showroom stock and repairs. 07 5492 5838

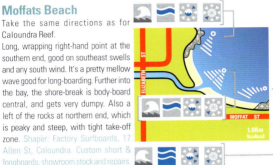

Kings Beach

In Caloundra, from Regent St, turn R into Verney St then King St. R at the end.

Home to small, peaky L & R beach break peaks on sand & rock bottom. One of the few offshore breaks in this area in summer NE winds, so gets crowded in summer. In a S swell on lower tides, check **The Groyne** further S. It is a fast, wedgy wave off the rocks delivering pretty square barrels on its day. It'll be crowded if good with tight take-off zone. **Happys**, around the corner south, hosts a fun, fat long left for intermediates.

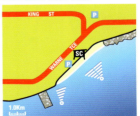

QUEENSLAND

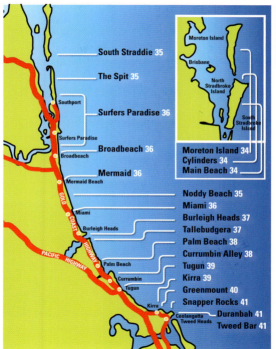

South Straddie 35

The Spit 35

Surfers Paradise 36

Broadbeach 36

Mermaid 36

Southport

Surfers Paradise

Broadbeach

Mermaid Beach

Moreton Island

Brisbane

North Stradbroke Island

South Stradbroke Island

Moreton Island 34
Cylinders 34
Main Beach 34

Noddy Beach 35
Miami 36
Burleigh Heads 37
Tallebudgera 37
Palm Beach 38
Currumbin Alley 38
Tugun 39
Kirra 39
Greenmount 40
Snapper Rocks 41
Duranbah 41
Tweed Bar 41

GOLD COAST HIGHWAY

PACIFIC HIGHWAY

Miami

Burleigh Heads

Palm Beach

Currumbin

Tugun

Kirra

Coolangatta
Tweed Heads

QUEENSLAND

Moreton Island

Ferry from Scarborough NE of Brisbane. Call 07 3203 6399 for timetable. This is the best ferry as it goes to Bulwer, which has access to N & E coasts. Check moreton-island.com for more details & accommodation. Surf trip supplies needed, + 4WD & a $30 permit to drive it around the island (see ferry guys).

On a southerly wind, head to Cape Morton for protected bays with reef and point options that can be sniffed out from

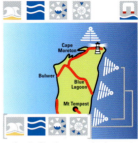

the track leading to the lighthouse. In westerlies the Blue Lagoon track takes you to the start point for some awesome expanses of beach-break along the east coast. This is surf discovery at its best.

North Stradbroke & Cylinders

Ferry from the harbour at Cleveland to Dunwich. Call 0732862666 for Stradbroke Ferries. It costs about $10 return.

Cylinders: on northern tip. Long, barrelling R breaks over reef & sand bottom. Can be all-time. Holds up to 6-8ft of big SE swells, but cops the NE cyclone swells head-on. Intense takeoff. Long paddle-out (get a boat).

Very isolated & sharky. Experienced surfers only. If wind is north, head to **Main Beach** for consistent beach-break peaks.

North Straddie Main Beach

Take the same directions as for Cylinders, but it runs south from Point Lookout.

In the centre of the E coast. very long sandy beach with numerous L & R beachies, quality dependent on the banks. Most are best in up to 6ft SE swells but it works in NEs too. Very isolated & sharky. Experienced surfers only. Uncrowded, and best early mornings or winter.

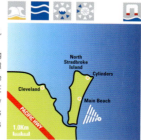

CHEYNE HORAN SCHOOL OF SURF
SURFERS PARADISE 07 5539 2027

The Spit & South Straddie

Heading N on Gold Coast Hwy, turn R on Waterways before the Gold Coast Br. L on Seaworld Dr to end.

Just off S break wall, a nice L breaks on the structured sand banks. Mellow, if short rides. Best in up to 6ft NE-SE swells. You can paddle across to South Straddie if wind more S. Both spots pull swell when it's small, and generally have more power than Surfers' breaks.

Shaper: Joker Surfboards, 1/1840 Lower Gold Coast Hwy Burleigh Hds, 07 5520 2244

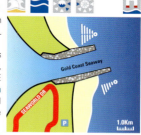

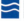
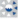

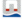

Surfers Paradise & Broadbeach

Heading N on Gold Coast Hwy, R on First Av for Broadbeach & R on Hanlan St for Surfers.

A long stretch of east facing beach from The Spit down to **Broadbeach**, producing a large variety of L & R beach-break peaks, breaking over gently shelving sand bottom. Works in up to 6ft swells from just about any direction, but catches both summer on-shores and winter storm southerly winds, so it's a morning surf spot. When big it's often messy and affected by currents, although banks can form on the outside and hold the size. Despite the throngs of all type of surf device, the expanse of beach soaks it up and it is possible to find a lucky spot with low crowds if you check a few areas. Look for the Big P, and Swannies.

Check the whole strip south to **Mermaid**, where there are pretty consistent beach-break peaks in most swells but needing winds in the north west to southwest sectors. Further south still, **Nobby Beach** has more of the same but may have the banks of the day, and **Miami**, can also get great banks, especially around **South Nobby Headland**.

Shaper: Nev, 2586 Gold Coast Hwy, Mermaid Bch, 07 5592 4010

Nevdirect@nevsurfboards.com

Sleep: Couple 'O' Days 18 Whelan St Surfers 07 5592 4200

(Map labels: NORTHCLIFFE TCE, REMEMBRANCE DR, THORNTON ST, GOLD COAST HWY, BURLEIGH RD, FIRST AV, River, SC, 1.0Km)

Burleigh Heads

Head S from Surfers on gold Coast Hwy past Nobby's Beach. Left to Goodwin Tce. Walk down and around the headland for jump-off and paddle through big hard rocks. Paddle fast & straight!

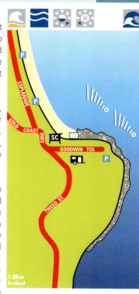

Legendary right-hand point break, refracting around the headland over a boulder bottom in-filled with sand. Will take anything from NE to S swell, but a solid SSE wraps to generate very long rides.

In the right conditions, Burleigh can produce perfect, hollow, long-walled waves, breaking all the way in to the sand bottomed inside. It will handle a lot of size; over 10ft if swell is in the south, but currents are insane, and constant rowing for position is required. Conspicuously consistent for a point-break, but can be of lesser quality for long periods when sand drifts away and out of shape. Protected from winter south winds, so its crowded all year round. If too small for here, head south around the point to Tallebudgera for pretty consistent beach break action on most tides, early morning or in NW to SW winds.

Sleep: Backpackers In Paradise 40 Whelan St 1800 268 621

Currumbin

Head south from Burleigh on the Gold Coast Hwy over Currumbin Estuary and take the first left .

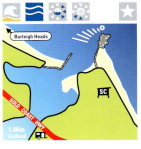

The wave breaks off the rocky point into the entrance to the creek, over sandy bottom. In 4-8ft S-SE swells with south to east winds it becomes a hollow & powerful barrel from take-off, & works all the way across to the beach. Advanced spot with currents and serious crowds when on. You'll have to wait patiently for the currrumbs under the master's table.

If you want more consistent beach peaks then back over the bridge is Palm Beach for 2-5ft plus NE to SE swells and any west winds, preferably early morning.

Currumbin's surf club, just south of the creek, hosts consistent beach-break peaks and a good groyne-structured set-up just south of that. Also, again further south, the creek at the end of Pacific Parade is a good check on low to mid tide, northeast swells and west winds. It'll be less crowded and can have good banks.

Shaper: The Surfboard Factory, 1/1 Leonard Pde, Currumbin Waters 07 5521 0833 / 0414 553 443

Kirra

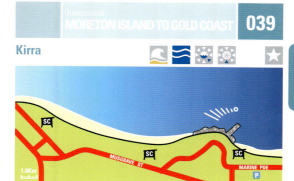

Heading N on Pacific Hwy, turn off at Coolangatta on Musgrave St and follow into Marine Pde. Look for the first groyne. If it's going off, you won't miss it.

The legend that is Kirra. There isn't a surfer in Australia (or the world) who doesn't look at Kirra as one of the ultimate, barreling R handers on the planet. In perfect conditions, the wave breaks in shallow water over sandy bottom with a real power & intensity. As you can imagine, takeoff is fast & steep, following straight into a sucky, square barrel which can mysteriously close out at a moment's notice... or let you exit and claim the glory. These days Kirra is often an extension of Snapper & Greenmount further round, and it can be the end section of that wave. It is however, often smaller. It likes a wrapping SE swell, but it has to be just right. On small days, it's a good novice wave. When it goes off, its for the better surfer. You can guarantee you will not be alone - the crowds are massive. On classic days when there's a fast current, it can pay to jump out at Snapper and drift round. North Kirra and Tugun have more consistent, often good beach-break peaks further north, with less crowds.

Shaper: Wayne Deane Custom Surfboards, Fac 18, 48 Machinery Drive, Tweed Hds South, 07 5524 2933

QUEENSLAND

Greenmount

From Kirra, follow Marine Pde, heading E to the next bay.

On the E side of the bay, a R works with peaks forming off the point and also across the beach. Best in up to 6ft SE swells, and S - SE winds. A mellow wave, which can create a long ride if the banks are good. Crowded. OK for novices. When lined up Can link from Rainbow Bay and continue to Kirra.

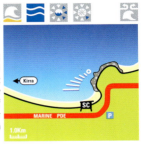

Shaper: JR International. 3/ 2560 Gold Coast Hwy, Mermaid Beach, 07 5554 5488

Rainbow Bay

As for Greenmount, only head E through the town to the next bay.

As at Greenmount, works best in similar conditions, in up to 6ft SE swells. If the sandbanks are good, you can get a long, mellow ride through to link up with Greenmount. Good novice wave but crowded with locals.

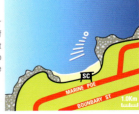

Shaper: M.P. Underground Division, PO 352 Currumbin, 4223. 07 5534 1469. rhemaart@bigpond.net.au

QUEENSLAND

Snapper Rocks

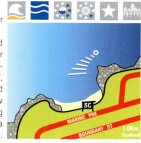

From Coolangatta, look for Snapper Rocks Rd.

The start point of the longest right-hand barrel machine on earth. The Snapper section gets more swell than Kirra, often delivering a hard-breaking take-off, leading to a makeable tube section and race-track. Can link up across Rainbow and Greenmount for record-breaking shack time. Current is mad so get a wave quick and walk back up the beach. Advanced. Crowds? Ah Yeah! Shaper: D'Arcy Surfboards, Fac 1, 61 Ourimbah Rd, West Tweed, 0409 527 467. darcyhandshapes@optusnet.com.au

Duranbah

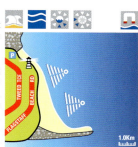

At the end of Wharf St, turn right on Boundary St and follow it to the lighthouse.

Consistent, peaky L & R beach breaks up & down the beach due to sand deposited out of Tweed River mouth. Quite powerful and punchy with some shore dump. Best in 3-6ft SE swells. Very crowded with a heavy local scene. All standards. Consistent. If its huge, you may see the Tweed Bar from here, outside rights and lefts way off-shore.

Shaper: DHD Surfboards, Fac 1, 61 Ourimbah Rd, West Tweed, 07 5536 5233

NEW SOUTH WALES

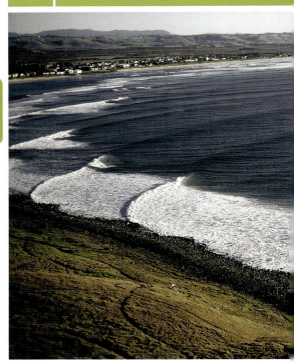

Lennox / *Sean Davey*

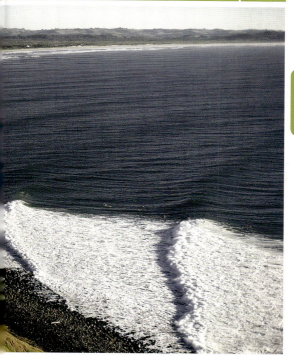

NEW SOUTH WALES

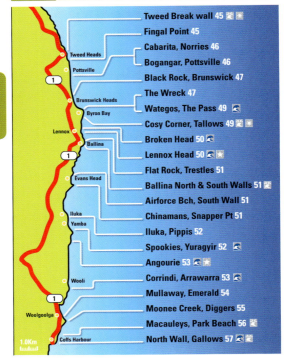

Tweed Heads
Pottsville
Brunswick Heads
Byron Bay
Lennox
Ballina
Evans Head
Iluka
Yamba
Wooli
Woolgoolga
Coffs Harbour

1.0Km

Tweed Break wall 45
Fingal Point 45
Cabarita, Norries 46
Bogangar, Pottsville 46
Black Rock, Brunswick 47
The Wreck 47
Wategos, The Pass 49
Cosy Corner, Tallows 49
Broken Head 50
Lennox Head 50
Flat Rock, Trestles 51
Ballina North & South Walls 51
Airforce Bch, South Wall 51
Chinamans, Snapper Pt 51
Iluka, Pippis 52
Spookies, Yuragyir 52
Angourie 53
Corrindi, Arrawarra 53
Mullaway, Emerald 54
Moonee Creek, Diggers 55
Macauleys, Park Beach 56
North Wall, Gallows 57

NEW SOUTH WALES

Tweed River Breakwall

S of Tweed Heads, go N on Fingal Rd. Take Letitia Rd to the break wall.

Good L along the length of the S break wall, breaking on rocky bottom. Works best in summer & in 3-6ft E-NE swells. Can be a couple of other peaks if the banks are good. Try the N break wall for a variable L & R. Intermediate standard.

Sleep: Tweed Billabong Holiday Park, Holden St, 07 5524 2444

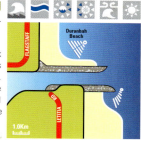

Fingal Point & Beach

S of Tweed, turn off Hwy at Fingal Rd. Head to the carpark.

Right point break, breaking over rocky bottom which works best in the summer NE swells. Can be pretty hollow. Maxes out in 6ft. Along the beach, various L & R beachies breaking over sand, reliant on the state of the banks. All standards.

Sleep: Fingal Holiday Park, Prince St, 02 5524 2208

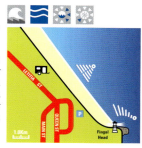

Cabarita & Norries head

From Kingscliff, head S along the Tweed Coast Rd.

R point break on rocky sandy bottom. Long 3-400m ride if the banks are right. Best in 6-8ft SE swells. Heavy currents & crowds. Round the head is **Norries** - a pretty fickle L. Kingscliff itself has a fickle R on shallow reef at high tide only!

Sleep: Emu Park Backpackers Holiday Resort 77 Coast Rd

Pottsville Beach

Follow the rd through Pottsville over the creek, then walk to Black Rock.

OK beachies up & down this open beach as far as Brunswick Heads, bank-dependent. Check out near the rocks. Best in 3-6ft summer NE-E swells. Good spot for smaller, uncrowded waves. Fickle L & R at **Hastings Point**.

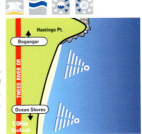

Brunswick River & Black Rock

Turn off Highway after Pottsville. Take North Head Rd to the end.

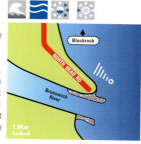

An OK R breaks on North break wall, best in 3 to 6ft NE swells. If wind is in N, check the S break wall and a L at river mouth. Various L & R beachies from Brunswick Heads North. The best of these is **Black Rock**; a clean R on sand /rock bottom.

Sleep: Ferry Reserve Caravan Pk, Pacific Hwy, 02 6685 1872

The Wreck (Byron Bay)

Head into Byron Bay. Take Jonson St to main beach.

A beautiful R breaking over an old shipwreck on sandy rock bottom. Sand builds up round the wreck, creating a hollow 50-150m wave. The beach itself can produce the odd beach-break peak, getting big in massive SE swells. V crowded. Spot for all standards of surfer.

Shaper: David Parkes, 83 Centennial Ct, Byron Bay 02 6685 6627
d-par@bigpond.com, www.parkesaustralia.com

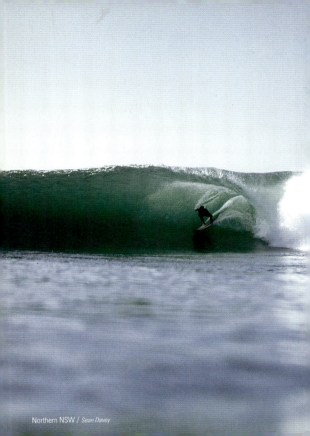
Northern NSW / *Sean Davey*

The Pass (Byron Bay)

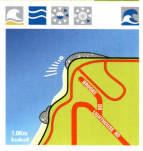

Take road E out of Byron to Lighthouse Rd & walk.

Quality R off the rocks on S point breaks over sand & rock, giving 3-400m ride into the beach. Holds up to 10ft swell. Heavy paddle-out, heavier crowds. Look for **Bullies** - a mean, rocky beachie round the corner in a cove. Check **Wategos** for novice beachies.

Shaper/repairs: Munro Surfboards, 2/29 Acacia St,Byron Bay 02 6685 6211

Cosy Corner
Tallows Beach

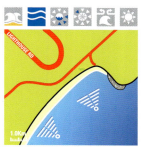

Take Lighthouse Road to Tallows Beach Rd. Cosy Corner is top corner of Tallows beach.
Very consistent L & Rs, breaking on sand & rock bottom. Can give 4-500m ride. Good in 3-6ft but holds up to 15ft. Also, pretty heavy shorey. **Cosy** is protected from NE winds so gets crowded in summer.

Sleep: Aquarius Backpackers 16 Lawson St Byron 1800 028 909 - Shaper: Banks Precision Surfboards, 8 Oceanside Pl, Suffolk Park, 02 6685 3853

NEW SOUTH WALES

NEW SOUTH WALES

Broken Head

Go S On the Byron/Ballina Rd, take the
L at Broken Head Reserve sign.

Classic R sand/point breaks inside the
headland in a perfect setting. If the
banks are working, a fast, barrelling
and hollow wave breaks over sand.
Normally more consistent in summer.
Plenty of sea life-not all friendly.

Shaper: McCoy Surfboards, 10 Acacia
St, Byron Bay 02 6685 3227 www.mccoysurfboards.com
Sleep: Broken Head Caravan Pk, Beach Rd, 02 6685 3245

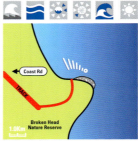

Lennox Head

From Lennox, take Coast Rd S 2-3kms
to the carpark.

One of the great Aussie point breaks.
Long, fast, peeling walls to be charged
on big days. Holds up to 15ft of swell,
though best in 6+. Very rocky entry &
paddle-out, even worse on the way
back. Can be fat on the higher tides.
Crowds.

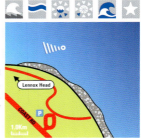

Ballina North & South Walls

From Ballina, take Sth Ballina Beach Rd all the way or get the ferry. North Wall is protected from S winds and consistent. **South Wall** is one of the best places to work in NEs, holding big swells. V dependent on the banks. On larger swells, you can check Angels Beach half way to Lennox. Here you'll find **Trestles**; hard right-hander over reef, and further up, **Flat Rock** (a.k.a. **Skinners**) for beach-breaks and a class left reef/point setup if wind is noreast.

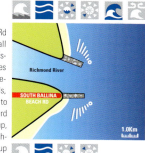

Evans Head

Off the Pacific Highway half way between Ballina and Yamba. You have options depending on conditions here; if wind is south and swell NE -E, check the N entrance wall on **Airforce Beach** for mostly rights over sand. The **South Wall** (back over the river on Razorback Beach) can have a good left, but not too consistent. **Chinamans**, heading south towards Goanna Head, is a more consistent beach-break that is OK on

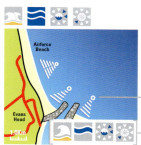

northeast winds. It also hosts a more challenging right reef break off the middle. Edging further south, **Snapper Point** is an inconsistent right-hander to inspect in south winds. Adventure zone.

NEW SOUTH WALES

Pippi Beach

Take Yamba Rd from Hwy. L on Yamba St or Pippi St to the beach.

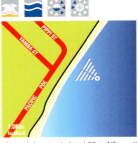

Pippies, the main town surf beach has a good array of peaks. Best in 3-6ft swell, and protected from northeast seabreeze in N corner under Yamba Point. In a Southerly, try **Iluka** on opposite side of the Clarence River mouth for small beachies and a nice break wall style peak known as **North Wall**. The northern end has good shape in a northeast wind and SE to NE swell. Good surf exploration here.

Shaper: Country Style Surfboards, 4 Yamba St, 02 6646 1330

Spookies

From Yamba, Head S to Angourie. Take the Crescent then walk past the blue pools.

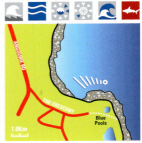

Just around the corner from Angourie is another gem. Called Spookies for 2 reasons. Sharks, and a gnarly R with steep takeoff over shallow rock then straight into a short square, hollow barrel. If flat go swim in the Blue Pools. Also great beachies for the adventurous, S in **Yuragyir park**.

Angourie Point

From Angourie Rd, take The Crescent. Follow the path.

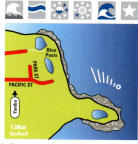

Classic R point, wrapping round the rocky outcrop. The wave jacks up steeply over a ledge to break powerfully over a pebbly/bouldery bottom and form long walls with plenty of barrel opportunities. Holds up to 8ft plus swell, with east pulses lining up nicely. Hairy entry jump off the rocks if big, and plenty of underwater obstruction if you fall. Only for the experienced. Big local scene.

Shaper: Fox Surfboards Angourie,U4, 6 Angourie Rd, Yamba 6646 1040

Arrawarra

Turn off the Pacific Hwy on Arrawarra Headland Rd, N of Woolgoolga.

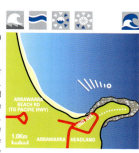

Long, fat R point break, breaking over rocky bottom. Fairly long paddle. Holds up to 6ft SE-NE swell. A good apprentice point break to get practice for Anga and the classics further N. Gets severely crowded. Filters out huge winter south swells into manageable walls, and protects from southerly winds. If wind is north, try **Corrindi** just north up the beach.

Mullaway

From Arrawarra, head S. Follow signs
to the beach.

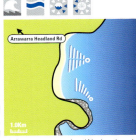

Powerful R point break, breaking on
sandy rock bottom & a deceptively
strong L & R beachie, breaking on sand
bottom if the sandbanks are working.
Works in up to 8ft E-SE swells but best
in 3-6ft. Can be crowded. Advanced
wave in bigger conditions. If it is huge,
and nasty southerly winds are ruining
your day, check **Woolgoolga** down south for some protection. Woolgoolga also
has a consistent back beach with outer bommie.

Emerald Beach

From Coffs Harbour, go North on
Pacific Hwy.

A lovely long Left breaking over
sand bottom, sandbanks permitting.
Produces a clean, peeling wave with
a quite steep takeoff. Best in 3-6ft
SE-NE swells, but can hold up to 8ft,
and gets popular in NE swells. Water
not always clean.

Moonee Beach & Creek

From the Hwy, go S from Emerald Beach 3-4kms.

You got the lot here: beachies, a river mouth and a point set-up too. Better in 3-5ft SE-NE swells, beachies close out over 6ft. The R point at Southern end can be fun and protect from Southerly buster winds. Rippy spot.

Sleep: Moonee Beach Reserve, 02 6653 6552

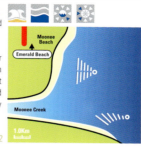

Diggers

Take Park Beach Rd into Coffs. Turn Left on Ocean Pde. Just N of Macauley's.

Peaky A-frame Left & Right beach breaks - can be great quality if the banks are working. More consistent at the N end of the beach, but generally there are good waves in the bigger NE-SE swells. Gets v crowded. All standards of surfer.

Sleep: Koala Villas, 02 6653 1109

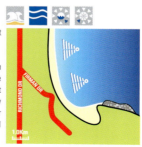

NEW SOUTH WALES

Macauleys

In Coffs, take Park Beach Rd. Turn L into Ocean Pde till the carpark at Macauleys Head.

In 4-10ft swells, a powerful L works from the outside point, breaking over rocky sand bottom, linking up with the beach sandbank if you're lucky. Good local scene - gets v crowded as the beach holds most swells.
All standards.

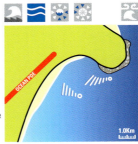

Park Beach

In Coffs, Take Park Beach Rd to the caravan site. Its right there.

In 3-6ft S-SE swells you'll find quality, peaky Left & Right beach breaks, banks permitting. Can get a good wave at the very South end, where there is some protection from southerly winds. At Coffs Harbour, the North Wall is infamous for a gnarly R in big S-SE swells & a rare L off the inside of the wall.

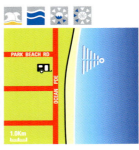

Lennox Head Backpackers 3 Ross St Lennox 02 6687 7636

North Wall

Go to the harbour at Coffs and follow the signs.

At the harbour mouth, a couple of metres off the N break wall, there is a severe, hollow R breaking over sandy reef bottom. Goes off in massive southern ocean swells. Experts only. Also a rare L that breaks on the inside of the wall. Gets crowded.

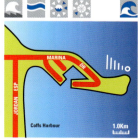

Sleep: Aussitel Backpackers 312 High St Coffs 02 6651 1871

Gallows

From High St in Coffs, take Jordans Esplanade. Easy to see in big swells.

A beast of a Left reef/point break needing big E-SE swells, a very heavy takeoff over rock. Continues to suck up to form filthy thick-lipped barrels. Experienced surfers only. It can be pretty hard - core.

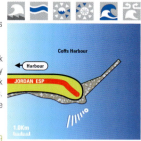

Sleep: Barracuda Backpackers 19 Arthur St Coffs 02 6651 3514

NEW SOUTH WALES

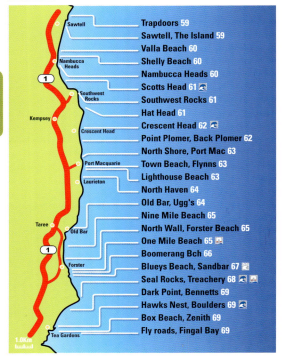

Sawtell

Nambucca Heads

1

Southwest Rocks

Kempsey

Crescent Head

Port Macquarie

Laurieton

Taree

Old Bar

1

Forster

Tea Gardens

1.0Km

Trapdoors **59**
Sawtell, The Island **59**
Valla Beach **60**
Shelly Beach **60**
Nambucca Heads **60**
Scotts Head **61**
Southwest Rocks **61**
Hat Head **61**
Crescent Head **62**
Point Plomer, Back Plomer **62**
North Shore, Port Mac **63**
Town Beach, Flynns **63**
Lighthouse Beach **63**
North Haven **64**
Old Bar, Ugg's **64**
Nine Mile Beach **65**
North Wall, Forster Beach **65**
One Mile Beach **65**
Boomerang Bch **66**
Blueys Beach, Sandbar **67**
Seal Rocks, Treachery **68**
Dark Point, Bennetts **69**
Hawks Nest, Boulders **69**
Box Beach, Zenith **69**
Fly roads, Fingal Bay **69**

NEW SOUTH WALES

Trapdoors

Just S of Coffs, by the creek at the S
end of Boambee Beach.

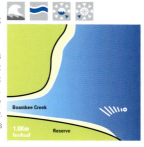

Trapdoors in the right conditions is
a long, grinding (300m plus) R point
working in big S swells. A creek
deposits sand onto the rocky bottom.
Takeoff is over a rocky ledge. Severely
fast & sucky. Experienced surfers only.
In a northeast wind, the top end of this
long beach will be protected.

Sawtell

Take Lyons Road to First Ave. Right into
Boronia Street to the end.

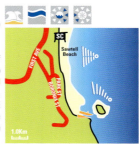

A Pretty consistent beach-break. Of
note a large sandbank can build up
between the headland and **The Island**
at the south end, creating fast, long Rs.
Handles plenty of size (6ft plus SE-NE
swells), but totally dependent on the
banks. Also nice L off the pool for North
winds at low tide.

Sleep: Barracuda Backpackers 19 Arthur St Coffs 02 6651 3514

NEW SOUTH WALES

Valla Beach

N From Nambucca on the Hwy, take Valla Beach Rd. Follow signs.

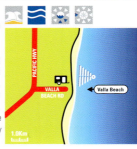

Consistent beach-break that works well in smaller swells and any west winds. The creek sculpts the banks, so it can get nice and hollow, with high tide being a bit of a shore-dump. If the banks arent there then it can be a disappointment, but it is a pretty reliable beach.

Sleep: Valla Beach Resort, Ocean View Dr, 02 6569 5555

Nambucca Heads

Turn off the Highway and follow Nambucca signs.

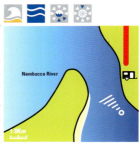

Some good river-sculpted banks at the top of the beach can deliver quality as well as slight protection from northeast sea-breezes. It needs a fair bit of swell. There are sharks here so avoid if water murky or after rains. When wind swings south, inspect **Shelly Beach** on the other side of the river, or **Main Beach** just north. Some fickle reefs also work in that area.

NEW SOUTH WALES

Scotts Head

On the Hwy S of Macksville turn and follow the signs.

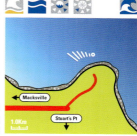

Intense 300m plus long R, breaking on sand bottom in solid 5-8ft SE swells (holds up to 15ft). Takeoff at the point is rocky, but not too heavy. Then cranks up & the sections join to take you into the beach. Big crowds. Novice & intermediate surfers. If it isn't working (highly likely), there is a vast acreage of beach-break up on **Forster Beach**.

Sleep: Scotts Head Reserve, 1 Short St, 02 6569 8122

Hat Head

Take SW Rocks Rd S from Smoky Cape. R on Hat Head Rd.

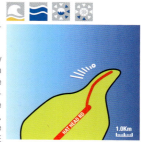

A R forms off a steep, imposing rocky shelf, breaking over a sandy bottom with a few easily-seen rocks. Can be a very good wave in bigger swells (6-8ft can be awesome) if the banks are good. Korogoro Creek feeds the banks, and adds to the variable nature of the break. Isolated spot. On huge SE-NE swell, check **SouthWest Rocks**.

Sleep: Hat Head Holiday Pk, 02 6567 7501

Crescent Head

From Pacific Hwy, take Crescent Head Rd. Turn into Pacific St. L at the roundabout.

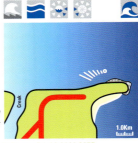

V long peeling R rocky point. Forms at the boulders by the golf course, & wraps across the creek for up to 500m of mellow potential perfection. Holds 10ft of swell so can get big (very rarely!). N of the river, L & Rs on smaller days. Crowds. All standards.

Sleep: Killuke Lodge holiday cottages, Pt Plomer Rd, 02 6566 0077

Point Plomer

Off the Pacific Hwy half way between Crescent Head and Port Macquarie. A trek! A long fat R point breaking over sand & rock. Protected from the southerlies, and a fun wave in the 3-5ft range. It can hold size. There is more consistent beach-break action walking north. Also **Back Plomer**, the beach just south, is more consistent, and still clean in summer north-easterlies It can be quality on small 3-5ft days. Both isolated.

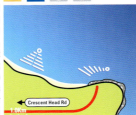

Sleep: Killuke Lodge holiday cottages, Pt Plomer Rd, 02 6566 0077

North Breakwall
Port Macquarie

On N side of Hastings River mouth.

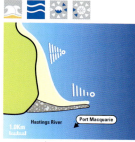

Hastings River's North break wall produces a wedgey R which works in bigger swells. Can get very crowded. Alternatively, trek up the beach for a bit of peace and quiet. There's a road up to Queens Head which takes in all 13 km of North Shore Beach but a 4WD is essential to get full access. On a small day with west winds, it's the most secluded surfing experience you can have.

Sleep: Beachside Backpackers 40 Church St 1800 880 008

Town Beach

Off Stewart & Pacific Drive in Port Macquarie

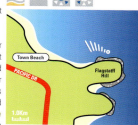

A R works off the rocky point, over mostly sand bottom. Pretty consistent as gets most swells going, and protected from southerly winds. Several other breaks round here, despite most surfers bypassing Port Macquarie. Good hunting! If wind is NE, try **Lighthouse Beach** a few bays South by Tacking Point. On the way you'll pass Flynn's; consistent quality and always worth a look.

NEW SOUTH WALES

North Haven

Turn off Hwy at Kew, then follow signs on Coast Road.

Quality R sand bar/beach break off the end of the N break wall of the Stewart River mouth where the sand deposits from the river. Can be long rides to the beach if the banks are good. Gets crowded with groms. Head N up the beach for peace!

Sleep: Brigadoon Tourist Park, Eames Ave, 02 6559 9172

Saltwater

From Old Bar head S past Saltwater.

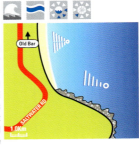

Long peeling R off the boulder-strewn Wallabi Point, known as **Ugg's**, or Green Point. The wave sucks up for takeoff over a rocky bottom. Can line up very well. Holds 3-8ft plus SE swells. Protected from S winds & gets very crowded as a result. Up north at **Old Bar** there is a range of beach and semi-covered reef breaks offering more consistency and pretty good shape.

Sleep: Old Bar Beachfront hol Pk, 02 6553 7274

NEW SOUTH WALES

North Wall Tuncurry

From Wharf St, R into Beach St. Turn left on Rockpool Road to carpark.

In big NE swell, a R breaks outside the end of the break wall onto a sand bottom, giving a long hard ride. It can handle bigger swells. Gets v crowded. Smaller days produce easier L & R's along **Nine Mile Beach**.

Sleep: Melaleuca Surfside Backpackers, 33 Eucalyptus Dr, One Mile Beach, 02 4981 9422, 0427 200 950

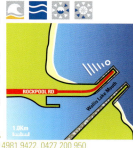

Foster Beach

Cross bridge to Forster. Turn off Wharf St into Beach St. Head to carpark. Busy little beach faces north so protected from southerlies. In large southeast swells and southwest wind, there can be a good right in the south corner. More northeast swells can also make the break wall work at the top end, if you are lucky. In smaller swells, try going S to the top of **One Mile Beach** for L & R beachies at N end. Also **Elim** for empty beachies. Sleep: Backpackers Forster 43 Head St 02 6555 8155

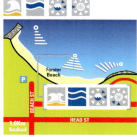

NEW SOUTH WALES

Boomerang Beach

From Pacific Palms, Turn off Lakes Way into Boomerang Dr. Follow signs to carpark.

North Boomerang has a powerful, peaky, mainly L beach break which works best in NE swells of up to 6ft.

South Boomerang has a good R which forms on the outside reef then breaks over reef & sandy bottom. Works best in a SE swell. Can be quite hollow. You may find a good L further S. Can be seriously good if the banks are right. Up and down the beach are normally peaky L & R beachies which don't get as crowded as the points. Check out N to **Booti Booti** for less-crowded clean, empty beachies.

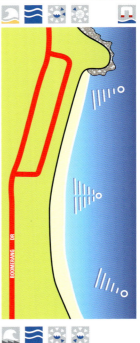

 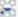

Bluey's Beach

Head S along Boomerang Dr from Boomerang.

A selection of good, peaky L & R (mainly L) beach breaks, breaking over sand bottom. Work most consistently in 3-6ft NE swells. Can get rippy here & the undercurrents can be dangerous. Not normally too crowded either. Good intermediate waves.
Sleep: Moby'sBeachside Retreat, Red Gum Rd, 02 6554 0292

Sandbar

Head S along Boomerang Dr to Bluey's Beach. Sandbar is just S.

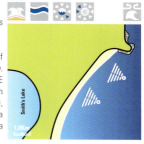

N end, an exceptional L & R beachie if the sandbanks shift in the right way. Protected from NEs but needs SE swell. Further down the beach, which holds heaps of swell (up to 10ft), good L & R barrelling beachies in a beautiful setting. Crowds. Generally a consistent spot.

Seal Rocks

On Gt Lakes Way, go through Bung-wahl. Follow signs.

Mellow R point break in S end of Sugarloaf Bay. In massive swells, it wraps round the point and barrels into the bay, giving a laid-back, short run. Try **Lighthouse Beach** just N for peaceful beachies. Both sharky.

Sleep: Hawks Nest Beach Caravan Pk, 02 4997 0239

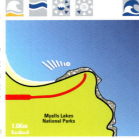

Treachery Head

From Seal Rocks, go S on a dirt track to the campsite.

Sizey L breaks off the point just S of the headland. The wave breaks over sand and rock and holds 10ft. There's a nice R breaking into the channel too. Spooky, beautiful swell magnet. Take care, it's a rocky beach. Look for that channel. The crazy can 4WD up from Hawks Nest on a very rough track.

Sleep: Hawks Nest Beach Caravan Pk, 02 4997 0239

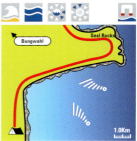

Hawks Nest

Turn off Pac Hwy for Tea Gardens & Hawks Nest. 4WD nirvana, plus dune trekking, dolphins and fishing. The long beach NE of the Nest has varied peaks that have more and more exposure to swell as you go N up **Bennetts Beach** (towards Treachery via Mungo Brush). Near Mungo is **Dark Point**, with good quality beach break (N side protected from the southerly but south side more consistent and a major walk!). Also a rare long L off the boulders on the South side of Yacaaba Head, only for the hugest SE swells and north winds....called **Boulders**.

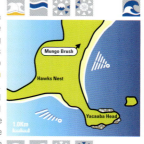

Box & Zenith Beach

Head to Shoal Bay on the southern edge of Nelson Bay.

Box: Heavy & powerful wedgy beach break. Takes NE & SE swells, banks permitting. Try **Zenith Beach** 2 beaches to the N for similar. **Fly Roads** just S, can have quality lined up lefts off Fingal Spit in a solid S swell with south to west winds. **Fingal Bay** just S of that, works in massive southern ocean swells and northerly winds. It has an occasional right-hand point break that can get good. Shoal Bay Backpackers 59-61 Shoal Bay Rd 02 4981 0982

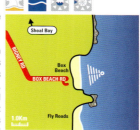

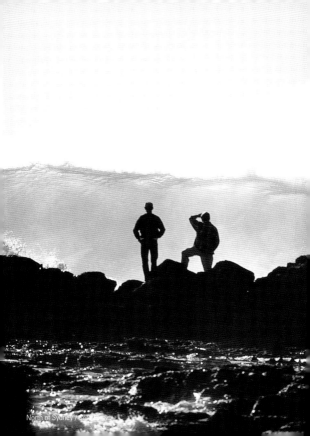
North of Sydney /

NEW SOUTH WALES

Anna Bay

Top of Stockton Beach. **Morna Point** (AKA Birubi). South out of town past caravan park on J Paterson Ave. In a horrid northeast sea-breeze with solid south to east swell, check this spot for a worthy set of beach peaks. A quality left can sometimes line up. **One Mile Beach**: E from Anna Bay on Gan Gan Rd. Expansive, consistent beach-breaks working S through NE swells. Northern corner (Samurai) out of the sea-breeze, and quality waves at southern end too off the rocks.

MELALEUCA SURFSIDE BACKPACKERS
33 Eucalyptus Dr, One Mile

Stockton Beach

Stockton is on north side of Newcastle Harbour, but the beach runs north from here for 30Kms, all the way up to Anna Bay.

Many varied beach breaks, working best in NE or SE swell conditions. Seek out the wreck of the **Sigma** for some well-shaped banks. In Summer Noreasters, cruise up Nelson Bay road until the beach bends round to face the south. The beach is very open, so beware the rips. It can also be isolated.

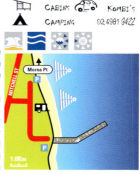

Sleep: Backpackers By The Beach 34-36 Hunter St 02 4926 3472

The Wedge & Stratts Spit

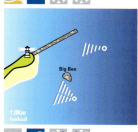

In Newcastle, just along the sandspit off Nobby's Head.

The Wedge is a powerful, thick L wave working in medium to large swells.

Stratt's Spit is just S of The Wedge, right next to Big Ben Rock. Not as consistent and better in lighter conditions, it's a thick-lipped wave breaking L or R. Serious locals; show max respect. If the swell is massive and from the northeast with southerly winds, check the rare right-hander inside the southern break wall of **The Harbour** - a truly dangerous spot best avoided by the sane. Sleep: Newcastle Beach YHA 30 Pacific St 02 4925 3544

Nobby's Reef

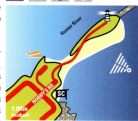

In Newcastle, take Hunter St to the end. Turn Left into Nobby's Road to Nobbys Beach.

The reef is just outside the sand bar which joins the island to Newcastle, immediately south of Stratts. It produces peaky, shifting L & R's. Combined with the currents makes positioning for sets difficult. Holds sizeable swell but is unpredictable. A difficult rip too. Keen local scene. Immediately south you might see The Spot working, another Left Right reef set-up.

Cowrie Hole

Newcastle: Just off the Soldiers Baths pool on The Esplanade.

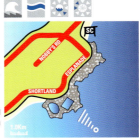

A gap in the rocks leads to a gnarly reef. A stunning R jacks up at the point of the reef & breaks over a shallow ledge. If conditions are right, it links with the inside section. Best in big SE swells. Try **Flat Rock** (reef L breaking further out on the opposite side) in NE swells.

Newcastle Beach

Head into Newcastle and go as far E as you can go!

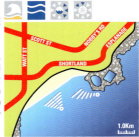

Plenty of L & R beachies, and a good L (and an occasional R) off the rocks at N end of the beach. Best in SE swells, or big NE's. Look out for reforming beach dumps from bigger swells. Home to many surfing legends and equally hardcore locals!

Bar Beach & Dixon Park

S in Newcastle, Memorial Dr to Helen St. N end of Dixon Park Beach.

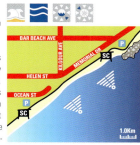

When the sandbanks are good, **Bar** is as good as anywhere for heavy, punchy L & R's forming on the outside banks. Very crowded at times with a serious local scene. If so, look for reforms on the inside banks. Best in 3- 8ft swells. It runs continuous with **Dixon Park**, one of Newcastle's more well known beach-breaks, generally accepted as being the area around Dixon Park Surf Club.

Merewether

Merewether is the southern end of the Bar/Dixon Park Beach trio.

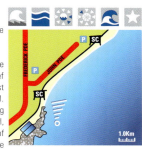

The Ladies' reef works just off the rocks - heavy R breaking on patchy reef and sand. Holds up to 15ft swells (best in 6-8ft) and can get very powerful. Serious local crew with many surfing legends here. If there's solid SE swell, Head S to **Leggy Point** at S end of Glenrock Beach to get away from the crowds. On the way there you may see **Shallows**.

NEW SOUTH WALES

Redhead

Take Dudley Rd S into Redhead St. Turn L into Beach Rd and head to carpark.

A good L (does break R) over reef & sandy bottom. Protected from NE winds, and prefers a 6-8ft NE swell for best conditions, where it gets thicker and more powerful. It's that bit further out, which reduces the crowds.

Sleep: Caves Beach Hotel Caves Beach Rd Caves Bch 4971 1532

Blacksmiths

From Pacific Hwy, turn off on Gommera St at the signs.

Good rights on sand off the break wall here, protected from southerlies. Likes southeast swells and is wedgy in a northeast. Inside the channel itself is a great but fickle rivermouth style peak that's affected by current unless you catch it on dead low tide. If crowds are thick, stroll north to find your spot.

Sleep: Blacksmiths Beach Tourist Park, Gommera St, 02 4971 2858

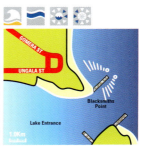

Crabbs Creek

Just S of Swansea Channel. Take Northcote Av into Lambton Pde. Its at Swansea Wall Beach.

Works in powerful S-SE swells. There's a short, hollow L, but the main attraction is a monster of a R (can hold 15ft). Scary takeoff, then a beast of a bowl section, breaking over a reefy ledge for 300m. Experienced surfers only. Very fickle.

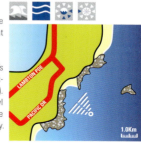

Swansea Beach

Take Caves Beach Rd off Hwy as for Crabbs Creek.

At N end, a L breaks outside the rocks, breaking over smooth rock. A mellow wave in up to 6ft NE-SE swells. Round the rocks is **Frenchmans**, a series of good L & R beachies. Further S, try **Caves Beach** for beachies and a rare R at the S end. All standards.

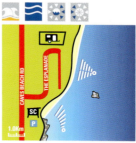

Sleep: Swansea Backpackers 196 High St (02) 4971 1227

NEW SOUTH WALES

NEW SOUTH WALES

Catherine Hill Bay

From Hwy, S of Swansea. Take Colliery Rd to Flowers Dr.

Punchy & peaky L & R A-frame shore dumps, breaking over sand bottom. Works in 3-6ft SE swells. Just S is **Moonee** which is less-crowded as it's a walk in. If not, further S is **Ghosties** in similar conditions. All surfing standards.

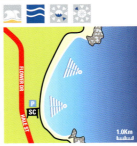

Frazer Park

Just S, take Campbell Dr to Frazer Beach Rd, in Munmorah Rec Area.

Nice peaky L & R s, breaking over sand bottom in this swell magnet of a spot. Best in 6-8ft NE-SE swells. Also, it's beautiful! Get there early and you might surf alone. Pulls 1-3ft more swell than other exposed beaches.

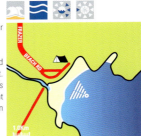

NEW SOUTH WALES

Norah Head

Head for the Boat ramp at Norah Head.

Reef breaks, **Little Bombie** & **Boat Ramp** like big NE-E swells. Boat Ramp a super hollow Right bodyboard paradise over rock ledge. When really big, some good reefs in the area can go off. On smaller days with wind in the south, check **Lakes** up towards Budgewoi for well-shaped beach-break.

Sleep: Norah Head Tourist Park, Victoria St, 02 4396 3935

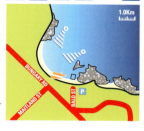

Soldiers Beach

From Norah Head go S on Soldiers Point Dr to carpark.

Nice occasional L point catches the bigger swells. Beachies work well in most conditions and are hollow if fickle banks are right. At the South point is **Sunset** - a long Right; fat at the start, hollow inside, inconsistent. Some quality surf discovery nearby - be nice!

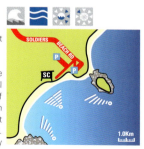

Pelican Beach

Head S from Soldiers Beach on Wilfred Barrett Dr, L to Carpark.

Group of beachies, all working in small 2-5ft NE-SE swells, dependent on bank quality. Will close out in over 6ft swells. Most protected break in the area from summer NEs so gets crowded. Plenty of good beachies S at **The Entrance**.

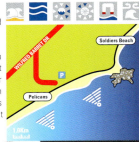

RMS SURFBOARDS
PH. / FAX 02 4384-7263
0414 378 764
rms01 @hotmail.com

Shelley Beach

Head S on The Entrance Rd from The Entrance. Left after Long Jetty.

One of the most likely places you'll find a wave up this coast. A series of peaks all along the beach. The N end is the most consistent with a good L working in up to 8-10ft NE-SE swells. Good novice wave. Consistent. 2 Nice reefs further N for the more adventurous...

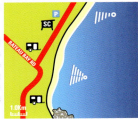

Shaper / Repairs: Wizstix, 9/465 The Entrance Rd, Long Jetty, 02 4334 3987, 02 4385 2087

Crackneck

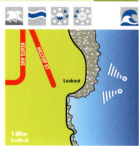

Take Entrance Rd to Bateau Bay Rd.
Turn L on Hilltop St to the Lookout.

As the name suggests, the mainly L wave breaks over a shallow, hard bottom. Short sharp R challenges too (bodyboard wave). Secluded, but rare to catch it at its best. Adventurous walk in, adventurous surf. For good surfers. Rights work OK in a southeast swell.

Sleep: Blue Bay Caravan Park, 02 4332 1991

Forresters

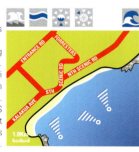

From The Entrance Rd, L on Forresters Beach Rd.

An all-time big wave spot catching more south swell than anywhere. Forries Lefts & Rights are off the semi exposed reef in the middle. 1/2km paddle, hollow, perfect up to 15ft. Not for faint-hearted. **Banzai**, at S end, is a really hollow R. Best in 5-8ft swell. Plenty of rocks. Expert surfers only. Surf a lower tide if you dare.

Shaper / Repairs: Wizstix, 9/465 The Entrance Rd, Long Jetty, 02 4334 3987, 02 4385 2087

 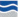 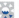 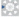

Wamberal Beach

Head N from Terrigal Esplanade, R over creek. Many exits.

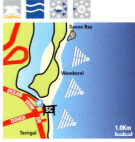

A series of peaky L & Rs , breaking over sand bottom on this long beach. Usually consistent at N end or by the lagoon in 3-6ft swells from any direction. The Bend by Terrigal Lagoon can get wedgy, but check the whole beach for best banks on the day. **Spoon Bay** (around the rocks at top of map) can be worth a check for a bit of peace & quiet. Consistent but affected by sea-breezes, go early. Sleep: Bellbird Caravan Park, 61 Terrigal Dr, 02 4384 1883

Terrigal Haven

HeHead to the harbour at Terrigal. You can hop off the end of the rocks (!) The R is a legend with long walls and some hollow sections, holding big swells and going for 250m. Some unexpected boulders. Consistent in most tides, best in solid winter swells when elsewhere too big, and off-shore in a southerly wind. Also great novice peaks on the beach.

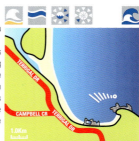

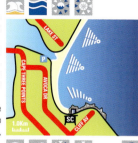

Avoca Beach

Turn R off Scenic Hwy on Avoca Dr to
the beach. Consistent R at the S point
has a rocky take-off and can be hollow.
Best in southwest winds and E or NE
swell. Protected from south winds.
Also series of L & R beach-break peaks
up the beach to N Avoca. Handles NE
- SE swell although a very S swell
can miss-fire in south end, and some
NE swells can create classic lined up
waves. Lower tides best. All standards,
but the point is intermediate plus.
Boards: Nirvana Surfboards, Lot 1,
Empire Bay Dr, Kincumber, 02 4368 1634

Copacabana

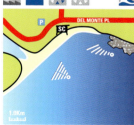

From Kincumber turn on Cullens Rd down
Copa Dr. Shallow rock ledge point working
best on higher tides. On small days the
inside take-off is sucky and ledged,
leading to fat whackable sections. When
big, back-peak take-off is fatter but the
next section is stepped and dangerous;
make this and you're through to lined
up fun walls. Banks on the beach are
extremely inconsistent and better at low
tide. High tide on a solid day generates
heavy shorey. Shaper: Wave Signature, 19
Koorabel Ave, Copa 4382 3030

Macmasters Point

Head through Kincumber to Macmasters.

Powerful R point, needing bigger 5ft plus E-SE winter swells. Rocky bottom. For experienced surfers, the wave offers jacking takeoff & bowling mid-section. Likes southeast swell, and the big ones peak right out the back towards **Caves**. Beachies are inconsistent due to the deep water, but a peak often forms off the sometimes exposed rocks at Tudy.

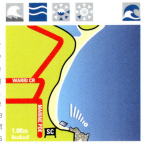

Box Head

Boat-trip from Sydney or Hawks Head Dr to Bouddi Nat Park followed by major, but scenic walk.

A spot to check if its howling NE with big south swell. The Box can be a 1500m peeling L in perfect conditions with good banks. Rare, sucky wave. Big paddle-out, rippy, sharks & boats galore when it's on. **Bouddi Nat Park** has isolated & varied breaks for experienced surf explorers.

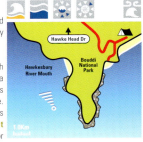

NEW SOUTH WALES

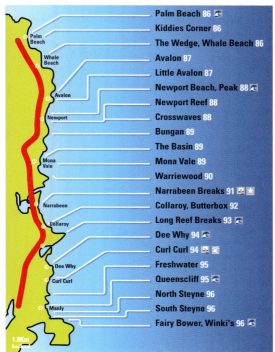

Palm Beach 86
Kiddies Corner 86
The Wedge, Whale Beach 86
Avalon 87
Little Avalon 87
Newport Beach, Peak 88
Newport Reef 88
Crosswaves 88
Bungan 89
The Basin 89
Mona Vale 89
Warriewood 90
Narrabeen Breaks 91
Collaroy, Butterbox 92
Long Reef Breaks 93
Dee Why 94
Curl Curl 94
Freshwater 95
Queenscliff 95
North Steyne 96
South Steyne 96
Fairy Bower, Winki's 96

1.0Km

NEW SOUTH WALES

Palm Beach

The end of the line going N on the Barrenjoey Rd.

Many L & R beachies, breaking over mainly sand bottom. Few crowds (normally). 1km N of the car park is Barrenjoey. When it works, a long isolated L which can be all-time. Tow-in size on the huge days. S is South Palm Beach for cyclonic days & **Kiddies** Corner for groms.

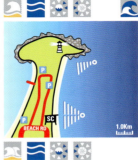

Whale Beach

A couple of kms S of Palm Beach off Barrenjoey Rd.

Home of The Wedge (N end) - solid, pitching L that works in 4-8ft plus NE swells. Don't go R! Easy paddle out via the rip along the rocks. Only for the experienced. Beachies can be fun if small. At the S end, you'll find the odd R.

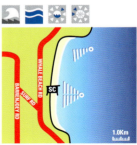

Shaper: Darren Symes, DS Surfboards, 4/76 Darley St, Mona Vale, 02 9997 8266

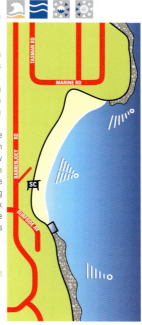

Avalon

Heading N from Newport, turn R off Barrenjoey Rd.

Avalon has 3 areas. North Avalon can be one of the great East Coast waves - best in a massive E-NE swell. The wave peels L over sand from outside the point all the way in to the beach. Can be a great spot when its offshore.

South Avalon has a scary jump off the pool wall to get in on big swells. When the banks are good, there's hollow L's and long R's up the beach. **Little Avalon (LA)** jacks up on a rocky ledge 400m out from the pool, producing a big sucky wave with a really thick lip and round barrels. Takeoff can be scary and uncompromising when its big. Experienced surfers only.

Shaper/Repairs:
LSD (Luke Short Designs), 4 Harkeith St Mona Vale, 02 9979 1231
Sleep: Avalon Beach Backpackers 59 Avalon Pde 02 9918 9709

NEW SOUTH WALES

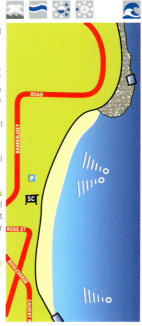

Newport Beach & The Peak

Heading N on Barrenjoey Rd, turn R at Newport.

The Peak, at N end of the car-park, is a very busy L & R breaking over sand and rock. Home to a hardcore set of locals, including the legendary Tom Carroll.
In the right conditions, there is an inconsistent L off the N headland.

The S end of the beach by the pool hosts **Newport Reef** aka **The Path**.

Further out (off map) is **Crosswaves** (also known as the Island) - a powerful R breaks on the N side of the island. It can hold massive swell and is only for the advanced surfer.

Shaper Al Merrick, Channel Islands Surfboards, 4/76 Darley St, Mona Vale, 02 9997 8266

NEW SOUTH WALES

NEW SOUTH WALES

Bungan Beach

Heading N on Barrenjoy Rd, go through Mona Vale, up the hill and turn R before Newport. Walk down.

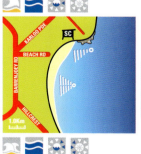

Good Right at N end, some A-frame potential in middle, and when big E swells hit, the South point can have a hair raising Left sandy/rocky point style creature.
Shaper: - Rod Dalgleish Surfboards, 2/89 Darley St Mona Vale, 02 9979 8801, AH 02 9973 1537

Mona Vale

N on Barrenjoey Rodd, go past the Hospital, turn R at the lights.

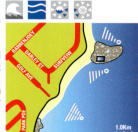

Works in most swells. At the N end, N of the swimming-pool is **The Basin**. Fast Right which breaks over a rocky bottom. S of the pool is a hollow L, breaking over reef and sand. Plenty of other peaks along the beach if crowded.

Shaper: Thomas Jensen, Insight Surf-boards, 4/76 Darley St, Mona Vale, 02 9997 8266

NEW SOUTH WALES

Warriewood

From Mona Vale, head S along the beach front.

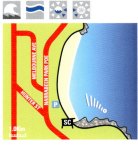

Pretty consistent R at the S end point, breaking over rocky bottom. Good & fast in larger 6ft plus E-SE swells, protected from Southerlies . Smaller days produce OK beachies. Can get rippy. No surprises, it can get busy, but **Little Narra** to the South is a good escape....

Sleep: Sydney Lakeside Narrabeen, Lake Park Rd, 02 9913 7845

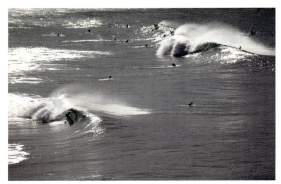

Avalon / *Sean Davey*

NEW SOUTH WALES

Narrabeen

Heading N on Pittwater Rd, various exits in Narrabeen.

North Narrabeen is a very consistent long Left at the lake mouth which can produce a perfect barrel all the way in. There's also an occasional R point type set-up, further up off the rockpool on bigger days.

Alley Rights, just to the S, breaks into the same channel, and has a shark reputation.

Just off the middle of the Car Park is...

Car Park Rights. Another generally well-shaped bank that deliver steep take-offs and barrels on a mid tide.

To avoid crowds, you can check the peaks further down South towards Collaroy. You may get less shape but there's a good chance of a lonely session.

Shaper: Warner Surfboards, 236 Harbord Rd, Brookvale 02 9907 1239
brett@warnersurfboards.com
Bodyboard Shop:
Bodyboarders Surf Co,
1421 Pittwater Rd Narrabeen
02 9913 3847

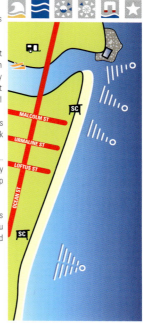

Collaroy

Head N from Dee Why. Right after Long Reef Golf Course.

Nice small waves breaking on soft sandy bottom. A consistent novice wave. Small R's at the point breaking on rock and can be rippy. On big days look for reef outside the pool. Further S are plenty of reefs for experienced surfers.

COLLAROY ST
ALEXANDER ST
SC
BIRDWOOD AVE
1.0Km

Sleep: Collaroy Backpackers 02 9981 1177

Butterbox

From Long Reef, go through the Golf Club, then a 10 min scramble down.

A long, powerful L, a lot bigger when you actually get out there! Also some R's which are shorter. Prepare to be freaked out by the seaweed all around you, and a scrabble out over the rock ledge.

Long Reef
Golf Course
1.0Km

Shaper/Repairs:LSD (Luke Short Designs), 4 Harkeith St Mona Vale, 02 9979 1231

Long Reef

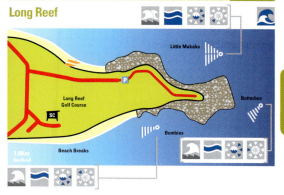

Heading N on Pittwater Rd from Dee Why, take a right down to the beach, or go further on and into the golf course for the reefs.

Lots of options in just about any condition here on the many rocky reefs. NE tip of the point is **Little Makaha**. Long paddle out, isolated, and only in big SE swells & SW winds.

The bombies offer quite consistent waves on the inside, breaking over a set of reefs. As the swell increases, the reefs work further out. The long L & R's closer in link with the beach.

Beach breaks can be found all the way down to Dee Why, and worth checking to avoid the crush. In the centre of the beach is **No Man's Land**. Its a long way from anywhere so is normally a bit less crowded, although the high density development in Dee Why is changing that fast.

Dee Why

Heading to Dee Why on Pittwater Rd, head for the front.

The R at the point, breaking over shallow rocky bottom can be a lippy, all-time wave. Head here on a S wind & in big 6ft plus S swells. Big take-off next to the rocks followed by hollow barrels or bust! Try N for less crowded beach-breaks. Experienced surfers.

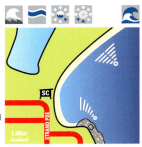

Curl Curl

Turn off Pittwater Road between Manly & Dee Why.

North Curlie is protected from NE's. Various crowded L & R peaks, breaking on sand. In bigger swells, nice outer banks in the middle. Occasional L point at N end. Useful rip at North Curlie SLSC. Consistent spot. South Curlie's heavy R can get hollow. All standards.

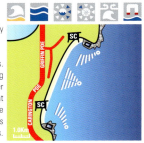

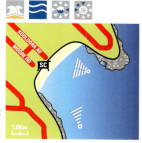

Freshwater / Harbord

Head N on Manly Rd from Sydney. Next bay N round the head from Manly.

Small beach famed for the Duke's surf demo in 1915. Best in the S corner, and the Harbord Diggers, Where you can find good L & R's breaking over sand in 3-6ft E-NE swells. Protected from NE's. Mellow to fat so good for novices, but can get crowded.

Sleep: Boardrider Backpacker Rear 63 The Corso Manly 9977 6077

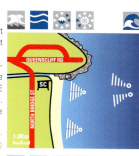

Queenscliff

On Manly beach, Queenie's at the most N end. You can rock-hop from path at end of Queenscliff Rd.

R & L near the rocks, on rock/sand bottom. Other peaks further S. Can be nice & hollow in best conditions (3-6ft E-NE swells). Crowds & locals - be warned. 1/2km offshore, the legendary **Bombie** in 10ft+ E-NE swell: awesome.

Shaper: Warner Surfboards, 236 Harbord Rd, Brookvale 02 9907 1239 brett@warnersurfboards.com

Sleep: Manly Beach Hut 7 Pine St Manly 02 9977 8777

NEW SOUTH WALES

Manly, Winkipop & Fairy Bower

R off Pittwater Rd or the ferry from Circular Quay.

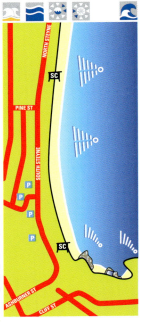

North Steyne: can have unreal barrels in a solid S to E swell, often forming up opposite the shit pipe!

South Steyne by the rocks: Can have nice R barrels, protected in a southerly. On huge S swells, jump off the rocks on the footpath to **Shelley** and go for it! One of the cleaner spots in these conditions.

The Bower or **Fairy Bower**: Access from the carpark above Shelley beach. Hollow long right. Take off almost into rock shelf, then hang on for a heavy ride. Handles any amount of S to E swell. Crowded as hell, as often the best option if everywhere else is closed out or blown off by the southerly buster. Prepare to lose some bark when getting in or out. Outside section (Winki's) demands skill, guts and a biggish board.

Sleep: APAC Backpackers 6 Steinton St Manly 02 9977 0884

NEW SOUTH WALES

Map labels: Bondi, Coogee, Maroubra, La Perouse, Botany, Cronulla, Bundeena, Garie Beach, Stanwell Park, Coledale, Sandon Point, Woonona, Towradgi, Wollongong

Bondi Beach

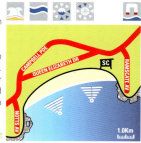

Go to the E end of Oxford Street in Sydney & follow the signs.

South Bondi's sandbanks shift to form 3-4ft beachies in 3-6ft S swells. North Bondi has gentle sloping banks for novices. Closes out over 5ft. Very crowded if it is on, especially as it is protected from summer northeast winds.

Sleep: Sinclairs of Bondi 11 Bennett St 02 9744 6074

McKenzies Bay & Tamarama

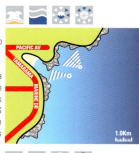

From Sandridge St in Sydney, go through Mark St to the beach.

Very small, rocky beach producing a short wave breaking L& R. L can be wedgy, R tends to be smaller. Closes out over 4ft S-SE. Tamarama in the S is best May-Oct for a small L off the reef. It's a Rippy, small beach, dangerous in S-SE.

Sleep: Biltmore On Bondi 110 Campbell Pde Bondi 02 9130 4660

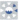
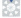

Bronte Beach

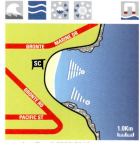

Follow the coast S from Bondi.. You'll stumble in.

Cool, cosmopolitan beach with a R, Bronte Reef, breaking over sand & rocky bottom. Handles up to 6ft S-SE swells - can get barrelly. Reasonable Ls break off the sandbank in middle. Gets rippy. There was a nice big groper until 2001; he was murdered.

Sleep: Bondi Beach Guest House 11 Consett Ave Bondi 9300 9310

Clovelly Bombie

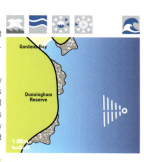

In Clovelly, go S on Arden St, L at Arcadia St to Dunningham Reserve. Track to bottom.

Some call it The Pebble, others say Thompsons Bay...one thing is sure: it's a hard core bombie, a with sucky R and a major L when big. The L breaks right into the cliff. Rocks on the way in and out. Terrifying. Experienced surfers only.

Sleep: Packers At Clovelly 272 Clovelly Rd Clovelly 9665 3333

Coogee

Follow coast South from Bronte, past Clovelly.

Inconsistent spot, but varied. There's a nice L at the north point, & some OK beachies all along. Also **Inner** and **Outer** are Right and L reefs at S end. Off the map S near Wedding Cake Is The **S(o)uthy**, a rare, heavy R reef for large days.

Sleep: Aegean-Coogee Bay Rd 40 Coogee Bay Rd 02 9314 5324

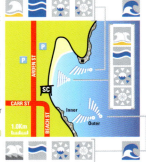

Lurline Bay

Just N of Maroubra.

Heavy R reef break which can hold massive swells (starts working on 6ft plus swells). Breaks over rocky reefs. As the swell gets up, the outer reefs work. Don't even think about it unless you have a gun and are happy getting across the jagged rocks then back again! Hard Core.

Maroubra Beach

South from Bondi and Coogee.

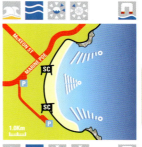

Consistent spot. There is a semi point style L at the N end. Just down from that is Dunny Bowl, a L & R peak on sand. At the S end is a hollow fickle R reef. Along the beach you can catch some good L & R beach breaks. If Maroubra is maxed out then **Malabar** to the South is a good bet for urchin-covered reef and L point options.

Sleep: Beachfront Accomodation 182 Marine Pde 1800 032 233

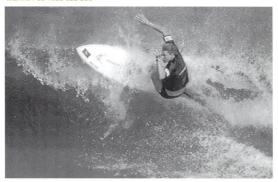

NEW SOUTH WALES

Voodoo

S from Sydney on Rocky Pt Rd. L on Capt Cook Dr. It's E of Green Hills.

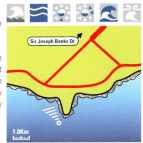

Sir Joseph Banks Dr

1.0Km

Heavy L breaking over a rocky ledge on a rocky bottom. In the right S swell, it holds 20ft! Most consistent between Dec-Mar. Not easy to reach, even by car. Experienced surfer's only. Try Green Hills for small beachy days.

Green Hills

Same directions as Voodoo. From Capt Cook Dr, go S or get the train to the beach.

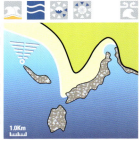

1.0Km

There are several L & R beach breaks in and around Green Hills. Most work in smaller 3-6ft swell and you can usually find a secluded quiet spot. Breaks work in most swells but generally more consistent in S swells.

NEW SOUTH WALES

Cronulla Breaks
Shark Island

Come into Cronulla on The Kingsway. At the end you can go N to N Cronulla & Elouera, or S to Shark Is and The Point. **Shark Island**, off the SE of Cronulla Pt is a heavy, dry-sucking intense R-hand reef break. It breaks bodies and boards, but delivers some of the squarest, most photographed barrels in Aus. **Cronulla Pt** (end of Elizabeth Pl.) a fast, powerful R-hand rock-ledge point, is for experienced surfers only, and super-crowded. 3-10ft, fickle, and on-shore in summer noreasters. Next wave of note is **The Wall** (top end of S Cronulla Beach); structured rock/sand taking most swells but also on-shore on summer afternoons. Can get hollow and fast. Some OK beach-break pops up on **North Cronulla Beach**, getting better shape and more consistent up towards **Elouera**, by the surf club (end of Prince St). Of note, N of here, is **John Davey**, where consistent beach peaks appear around **Wanda** Surf Club and the Wanda Reserve. This section of the beach is a good bet in summer NE winds, and the further up you go the cleaner it gets. Always a bunch of good surfers on the best peaks, but be mobile and relaxed and you'll snaffle some nice ones. All levels. Sleep: Cronulla Beach YHA 40-42 Kingsway Cronulla 02 9527 7772 enquiries@cronullabeachyha.com

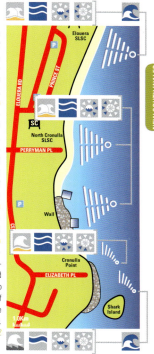

Royal National Park

S on Princes Hwy to Waterfall Station. Turn L. Garie is 20m drive.

15,000 hectares of National Park with 20kms of coast, 1 hour from Sydney. Paradise?

Garie Pt is the most popular. Normally a good L at North Garie, breaking on sand and rock, and holding 10ft of swell. There is a rocky ledge at the S end which occasionally spawns a small R.

15 min walk S is **North Era**. This is an isolated L point break which is great in 6ft swell on the right wind and tide. In smaller swell several beachies work, and the odd R at the S end.

There are plenty of other breaks all this coastline for the adventurous.

Heading south towards Coalcliff you'll get to **Stanwell Park**. Head down Stanwell Ave to the car park and you'll find a nice beach-break that isn't too affected by summer sea-breezes (they blow cross-shore) and takes most south swell going.

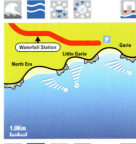

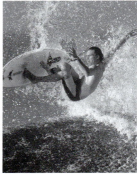

NEW SOUTH WALES

Coal Cliff

Head to Lawrence Hargrave Dr in
Coalcliff.

At the S end a hollow wave breaking L
over a sandbar can be very good. Can
get surprisingly big, hollow barrels.
You may get a ledgey R off the rocks.
Also head up the beach for beachies in
small swells. All standards.

Scarborough Beach & Wombarra

South of Clifton, Left off Lawrence
Hargrave Dr.

N end of the beach is Scarborough
- a L which rolls down the beach if the
banks are right. S end is **Wombarra**
where a R can be great in winter if the
banks have plenty of sand deposited.
Can handle a bit of size too. Both work
best in summer.

NEW SOUTH WALES

Thommo's

Head to Coledale on Lawrence Hargrave
Dr, then pull up at Shark Park.

Whilst Coledale Beach itself can
be quite ordinary, **Thommo's** is a
deceptively heavy L breaking over
rocky bottom, at the N end of the next
beach South. Works best in 5ft+ E-N E
swells. Advanced. Heavy paddle-out
and punishing waves.

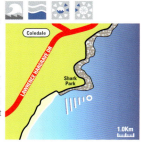

Headlands & Sharkies

Sharkies is just South of Thommo's in
the middle of beach. Headlands - off
the boat ramp at Brickyard Pt.

Headlands: Great R breaking over
gnarly reef bottom. Handles 6ft plus
NE-SE swells. OK takeoff unless shallow,
then fast, ledgey barrel. **Sharkies** is
a LR reef. The L needs a NE-SE swell,
the R needs more E-S swells.

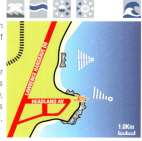

Austinmer Beach

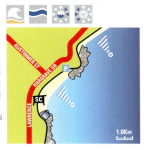

In Austinmer, head E on Austinmer St.

To the N, **Little Austie** is a nice small R, breaking over sandy, patchy rock bottom. Further S, punchy, barreling R & L (mainly R) beachies, breaking over sand, work in 4-6ft NE-E swells. Improver / intermediate spot. Gets pretty crowded in the summer.

NEW SOUTH WALES

Thirroul & Macauly's

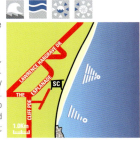

South of Austinmer on Lawrence Hargraves Dr.

Thirroul has a good, small R at S end, breaking over sandy & rock bottom. Best in 3-6ft NE-SE swells. Also peaky L & R s up & down the beach over sand. Improver break. Crowded in summer. Go south around the rocks for rocky/sand bottom L & R beachie at **Macauly's**; less crowds.

Sandon Point

Northeast of Bulli, Turn off Lawrence Hargrave Dr into Point St.

All-time world-class R point, breaking over rocky reef bottom. In smaller 3-5ft E swells, a good intermediate point break. Anything from 6-15ft awakens the beast. Freefall takeoff & intense, top-to-bottom spitting barrels for the heavy locals & experienced surfers only. On south side of the point is **The Bombie**, a left-hander breaking on the same slab. It gets pretty good on its day and has a peaky inside right-hander frequented by bodyboarders.

Peggy's & Banzai

From Sandon, 5 mins S, at the northern tip of Bulli Beach. A shallow ledge sticks 400m out to sea. N side is **Peggy's**. At best (4-8ft NE-E swells) a heavy R breaking over rock bottom. Hairy jump-in or huge paddle-out. S side is **Banzai** - fast, hollow barreling L over rock bottom, way too close to the rocks. Chargers only. Inconsistent. Check out **Bulli Beach** for sanity. The northern end can get good. The southern end of Bulli Beach is also worth a look. They call it North End (North Woonona) and it gets quite busy.

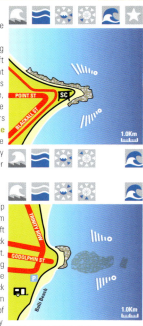

Woonona

Just south on the other side of the rocks from Bulli Beach.

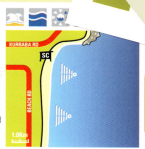

A versatile beach, best in summer. A variety of L & R beachies, breaking over sand bottom. Best in 3-8ft NE-E swells. Punchy, peaky A-frames. V consistent in 3-4ft. Good beach to find empty peaky L & R beachies over sand bottom. All surfing standards.

Bellambi Point

Just S of Woonona on the Lawrence Hargrave Dr.

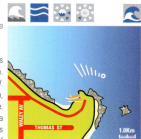

In 6ft+ E-SE swells, the bommie goes off 200m out from middle of the beach. Needs solid swell with light SW - W. Forms a classic bombie set-up - steep, hollow & short but can be pretty awesome. Experienced surfers only. If it's blowing a northeast sea-breeze, **East Corrimal** is a good bet for some protection, end of Murray Rd by the lagoon. Further south still, at the bottom end of Corrimal Beach is an interesting reef option in a westerly with solid SE swell.

NEW SOUTH WALES

Towradgi / Fairy Meadow

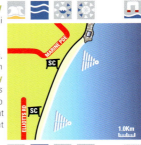

From Princes Hwy, turn L on Towradgi Rd. A Northern suburb of the 'Gong.

Towradgi - Shifting peaked L & R's, breaking on sand-covered reef in 4-6ft NE-SE swells. Just S is **Fairy Meadow** - a combo of L & R sandbars best at low tide & rarely crowded. Go S of Port Kembla harbour to Red Point in big E-SE swells for semi-secret Port Reef.

Wollongong Surf Leisure Resort, Pioneer Rd, 02 4283 6999

Wollongong

Take the Hwy into the Gong. Head to the beach.

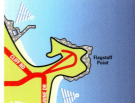

North Beach, N of Flagstaff Point has L & R's breaking on sand-covered reef in 3-6ft NE swells / SW winds. **South Beach** has L & R beachies on mainly sand bottom in N winds, but protected in summer NE's. Both get crowded. Waves for all.

Sleep. Sky Accommodation 5 Parkinson St Wollongong 4228 9320

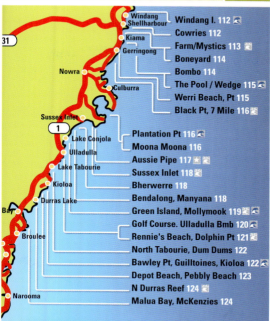

NEW SOUTH WALES

Windand
Shellharbour

Windang I. 112

Cowries 112

Kiama

Farm/Mystics 113

Gerringong

Boneyard 114

Bombo 114

Nowra

The Pool / Wedge 115

Culburra

Werri Beach, Pt 115

Black Pt, 7 Mile 116

Sussex Inlet

Plantation Pt 116

Lake Conjola

Moona Moona 116

Ulladulla

Aussie Pipe 117

Lake Tabourie

Sussex Inlet 118

Kioloa

Bherwerre 118

Durras Lake

Bendalong, Manyana 118

Bay

Green Island, Mollymook 119

Golf Course. Ulladulla Bmb 120

Broulee

Rennie's Beach, Dolphin Pt 121

North Tabourie, Dum Dums 122

Bawley Pt, Guilltoines, Kioloa 122

Depot Beach, Pebbly Beach 123

N Durras Reef 124

Narooma

Malua Bay, McKenzies 124

Bermagui

Windang Island

South from Port Kembla, cross Lake Illawarra & turn L to Pur Pur Pt & the island.

Big wave spot in 6-12ft SE-NE swells. Grinding, barreling long L beast. To the N is **Sharkie's** - offshore reef breaking L & R and less consistent. Banks can get good up there too. Lake Illawarra can burst on either side of island, affecting bank quality. Sharky!

Sleep: Windang Beach Tourist park, Fern St, 4297 3166

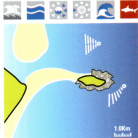

1.0Km

Cowries & The Pool

Head to Shellharbour. Cowries is off the NE tip of harbour, Pool..off the pool!

Cowries - R breaks on a shallow rocky ledge in 3ft +. Dry suck on take-off, hollow and shallow! **The Pool** is also a heavy number, handling loads of swell.
To the S is **Shallows** - major R (With slight L) for NE swells and S winds.

Sleep: Shellharbour Beachside tourist Park, John St, 02 4295 1123

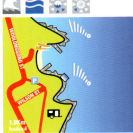

1.0Km

The Farm

S of Watsonia on Princes Hwy, turn down Buckleys Rd. On private property.

Well protected from Noreast winds. The banks are pretty consistent so often peaky A-frame L & R beachies. R point also worth a look. Jacking takeoff & hollow barrels. Intermediate.

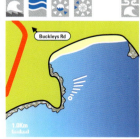

Mystics

From The Farm, head S round the bay. Access through private property.

Great Beachies here, and good L breaking off the point over shallow sand & rock bottom. Holds plenty of swell, South swells most beneficial. Explore this coast for secret spots. Intermediate level.

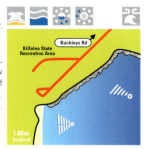

Boneyard

Just N of Kiama.

Isolated & beautiful spot. Head down the cliffs to the rocks. 100m offshore is a large rock with a reef, breaking L (& rumoured rights) in big SE swells forming a serious, hollow barreling wave of awesome power. Heavy paddle-out. Protected from Winter southerlies Experienced surfers only.

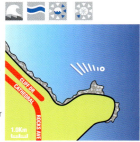

Bombo Beach

Kiama. Just N of town, look across the railway to the beach.

Long, open beach picking up most swell going, means pretty consistent, good peaky L & R beachies, over sand bottom. Best in 3-6ft SE-NE swells. Surprisingly punchy. Likely to find empty peaks. Beware rips & currents. Waves for all surfing standards.

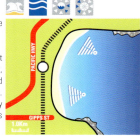

Sleep: Kendalls Beach Holiday Park, Bonaira St, 02 4232 1790

The Pool & The Wedge

Take Hwy to Kiama. Head East from town to Blowhole Point.

The Pool - quality R, breaking off rocks, on rocky reef bottom. Best in 6ft+ SE-NE swells. In big swells, freefall takeoff then intense barrels. **The Wedge**, S of car park, is a sucky L breaking along the rocks in same conditions. Experienced surfers only.

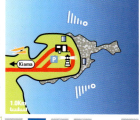
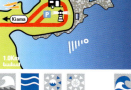

Sleep: Kiama Backpackers Hostel 31 Bong Bong St 02 4233 1881

Werri Beach & Point

Head to Gerringong. Its just out of town on Pacific Ave.

S end is **Werri Point** - long (3-500m) powerful barreling R, breaking over shallow rock bottom. Best in 6-8ft E-NE swells. Advanced wave. Try N of beach for peaky A-frame beachies (mainly Lefts) on sand in 3-6ft NE-SE swells. All standards.

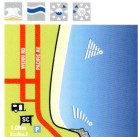

NEW SOUTH WALES

Seven Mile Beach & Black Point

From Gerroa, take Fern St. south. Long, perfect barreling L breaks at the point at the N end of **Seven Mile Beach**, over reef. Likes solid E-SE swells. Protected from the noreaster. Currents in bigger conditions. Intermediates+. Head N for semi-secret empty reefs, or S onto the beach for good, empty consistent peaks.

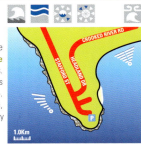

Plantation Point

Huskisson to Vincentia. Head to E Barfleur Beach.

Rare, barrelling Right breaks off the headland, over rock. Needs biggest SE swells as Beecroft Peninsula blocks out north swell, and Cape St George blocks the S. Advanced. If wind is W or NW, try **Moona Moona Creek** at the top of Collingwood Beach for a quality but fickle rivermouth in same swells. Intermediate. In northeast conditions with smaller swell, **Steamers** is a mysto spot on the E side of St Georges Head (walking track). Advanced.

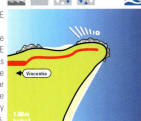

Sleep: Huskisson Beach tourist Resort, Beach St 02 4441 5152

Aussie Pipe

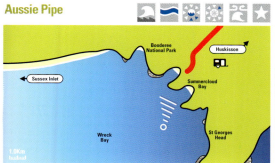

(Summercloud Bay)

Head south from Jervis Bay into Wreck Bay. Aussie Pipe is off the eastern point of one of the small coves at the heart of the bay, called Summercloud Bay.

Summercloud Bay is home to an all-time classic reef break, Pipeline (sometimes called Summercloud or Wreck Bay). It's a perfect, hollow barrelling wave of immense power, hence the North Shore tribute. The Pipe works perfectly in 3-8ft SE-S swells, producing a L and a shorter R of immense quality. It does hold bigger swells up to maybe 10ft, and then the L really cranks. Steep, lightening takeoff, bottom turn & pull-in to perfect peeling top-to-bottom barrels. All needs to be combined in 1 quick move or you may be axed by the often thick lip.
Bang off-shore in Summer Noreast winds, but only works in reasonable swell from the South so very fickle. Square barrels going on for seconds...of course there's a price to pay - it's a crowd puller. If its over-crowded or just not doing it you can make a detour to **Bherwerre Beach** for more consistent spread out beach-break pleasures.

NEW SOUTH WALES

Sussex Inlet

Going S on Hwy, turn off on Sussex Inlet Rd. Follow signs to the beaches.

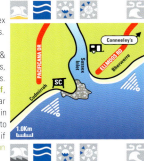

In northeast winds, **Cudmirrah** & **Bherwerre** have small L & R beachies, over sand bottom in 3-6ft S-SE swells. Head south to **Coneeley's Reef**, a quality peak breaking in similar conditions at the end of Third Av in Berrara. It breaks at the entrance to Swan Lake. Waves for all standards if you go explore. Sleep: Riverside Caravan Pk, Sussex Rd, 02 4441 2163

Bendalong Beach

Heading S on Hwy, take Red Head Rd to Bendalong Rd. Follow to the beach.

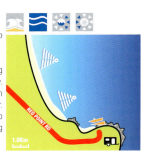

Some great L & R beachies breaking in most swells. Best in 3-6ft, hollow. You may have to share these with crowds though, particularly in summer. Improver spot. **Manyana Beach** to your S is a good swell puller, facing more South.

Shaper: Rabbidge Surf Design - Retro Longboards. 441a Bendalong Rd, Bendalong. 02 4456 4045 / 0427 767 176

Green Island

S from Nowra to Cunjurong. Cunjurong Pt rd to end. Or trek/paddle from Conjola.

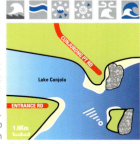

Long walled L jacks up on the reef at SW end of the island (which is cut off from mainland at high tide). Long walled rides, yet strangely mellow. The walk then the paddle are an adventure. Eerie, pretty spot. One of a select group of spots that are dead off-shore in summer noreasters. Shaper: Rabbidge Surf Design - Retro Longboards. 441a Bendalong Rd, Bendalong. 02 4456 4045 / 0427 767 176

Mollymook Beach

Go S on Hwy to Ulladulla. Turn L at the roundabout on Golf Av to the beach.

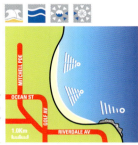

L & R beachies on sand bottom in the centre of the beach in 3-6ft E-SE swells. Alternatively, Jump off the rocks for a R at the Point which can be fast & ledgey (best in SW winds). In NEs, try N to **Bannisters Head** for an often-empty L reef & peaks.

Sleep: Mollymook Caravan Park, Princes Hwy, 02 4455 1939

NEW SOUTH WALES

Golf Course Reef

Go S on Hwy to Ulladulla. Take Golf Av to Mollymook Beach. Take Riverdale Ave to the Golf Course.

Long, hollow-barreling L breaking on shallow rocky reef. Best in big 8-10ft plus SE-NE swells. Monster paddle-out. Just S, there is an even shallower reef breaking R & L in 6-8ft. Experienced adventurers only.

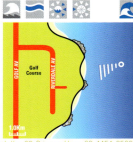

Sleep: South Coast Backpackers Ulladulla, 63 Princes Hwy, 02 4454 0500, 0412 445 303

Ukkadulla Bommie

Go S on Hwy to Ulladulla. Turn L at Deering St to Ulladulla Head.

Legendary, classic Bommie breaks Right & Left (Right most consistent) over reef bottom. Sucky, hollow bowling barrels with guillotine lip-from-hell. Holds 10-15ft South swells. Shifting takeoff, unpredictable sections & currents make it for experienced surfers only.

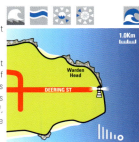

Sleep: South Coast Backpackers Ulladulla, 63 Princes Hwy, 02 4454 0500, 0412 445 303

Rennie's Beach

Take Hwy S to Ulladulla. Go past the harbour & turn L on Hollywood Av to end.

R breaks over sandy reef bottom at S end. Best in 3-6ft S-E swells, forming a sucky peeling wave. Check the beach for L & R's on sand bottom, and a R at N end. Head S for a hollow barreling L at **Racecourse Creek**.
Intermediate spots.

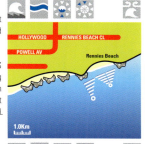

HOLLYWOOD RENNIES BEACH CL

POWELL AV

Rennies Beach

1.0Km

Dolphin Point

Head S on Hwy from Ulladulla across Burrill Lake & turn L just S, on Dolphin Point Rd.

S of the point, a mellow L breaks over shallow reef bottom in 3-8ft NE swells. Take-off over rocky ledge, then a jacking, hollow barrel section. Try the beach for small but often empty Left & Right beach breaks. Improver to intermediate levels.

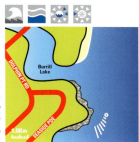

DOLPHIN PT RD

Burrill Lake

SEASIDE PDE

1.0Km

NEW SOUTH WALES

North Tabourie & Dum-Dum's

Head north from Termeil to Tabourie Lake. Turn off right to bottom end of Wairo Beach.

Offshore reef breaks L & R in 4-8ft plus SE-NE swells. Short but peaky, hollow waves. S of Crampton Island is **Dum Dums**, fickle but quality R breaking over very shallow reef bottom. Best in 3-6ft SE-NE swells. Also check for peaky L & R beachies.

Sleep: Lake Tabourie Tourist Park, Princes Hwy, 02 4457 3011

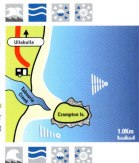

Bawley Point

Princes Hwy to Termeil. E on Murramarang Rd. First L to the point.

Mean, grinding Right barrelling off the flat-rock point over rock bottom. Severely steep takeoff in up to 12ft NE-SE swells, and the break holds more! Nasty getting in & out on slippery rocks in anything sizey. Experienced surfers only. **Kioloa Beach** to the south can be checked in smaller conditions.

Sleep: Racecourse Beach Caravan Pk, 381 Murramarang Rd, 02 4457 1078

Guillotines

Princes Highway to Termeil. East on Murramarang Rd. First L to the point.

Just inside Bawley Point is Guillotines a huge R fires down the rock ledge over shallow rock. Very steep and fast in big 6ft plus days. You must get back over the shoulder or you're jagged rock food. Experienced (and insane) only.

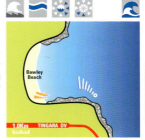

Depot Beach

Turn off Hwy just before the Lake on Durras Nth Rd. 2kms N of Durras Nth.

Just N of Point Upright, the beach has various shifting-peaked beach breaks in 3-6ft NE-SE swells. It is protected from southerly storm winds so a good winter spot. Can be some great waves. Good spot to explore for secluded beachies & reefs. Try Pebbly Beach & Merry Beach. All standards.

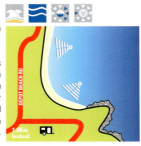

North Durras Reef

Turn off Princes Hwy to Durras North. Take N Durras Rd to Point Upright. It's just S.

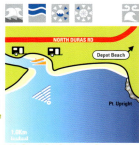

A reef juts out from lakes entrance. Also, if the sandbars are good, peaky L & R beachies in 3-6ft SE-NE swells. Fickle. Beware deep channel rips. Go S to explore breaks at **Durras** & **Beagle Bay**. Intermediates.

Sleep: Beach Road Backpackers Hostel 92 Beach Rd Batemans Bay 02 4472 3644

Malua Bay

Go 10kms S of Bateman's Bay on George Bass Dr.

A good beach-break option in NE summer on-shores. Best in 3-6ft SE-E swells. A couple of bays N is **Mosquito Bay**, where a right-hand rocky point breaks into the bay by the boat ramp in SE-NE swells and S-W winds. Also **Mckenzie's** round the S head for a sucky L, best in 3-6ft SE swells. Great area to explore here. Sleep: Batemans Bay Backpackers Old Princes Hwy Batemans Bay 02 4472 4972

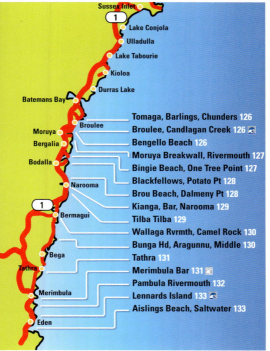

NEW SOUTH WALES

Sussex Inlet

1

Lake Conjola

Ulladulla

Lake Tabourie

Kioloa

Durras Lake

Batemans Bay

Broulee

Moruya

Bergalia

Bodalla

Narooma

1

Bermagui

Bega

Tathra

Merimbula

Eden

Tomaga, Barlings, Chunders **126**
Broulee, Candlagan Creek **126**
Bengello Beach **126**
Moruya Breakwall, Rivermouth **127**
Bingie Beach, One Tree Point **127**
Blackfellows, Potato Pt **128**
Brou Beach, Dalmeny Pt **128**
Kianga, Bar, Narooma **129**
Tilba Tilba **129**
Wallaga Rvrmth, Camel Rock **130**
Bunga Hd, Aragunnu, Middle **130**
Tathra **131**
Merimbula Bar **131**
Pambula Rivermouth **132**
Lennards Island **133**
Aislings Beach, Saltwater **133**

Tomaga Rivermouth

Head for **Tomakin** via Mogo, 20K N of Moruya. Take Annetts Pde off the Princes Hwy.

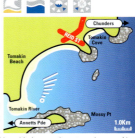

Long gentle right-hander on sand needs quite a bit of swell to work, preferably from the southeast, at low tide. Can get hollow if banks are right. SW wind best. On an outgoing tide theres a good rip to flush you out along Mossy Point rocks. Further N, try **Barlings Beach**, AKA **Chunders** for a good south swell beachie in a northeast sea-breeze. Also **Rosedale Bay** & beyond for secluded beachies. Waves for all standards.

Broulee

S end of Broulee beach. Insane R; **Pink Rocks** works in 6ft+ E swells. South swells push across and generate current. Sucky, steep takeoff over rocky ledge, into a barrelling section. On big days, take-off is further out & harsh. Experienced surfers. If small, try **Candlagan Creek** at top of beach; fast hollow Rs on sculpted sand in W winds. If wind NE then **Bengello Beach** has a reeling left, just south, in front of surf club at end of Heath street. Likes small S swell, low tide. If swell bigger on high, a left reef breaks off the rocks here too, by the car park.

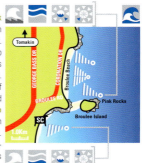

Moruya Break Wall

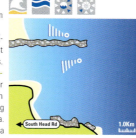

Head S on Hwy to Moruya. Turn L on Sth Heads Rd for 5kms.
Peaky R off N **Break wall** in solid NE-SE swells, lining up best in a southeast swell. Protected from southerly winds. Heavy rip along the wall. In the **Rivermouth** itself is a quality left-hander that works best at low tide. In between tides there as an awful rip dragging you, and a heap of debris, out to sea. If the river's being generous, there's a good R too. Sharky. Just S, the back beach at **Congo** is one of the best, most hollow beach-breaks on the south coast. Works best in west winds, low to mid tide. End of Dampier Street.

Bingie Beach & Tuross head

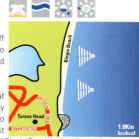

Top end of Bingie Beach accessed off the Princes Hwy in Bergalia; signs to Bingie Bingie Pt. South end accessed via Tuross Head.

Top end by Bingie Bingie Point is great beach-break in northeast breezes, any tide. South end at **Tuross Head** also consistent beach-break needing west winds, best when small. Just south of Bingie Beach is **One Tree Point**; quality on a mid tide with any north to west winds. Tuross Head area is always worth a look for beach and point options in most conditions!

NEW SOUTH WALES

Blackfellows Point

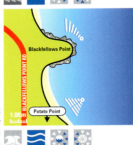

Take Princes Hwy S from Bodalla, and turn east to Potato Point. From here there is a long track up to Blackfellows. **Blackfellows Point**: Inconsistent R breaks on the north side over rock in NE-SE swells. Beach running south has a selection of often-empty L & R beach-break peaks. At the bottom of this is **Potato Point**: Quality R-hander breaking by the boat ramp over rock and sand. SE swells line up nicely but NE works too. SW winds best. All standards. In a noreaster, Jemisons Beach is a consistent option, on the S side of Potato pt.

Dalmeny Point

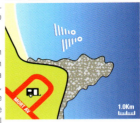

30kms S of Moruya on Hwy, turn L past Lake Mummaga on Mort Av to the point.

A reef directly opposite the caravan park forms solid L & R's breaking on sandy reef over sand bottom. The R is a long mellow ride into the beach. The L, close to the rocks is a short, sucky wave in 6-8ft NE-SE swells. Intermediate spot. **Brou Beach** itself is a peaceful beach-break with some reef action if you check further north.

Narooma Breakwall

Take Hwy S of Kianga to Narooma. Turn L to Bar Rock Rd to the break wall.

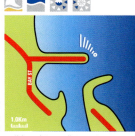

Consistent walling R peels off the break wall at the bottom end of **Bar Beach**. Holds up to 8ft plus NE-SE swells with the NE being pretty wedgy. Attracts the crowds especially in a southerly wind when elsewhere is blown out. Stroll N for beach-breaks. Further N at **Kianga**, a hollow, barrelling R works off the break wall over rock bottom in similar conditions. Intermediate spots.

Sleep: Easts Riverside Holiday Park, Princes Hwy, 02 4476 2046

Tilba Tilba Beach

A trek south from Mystery Bay, in the Eurobodalla National Park.

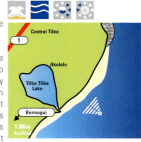

A remote, quality river mouth style wave at the usually closed entrance to Tilba Tilba Lake. The beach generally has consistent beach-break peaks in any NE - Se swells, although 2-5ft is best. There will be hollow waves in north-west winds, and major rips and currents if big. Remote so don't surf alone.

Wallaga River Mouth

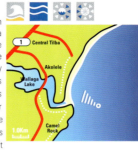

About 17K S of Narooma, on south end of Wallaga Beach, Access via Tilba Tilba Track, on foot. The entrance to Wallaga Lake can produce some excellent right-handers, especially after the creek flushes out and throws up the right banks. Best in south swells from 3-6ft, and protected from S or SW winds. A few K's south across the creek mouth, **Camel Rock** has fun Ls protected from sea-breezes on 3-5ft ENE swells. Sleep: Zane Grey Park, Lamont St, Bermagui, 02 6493 4483

Bunga Head (Mimosa Rocks)

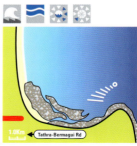

Just S of Murrah on Tathra-Bermagui Rd, turn L on the track before Wapengo Lake. North of Mimosa Rocks.

A fair paddle-out or in bigger days, a hairy jump off the rocks to get to a good, peeling R with long walls, breaking on shallow reef in 3-8ft plus NE-SE swells. Hairy takeoff then fast bowl section. Inconsistent. Experienced surfers only. Likes south-west winds, so in a summer northeast, **Aragunnu Beach** is a K south and will be semi-off-shore. **Middle Beach**, about 10K N of Tathra is consistent beach-break in 3-6ft E - NE swells.

NEW SOUTH WALES

Tathra

10kms N of Merimbula take Snowy Mt Hwy into Tathra to the Reserve at the point.

An inconsistent L breaks at the rivermouth of the Bega River. Can form a long, hollow 3-500m mellow ride. More consistent L & R beachies work best in 3-8ft NE-SE swells, but are sandbank dependent. Good area to explore for secret spots for all standards.

Sleep: Seabreeze Holiday Park, Andy Poole dr, 02 6494 1350

Meribula Bar

In Merimbula, head down Market St over the lake. Classic L on sandbar in huge S-SE swells, forming a hollow barrelling wave up to 300m long, with a steep takeoff, then long bowling sections. V erratic & fickle but the beach running S is more consistent. **Short Point** beach, just N, is a worthy beach-break in S conditions, with its top end protected from NE sea-breeze too. Grom hangout but often good when other beaches are blown out. 5K north is **Bournda Island** at top of Tura Beach: Quality L on S side of Island picking up S swells and protected from summer NE breezes. **Tura Beach** itself is a consistent bet.

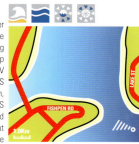

NEW SOUTH WALES

Pambula Rivermouth

Take Princes Hwy into Pambula. Take Beach Rd into Coraki Dr to carpark.

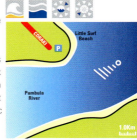

Fickle but classic wave if bar builds up with sand from the river. Dry-suck R at takeoff, forming a hollow, 3-500m fast barrelling piece of perfection. Best in massive NE swells. Holds 10 sec barrels. Crowds. Experts only.

Sleep: Wandarrah Lodge YHA, 8 Marine Pde Merimbula; ph 02 6495 3503. 200m to beach. Free Breakfast Daily.

Lennards Island (Ben Boyd Nat Pk)

From Eden, go 5kms N A turn into Ben Boyd National Park to the rocky point.

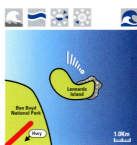

Fast R, wrapping round the point & breaking over sharp, seaweed reef in 6ft+ NE-E swells. Steep takeoff then short bowling sections. Advanced surfers' wave. Try N to explore isolated reefs & beachies in the National Park.

NEW SOUTH WALES

Aislings Beach

Head S on Princes Hwy to Eden. Left at caravan park on Barclay St to the beach.

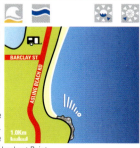

Good quality R works at S end of the beach, best in 3-6ft S-SE swells. Notoriously reliant on the sandbanks. Try up the beach for small, fun beachies & plenty of other spots to explore in the park. Waves for all surfing standards. On a northeast sea-breeze, there are protected options on the other side of Lookout Point.

Sleep: Garden of Eden Caravan Park, Princes Hwy, 02 6496 1172

Saltwater (Ben Boyd Nat Park)

Turn off Hwy 20kms S of Eden on Edrom Rd. Take Green Mussel Rd & follow track.

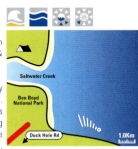

Lovely R at the point over sandy rock bottom when banks are good. Best in 3-6ft SE-S swells, but holds up to 12ft. Steep takeoff. Bowling barrel sections. Hairy jump-in off the rocks in bigger conditions. Isolated, experienced spot.

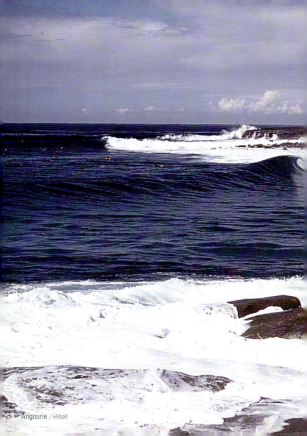

Angourie / *Hilton*

Winki's / *Sean Davey*

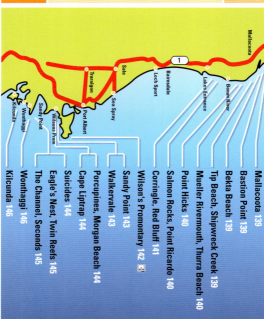

Map labels: Mallacoota, Benm River, Lakes Entrance, Barnsdale, Loch Sport, Sale, Sea Spray, Port Albert, Traralgon, Wilsons Prom, Sandy Point, Wonthaggi, Kilcunda

Mallacoota

From Genoa head S to Mallacoota. In town take Bastion Pt Rd to the point.

Bastion Pt: S headland of Mallacoota Inlet has long, walling Rs breaking over sand covered rock bottom. Best when a lot of sand deposited out of inlet mouth. Best in 4-6ft S swells, with SW being blocked. Currents can be very strong. Good Intermediate spot. One of the few spots around that are protected from SW winds. Head west along Bekta Rd for **Surf Beach**. Creek mouth beach-break that has the most consistent, accessible, quality wave in the area. Waves in the 2-6ft range, NW winds best.

Tip Beach (Mallacoota)

From town, take Betka Rd. Turn first L past the golf course to the beach.

A number of L & Rs breaking over sand and reef bottom at the east end of Surf Beach (AKA Bekta). Can produce short, peaky waves which can be quite intense in bigger winter South swells. Quality is dependent on the condition of the sandbanks. Can get rippy. Busy spot, so a trip down to **Shipwreck Creek** (another couple of ks down from Bekta) can pay off with nice beach-break peaks best in any west wind, 2-6ft plus.

Point Hicks & Thurra Beach

Heading E from Lakes Entrance on Hwy, turn off at Cann River. After 20kms, L to Cape Everard.

R point breaks off the headland at S of Thurra River mouth over sand-covered reef bottom. Tends to close out over 6ft, although you may find a wave further out breaking on a deeper-water reef. Best in summer S swells. Isolated. **Thurra Beach** runs east from here, and can have good banks. Tracking about 5k east, is the **Mueller Rivermouth**. This can have great banks depending on river flow, and there are beach peaks across the river too. Consistent spot, and offshore wind is northwesterly.

Salmon Rocks

From Lakes Entrance go E to Cann River. Turn R off Hwy around Cabbage Tree Creek to Marlo. Head 20kms E.

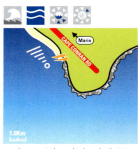

A L breaks off the W side of **Cape Conran** over a patchy sand coated reef out from the boat ramp. Can be a thick-lipped, heavy wave. Best in big S-SE swells, but southwest winds destroy it so early morning is often best.

There are plenty of beach-break peaks running west along the beach, that are of variable quality. 11k west however, lies **Point Ricardo**: a fickle but often quite lined up right-hander over rock and some sand.

Red Bluff

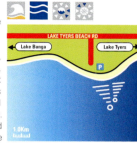

From Lakes Entrance, head E on the Lake Tyers coastal road to car park.

Consistent L reef break (also a R), over sand-covered reef. Can be a long, walling barrel if the sandbar is built up. Best in 3-6ft S-SE summer swells & offshore NE-NW winds. Good for all standards. The rocks can be a problem. Corringle, about 35k east, is also a good bet for often good quality banks at the mouth of the Snowy River.

Sleep: Lakes 90 Mile Beach Caravan Pk, Lake Tyers, 5156 5582

VICTORIA

Wilson's Promontory

You can drive s far as Tidal river on Wilsons Prom Rd. The ultimate in surf exploration. Be prepared to walk and camp out/stay in a cabin. The Prom has beaches facing all angles, with the west coast being the most consistent. From Tidal River, walk to **Oberon Bay** where there are small L & R beachies good on east winds & higher tides. Solid SW swell is needed to get past King Island. **Norman Bay**, next door, works in similar. **Squeaky Beach** (walk NW from Tidal River) is one of the more consistent and popular options in similar conditions. **Picnic Bay** right next door can have good banks, and is also an established spot. All the above have finger headlands offering some wind protection. On the northern side of Tongue Point is **Darbys**, a long consistent stretch of beach-break needing north to southeast winds to clean. Darbys is often the first beach to check on the way down the Prom. You

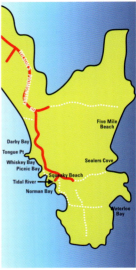

will sniff out **Buckleys Reef** here, a well-frequented right hand reef break best on higher tides and a solid SSW swell. **Sealers Cove**, on the east side of the island, needs very large south swells or a more rare E to work but can get good if winds are southwest. **Five Mile** is also v inconsistent but works in similar. For accomm, maps and camping info, call Tidal River info, 03 5680 9555.

VICTORIA

Eagle's Nest

Heading W from Inverloch on the Bass Hwy, follow signs to the beach. You'll see the rock stack off the bluff.

A long R point break peeling all the way down the bluff in the right conditions (4-6ft plus S swell). If you're lucky there will be clean, walling waves, but no barrels here. Can get busy in the summer with tourists. A wave for all surfing standards. The Gnarly **Twin Reefs** just south can be a challenge too.

Sleep: Inverloch Holiday Park, Cuttriss St, 03 5674 1447

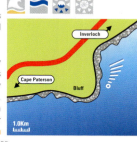

Cape Paterson

In Wonthaggi, take Cape Paterson Road South. Various breaks - best-known is an inconsistent L & more frequent R over sand and rock off-shore from the gap in the rocks; **The Channel**. Shallow. In big swells, **Insides** may also be working. There is also some small beach-break for beginners. If smaller and wind is east, **Seconds** is west around the point, for beach-break peaks on the more exposed back beach. Explorer country.

Sleep: Cape Paterson Foreshore Reserve, Surf Beach Rd, 5674 4507

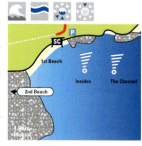

VICTORIA

Wonthaggi

Turn R off the main road as you enter Wonthaggi to Williamsons Beach.

Consistent stretch of beach that is best surfed when it's small and early morning before the winds get at it. It doesnt always have shape but when other spots cannot fire you may get a wave here. Banks are shifty and you need to look around for a good peak.

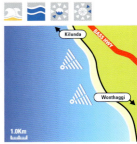

Boards & Stuff: Vortex, 111 Graham St, Wonthaggi, 03 5672 4112
Sleep: Coalfields Caravan Pk, Graham St, 03 5672 1798

Kilcunda

NW from Wonthaggi. Kilcunda itself has 3 small beaches, the western most of which is Shelly Beach. There is a right off Black Point here. You'll find an array of beach (& reef) options around, with some of the better options on the east side of town near Cemetary Point. Powlett River is the known spot here, with quality beach-break peaks in a remote setting for the hiker. You can however sniff out peaceful yet powerful beach and reef options all the way SE

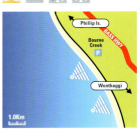

towards Coal Point. Courtesy, walking shoes and patience. Sleep: Kilcunda Caravan Pk, Bass Hwy, 03 5678 7260.

Sandy Point

Turn off S Gippsland Hwy at Foster to Waratah Bay & Sandy Pt. Head to the dunes.

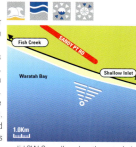

Sandy Point is a sand spit with beachies that are good in smaller 3-4ft swells, depending on banks. Outer banks can also work well for the more advanced. Other beachies going W to Walkerville & Cape Liptrap. Good novice waves. Of note however, **Cooks Creek** and **Chicken Rock** are a pair of reef breaks that can get good, usually on higher tides, solid SW-S swell, and northwest winds.

Sleep: Waratah Bay Caravan Park, Freycinet St, 03 5684 1339

Walkerville

From Inverloch, go SE to Walkerville, then NE up North Beach towards Cooks Creek.

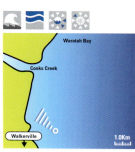

Home to good right-handers, breaking over reef. Needs very big swell to get in, and probably only reaches head high. Can be quite a sucky wave with a challenging take-off. The beach is protected from a lot of wind, so can be busy when bigger swells and southwest winds are on.

Walkerville Foreshore Reserve, 03 5663 2224

Cape Liptrap

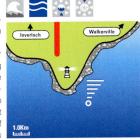

From Walkerville, Take the Cape Liptrap road out to the lighthouse, then scramble down the cliff.

A R hand reef break, working in bigger S-SW swells (10-12ft plus). Walling punchy wave. Nasty rocks break the surface even on mid-tides. Very isolated so for experienced surfers only. Up NE towards Grinder Point you may spot a quality reef option, **Porcupines**, if swell is adequate. **Morgan Beach** is the area to look at on small swells and east winds. Reef interspersed with beachbreak action running northwest from the Cape up towards Arch Rock, which bears some exploration itself.

Suicide

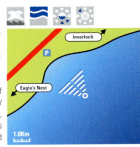

From Inverloch, take Bass Hwy SW to carpark on the bluff near Petrel Rock. Narrow sand strip and semi submerged rock flats line the base of the cliffs, with the rock ledge extending to form flat, holed reef. A left/right peak breaks off this, needing solid swell and a N to W wind to work well. Can produce thick, peeling L & Rs solid S swells but closes out over about 5ft. Quite an isolated spot, and unforgiving. Avoid low tides and show it a bit of respect. There are plenty of reef options between here and Cape Paterson, particularly in and around the aptly named **Shack Bay**.

Surf Beach & Surfie's Pt

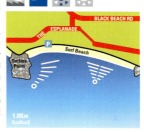

From Phillip Island Rd, L on Sunderland Bay Rd. L on The Esplanade.

Surf Beach has a couple of smaller L & R beach-break options. In the west is **Surfie's Point**, a heavy R off the rocky outcrop, breaking on rock. Needs solid S swell, and is often on when all else is closed out. In these conditions, gets very crowded, particularly as it isn't too bad in a southwest wind. Northwest wind is bang offshore on the point, and straight north to northeast is best for the beach.

Sunderland Bay

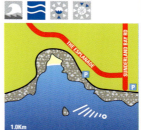

As above, follow Sunderland Bay Rd to the beach.

A L breaks off the point on the E side of Sunderland bay, over a rocky bottom. Gets very shallow, even at mid tide so beware. Extremely fickle, but a pretty powerful barrel in a solid 6ft South swell. Overshadowed by its W neighbour, and horrid in a southwest sea-breeze. Beware penguins, a sea-stack, and tourists!

Express Point

Head off Phillip Island Rd into Sunderland Bay on Sunderland Bay Rd. R at the Esplanade where there's a car park. You'll spot it.

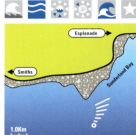

The Island's classic right-hand point break, peeling in over a rock shelf at the western end of Sunderland Bay. Holds about 3 to 12ft of S or SW swell, depending on tides. There's a steep, takeoff, followed by a hairy ride through a bowl section with the wave sucking dry even at mid-tide. Experienced surfers only and you should show it, and its afficionados, plenty of respect.

Smith's Beach & YCW

Head West on Back Beach Rd from Sunderland Bay to the next bay.

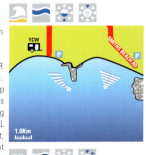

A selection of mellow, shifting L & R beachies, breaking on sandy bottom. Banks can be inconsistent. Good in up to 6ft S swells. Next bay around Smiths Point is **YCW's**, (in front of the Young Catholic Workers Camp), a mellow L point breaking off the E rocky point, and some easy beach-break. Great novice beach.

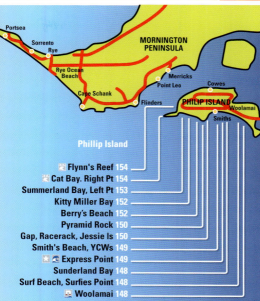

Portsea

Sorrento

Rye

MORNINGTON PENINSULA

Rye Ocean Beach

Merricks

Point Leo

Cowes

Cape Schank

PHILIP ISLAND

Woolamai

Flinders

Smiths

Phillip Island

VICTORIA

Woolamai

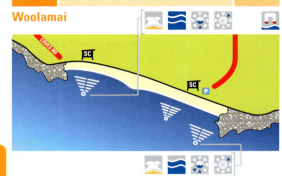

Heading S on Bass Hwy, take Phillip Island Road over the bridge onto the Island. After 2-3kms, turn L on Woolamai Beach Rd to the carpark.

Magic Lands is East down the beach towards Cape Woolamai. Several L & R beach breaks, breaking on sand-covered rock bottom. If the banks are good, there can be a range of punchy peaks and more mellow, longer rollers. Holds some good size, and tends to be cleaner in this more protected area of the beach.

Car Parks is a very consistent L & R beach break, breaking over sandy bottom. Can produce long rides of up to 300m if the banks are in good condition, and is generally surprisingly lined up for a beach-break. As with the rest of the beach, needs a S or SW swell. Can hold some real size - up to 8ft.

The W end of the beach is **Forest Caves**, for less crowded peaks over sand and reef. Usually smaller than the rest of the beach.

Being the first beach on the island Woolamai gets very crowded, particularly in summer, but there is space.

Sleep: Phillip Island Caravan Park, Newhaven, 03 5956 7227

Pyramid Rock

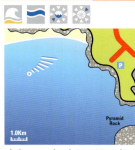

Continue on Back Beach Rd to Pyramid Rock Rd. 2-3kms on, is the beach. It's in Storm Bay.

Small bouldery beach running west from the scenic Pyramid Rock, awash at high tide. R over mostly sand around a boulder reef base. Can get lined up. Running north from the rock half way back towards Smiths Beach are a number of semi secret spots that intrepid surfers might check out, although they are a hassle to get to and not consistent. **Jessie Island** has a low tide R, hard to get to. Fickle and usually unrewarding. Right next door to the north, **Racetrack** is another right-hand reef off the beach of the same name, under the cliffs. Higher tides and west to north winds generally good. Next door north is **The Gap** itself, a slightly more accessible reef-break needing big swell and lower tides to make the trek worthwhile, with west to northwest winds. Access these 3 spots from the north via the Gap road, followed by a bit of scrambling... can't give away more than that.

VICTORIA

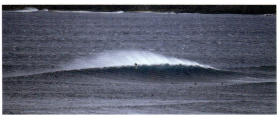

Express Point / Sean Davey

Berry's Beach

L off Back Beach Rd, past Kitty Miller, on Berry's Beach Rd. Follow for 2K.

A rather inconsistent but barrelly Right hand reef break, breaking on shallow sand-covered reef. The wave is dangerous and can suck dry in all but high tides. The W point provides protection from NW winds. Advanced surf spot.

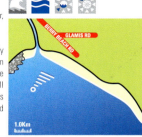

Kitty Miller Bay

From Back Beach Rd, turn L on Kitty Miller Rd. Go past the lake, 1km further on.

A bubbly Right breaks off the West point (Kennon Head) of this very small protected bay, over a rocky bottom. Holds up to 6ft of swell. Generally not too powerful, but can be quite an intense ride in best conditions. Good intermediate wave. The bay gives a little protection from SW winds too. Beware rips. Pretty much a high tide only spot.

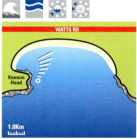

Summerland Bay

From Phillip Island Rd, turn L onto Back beach Rd, left at end into Ventnor Rd.

A nice R reef break off the W point of the bay, breaking over sandy & reef bottom. Best in at least 6ft swells, it has a tendency to be shallow at times so best at high tide. Steep takeoff in bigger conditions. Good improver's reef. You might check **Centre Crack** on a lower tide, just east across the bay. Reef break. Penguins, tourists.

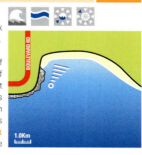

Left Point

Follow Ventnor Rd SW until you see the car park on your R. The road passes Flynns, then Right Point and Cat Bay. ending down at Left Point.

Left Point: Off Sambell Point at the west end of Cat Bay. Variable quality on this left-hander, and not the most consistent wave, needing very heavy W-SW swell to wrap. Worth a look if you are checking the bay and the wind is south. All levels except the rare days when it is going off.

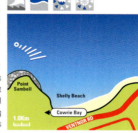

On the other side of the point is **Cowries**, a more consistent spot which is worth a check if swell is medium and winds have east in them.

VICTORIA

VICTORIA

Cat Bay

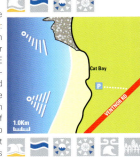

Follow Ventnor Rd SW until you see the car park on your R after Flynns. **Cat Bay:** L & R beach-break peaks up and down the bay. Only really works well in bigger WSW or SW swells. Offshore in S-SE wind. A good spot for longboarding/novices. Crowded, especially in summer and when southern beaches are on-shore or huge. **Right Point:** Further down in the bay is a poorly named left-hand reef break. Semi-exposed at low tide, so best surfed mid to high. Likes an east wind and southwest swell, and handles reasonable size.

Flynn's Reef

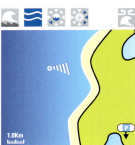

Turn off Ventnor Rd on McHaffies Lane. L into Flynn Way to Flynn beach. Flynn Beach is at the northern end of Cat Bay, and the reef is at north point of Sealers Cove.

A quality R reef break, breaking over partly shallow patchy reef. Can be a long & challenging ride back into the beach in the right conditions. Best in 6ft plus SW swells. Surf the higher tides to avoid the shallow inside reef. Gets very crowded and there's a lesser surfed reef just south that may absorb some of the population.

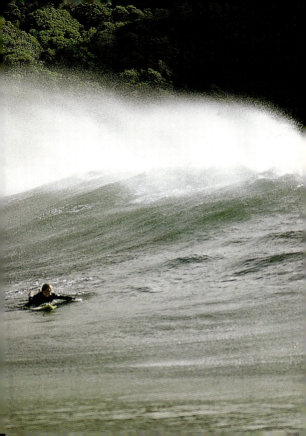

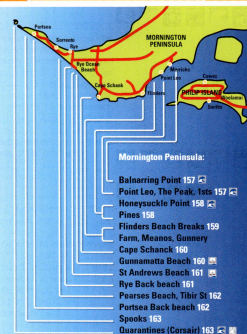

MORNINGTON PENINSULA

Portsea
Sorrento
Rye
Rye Ocean Beach
Cape Schank
Merricks
Point Leo
Flinders
Cowes
PHILIP ISLAND
Woolamai
Smiths

VICTORIA

Balnarring Point

Turn off the Frankston-Flinders Rd on Balnarring Beach Rd.

The first surfable wave on Mornington Peninsula. A small R breaking off the W point of the bay, on patchy sand & reef. Can get pretty shallow, so best to surf at mid-high tide. Needs an awful lot of swell. Good novice or intermediate spot. Fickle as can be.

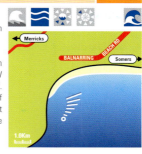

Point Leo

West of Balnarring, Turn L off Frankston-Flinders Rd on Pt Leo Rd.

Point Leo has 3 quality right-hand point style waves. The Point is a lined up wave needing lots of swell. Next door is **The Peak**, primarily a right reef that gets hairy at times.
Across at Shoreham is the right/left peak **1st Reef**. A fairly approachable reef break working on most tides and north to west winds. **Second Reef** next door is a good crowd absorber of variable quality.

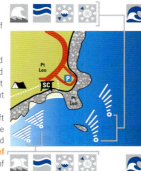

Honeysuckle Pt & Pines

 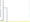

Honeysuckle Point is found at the Western end of Point Leo Beach, right next to first and second reefs. Pines is at the South end of Pines Beach in Shoreham.

Honeysuckle Point has a good fun R reef break, breaking over sandy reef bottom. Needs plenty of swell (best in 6-8ft SW swells) to really get going. At best, a fast moderately steep takeoff & long semi-steep walls. Advanced surfers' wave.

Pines (Little Noosa) is a high quality R point break, breaking over rocky reef bottom. Only works on long straight 6ft plus S-SW swells that enter the W end of the bay. Long, fast hollow sections that can link up to give a 3-500m ride from the point. Tends to get very crowded with mal riders & grommies. A good intermediate or improver wave. Well worth a look in the right conditions.

Farm, Meanos, Gunnery & Cyril's

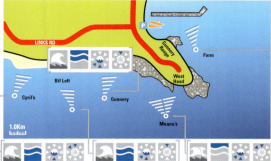

All of these breaks are located at Flinders Beach. Farm is found near the end of Flinders Jetty. Meanos to L of the main car park at West Head. Gunnery is the reef in front of the guns. Cyrils is the extreme W end of Flinders Back Beach. **Farm** is a fickle R reef / point break, breaking over rocky bottom, and working only in the largest S-SW swells which make it around West Head. On a good day, can be a 4-5ft fun wave for novices & intermediates. **Meanos** is a L & R reef break, over shallow reef bottom, with a dangerous takeoff on a dropping tide. Best in 4-8ft S-SW swells. Rarely crowded. Experienced surfers only. Gets sharky. **Gunnery** is a fat, sluggish but fun 5-6ft R reef break. Best in 4-8ft S-SW swells. Good spot to build confidence to take on some of the more extreme South Coast reefs. **Big Left**, way out the back, is a fun to fat left-hand reef best in the 5 - 8ft range on a lower tide and northerly breeze. **Cyril's** is a fickle R reef break which works in bigger 8ft plus S swells. Steep takeoff, then winds around the corner with a number of semi-hollow sections to follow. Intermediate plus wave.

Cape Schanck

From Frankston-Flinders Rd, take Cape Schanck Rd to lighthouse. Scramble down the cliff.

A long (2-300m) peeling L reef break, out in front of the lighthouse on the Cape. Breaks on a patchy reef bottom. Works best in SE swell and can hold some real size (8-10ft). Experienced surfers only.

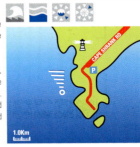

Gunnamatta Beach

Mornington Peninsula:From Point Nepean Rd, L at Tootgarook on Truemans Rd. Follow for 15kms to the car park.

Selection of L & R beachies. Pretty consistent but do vary with the sand bank conditions. Normally best in 6ft SW swells, though some banks will hold more size. Quite exposed beach so rippy. This is the place to check when it's small and winds are dead or northeast in the morning.

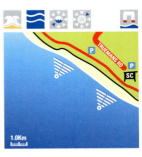

St Andrews Beach

East on Pt Nepean Rd at Rye, turn R on Dundas St. Go past Rye Ocean Beach.

Selection of L & R beachies, breaking on sandy bottom. Conditions are very similar to Gunna, just up the coast, though can often hold more size. Can be a great place to go exploring for crowdless peaks.

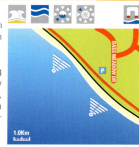

VICTORIA

Rye Ocean Beach

Head S from Rye, then follow Dundas Rd to the carpark at the end.

Works in similar conditions to its 2 neighbours up the coast. Many beachies. W of car park, a consistent R breaks over sand-covered rocks. In town, ask for directions to Allison Av beach for a quality R point in 3-4ft swells.

Sleep: Kanasta Caravan Pk, Sinclair Av, 03 5985 2638

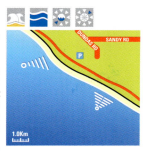

Pearse's & Dimmicks Beaches

At end of Tibir Street on the Rye/Blair-gowrie border.

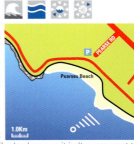

These 4 tiny pocket beaches host some good reef options. Of note, a quality R hand reef break breaks over sand & seaweed-covered reef at the end of Tibir Street. Best in up to 5-8ft SW swells and a higher tide. Vertical drop into a sucky wave. There's a tight take-off zone usually manned by a wiley local crew so it isn't an easy spot to get waves. Experts.

Portsea Back Beach

In Portsea, turn L off Pt Nepean Rd into Back Beach Rd to the car park.

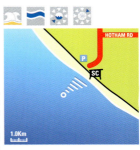

Many beach-break peaks interspersed with a tiny smattering of rock on this long stretch. Holds fairly big S swells. The most consistent bank, producing a quality R breaking over sand, is usually in front of the rockpile by the Surf Club. Very exposed so beware rips unless you wish to do a Harry Holt. Extreme summer crowding. A few bays down, swell & a NE wind permitting, Kirkwood Street is worth a look.

VICTORIA

Spooks

From Back Beach Rd go over the roundabout & take London Bridge to the end. Portsea Back Beach.

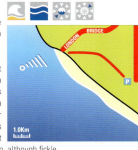

A heavy R sandbar forms working just off the rocks at the W end of Portsea Back Beach. In 4-6ft SW swells, it turns into a hollow beast of a wave with a scary takeoff and challenging power barrels. Experienced surfers. There's sometimes a good left in the 3-4ft range at the east end of the beach too, although fickle.

Quarantine (Corsair)

Corsair Rock sits off the northwest tip of the Peninsula, and Quarantine wraps around its western edge.

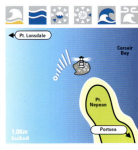

A L point breaking on a sandy bank just off Corsair Rock. Very fast, hollow beast, jacking up at takeoff, then bending round the bank. Great on a solid 4-6ft swell, but very heavy in anything bigger. Strong currents mean it should be surfed only on an incoming tide, and this is why having boat is useful in preventing you from being flushed out towards Antarctica. Only for the very experienced, crowds!

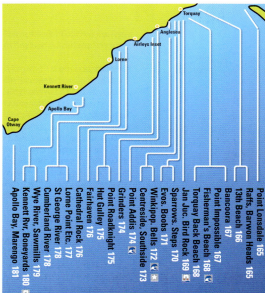

VICTORIA

Point Lonsdale

Head into Point Lonsdale. At E end of Lenny Beach.

Lighthouse is a L & R beach-break over sand off the rocks. Best in up to 6ft SW swells. Just next door is **Glaneuse** - a fantastic hollow reef break, breaking in very shallow water, opposite the surf club and down the track. Needs 4-6ft SW swells. Does not break at low tide. Serious local spot - show respect.

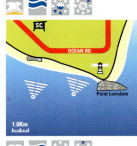

Raffs Beach

Head along Ocean Grove to car park just before Barwon Heads.

A variety of pretty consistent L & R beach breaks, breaking on patchy sand and reef bottom. Best in 4-6ft SW swells. Can get crowded in places, but a walk up the beach normally does the job. Waves for all standards of surfer.

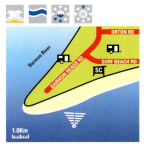

VICTORIA

Boards: The Green Room, Esplanade, Ocean Grove, 03 5256 2996

The Bluff, 13th Beach

Just W of Point Flinders at Barwon Heads. 13th Beach.

A consistent L & R reef break, breaking over shallow, patchy reef and sand. The R's can be sucky, long and hollow. Always a wave in 3-6ft SW swells. Also picks up a wave in smaller S swells unlike many beaches here. All standards.

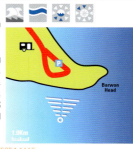

Sleep: Barwon Heads Caravan Pk, 03 5254 1115

The Beacon, 13th Beach

A 200m walk west down the beach from The Bluff on 13th Beach.

Best waves in the area when the sandbars are spot on. Very steep barrelling L & R peaky waves, breaking over sandy reef bottom opposite the shipping beacon. Can be crowded but its a big beach. Pretty cool locals. Intermediate plus spot.

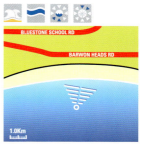

Bancoora & Breamlea

From Surfcoast Hwy, L at Bancoora on Blackgate Rd. R at the Surf Club.

A R breaks over reef off the rocky point 250m off the beach. Heavy paddle-out in big conditions. One of the best waves on the coast in perfect big conditions, with long, fast punchy, hollow sections. Best in 4-8ft SW-S swells. Beach-break is usually weak. Usually crowded.

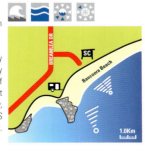

Point Impossible

From Surfcoast Hwy, turn left at Breamlea then follow the road to the car park.

2 sluggish Right point / reef breaks, breaking off the rocks (Insides) on a gentle sandy bottom. Outsides works better in bigger 6-8ft plus SW swells, with peaks forming on the outer reef. Both are good, if fat novice waves, with some protection from W winds. Good longboarding spot. Gets crowded.

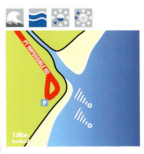

Fisherman's Beach

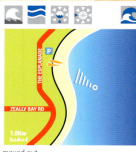

From Surfcoast Highway, turn left to Fisherman's Beach. Head to the boat ramp.

An inconsistent, fast right works from the point all the way in to the boat ramp, if the swell is huge elsewhere. Take-off is next to rock but mostly sand along the bottom. Only works on huge S swells, which tend to get filtered into manageable walls. Protection from the SW winds. Head here when all else is maxed out.

Sleep: Zeally Bay Caravan Pk, The Esplanade, 03 5261 2400

Point Danger & Torquay Back Beach

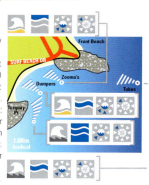

In Torquay follow signs to Torquay Beach, end of Surf Beach Dr.
Torquay Point: consistent R point over sand and reef. Works from 1 to 10 ft. Generally good longboarding spot but back peak is powerful on big days. Inside always easy. **Dumpers Alley**: Consistent high tide left-hander for intermediates. **Zoomo's**: Fast lefts on sand from 4 to 12ft. Experienced only. **Tubes**: Outside peak breaks left over reef off Point Danger from 4-12ft. Advanced. Will have a crowd if good.

VICTORIA

Jan Duc

1st left past Torquay Golf Club. Hoylake Ave to beach.

West Coast's busiest break, from grom to budding pro in good conditions. L & R beachies working best in 4-5ft SW swells. Quality depends on the banks. Car Parks one of the more consistent breaks. Head E up the beach to avoid the crowds.

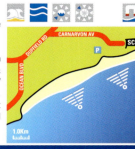

Bird Rock

Take Ocean Blvd west from Torquay. Just at the West of Jan Juc.

Short, sucky R barrel, breaking on a very shallow rocky ledge. Takeoff is a scary drop into the chasm. 100% concentration. Holds up to 6ft SW swells. Experienced surfers only. Solid local crew snaffle the best waves. Gally always gets his fair share.

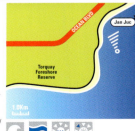

Sparrows

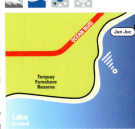

Between Bird Rock at the western edge of Jan Juc, and the Bells/Winkis arena, are 3 small rocky beaches at the bottom of the bluff. These host a selection of reef breaks, the first of which is Sparrows, accessed from the end of Princes St and by walking around the rocks.

Barreling R breaking on a shallow rocky ledge. The Rock's baby brother, working in similar conditions, only not as hollow or sucky. Probably slightly more consistent though. All abilities wave. Watch out for the end section collapsing!

Steps

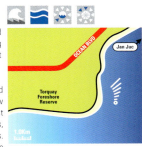

Take the same directions for Bird Rock, then its the next wave heading W after Sparrows, out from the next little beach.

In the right conditions, a good R hand reef break, breaking over shallow rock. Takeoff can be free-fall. Best in up to 8ft SW swells. Fat at times, but has some hollow, fast sections. Rarely overcrowded. Intermediate surfers' spot.

Evos

Just further out to the SW from the Sparrows/Steps combo.

Short fast right-hander with a barrel section that ends on razor sharp reef. For this reason it's a high tide only spot if you have any sense. Plus it isn't much good on low anyway. 4-5ft, advanced.

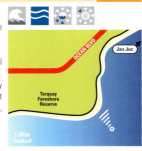

Boobs

Just West of the Sparrows/Steps/Evos Combo, off the last of the little beaches (Called Dead Man) and just before Winkis and Bells.

A L & R breaking on a very shallow rocky reef. R is more consistent and longer, but the L is a hollower, cleaner ride in smaller swells. Best in 6ft South swells but high tide only. For obsessives, due to the monster walk to get there (& it's often flat)! You can paddle from steps.

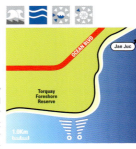

VICTORIA

Winkipop

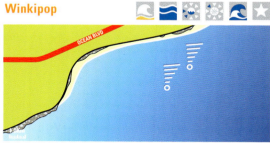

Head out of Torquay through Jan Juc. Left at Bells Blvd and follow signs. Very long (4-500metres), winding R reef / semi-point break wave, breaking over rocky reef. The wave has two distinct sections: **Uppers** (the top section of the break) and **Lowers**. The best days come when the swell is straight, and the two join up to produce a long, barreling R which can be amongst the best barrels you'll surf. Whenever there's swell this place is crowded (often with some seriously good surfers). This is not the case on big days, however, when the real experts come out to play. Can be great place just to chill and watch the action. Beware strong currents, particularly on bigger days. Can get shallow on the lower tides.

Bells in the 60's / *Barrie Sutherland*

Bells Beach

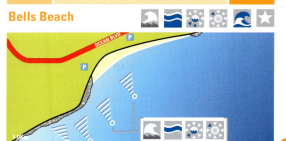

Head into Torquay from Melbourne. Go straight through town, past the Surf Plaza (a sight in itself) to the roundabout. Straight ahead through Jan Juc and left at Bells Beach Blvd. Australia's most famous beach - the wave that made Victoria the home of Australian surfing, and the home of the longest running surf contest in the world - The Bells Beach Easter Classic. Southwesterly Southern Ocean swells refract around The Otways, clean themselves, and reach the Limestone reef fringing the southern point of Bells Beach to create one of the worlds best point breaks. The point section under the cliffs is known as **Rincon** (on smaller days, it breaks pretty close in). The wave then forms into a powerful bowl section (**The Bowl**), which on larger days, is found right in the middle of the beach. One long, leg-trembling ride. Not a place to take a close-out set on the head, and can have a strong current running so, experienced surfers only. Works in 3ft plus W-SW swells, up to 15ft. Changes personality on lower tides. Not always consistent but worth the wait. Look S for a good R over shallow rock, **Centreside**. Head even further S for a quality left, **Southside**, over shallow weedy rock ledge. Southside can be a welcome crowd reliever. The next point along, **Jarousite**, hosts an outside right-hander that can handle any swell size. It's often town in now by a hardy crew of locals. Advanced.

VICTORIA

Point Addis

The same directions as for Bells. W end of the bay. Selection of reef-break peaks taking southwest swells and giving varying protection from the SW winds. **Crayfish**, in front of the big carpark, is a fast hollow left-hand on slab reef for experienced surfers. 4-10ft. **Point Addis Inside Peak** is a short sharp reef right for intermediates, offering good protection from the SW winds. **Willy's Left** breaks from small up to about 5ft, and works left from the peak all the way into the cave on the point. Barrels, for the better surfer, good wind shelter. **Outside Point Addis Peak** is the furthest out and takes quite a bit of size.

Grinders

Head W from Torquay to Anglesea. Turn L past scout camp, then a long walk to E end of beach.

Peaky L & R beachies breaking on sand. Work in most swells. Quiet. In town, Rs work down the sandbank L of the estuary. A wave breaks at the groyne too. V crowded & often closes out.

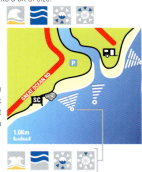

Steps & Pt Roadknight

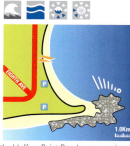

Take the Great Ocean Rd West from Anglesea, it's signed on left, south of the yacht club. Only check the point when everywhere else is huge. A mellow R breaks off the point south of the boat ramp, over sandy bottom. Needs a massive cyclonic swell to get going. Extreme protection from S-SW winds though. Works on a W. Excellent, if crowded, extreme grommets & mal break! Fun spot if you catch it actually on. South of the point, walking down the bluff on Point Beach, are a series of reefs AKA **Steps**, and some beach break running west. All of these face south so get the swell...and the wind.

Hut Gulley (Guvvos)

2km further W than Point Roadknight, turn L into the car park.

Peaky little open L & R beachies break in the car park area, over sandy bottom. Can get quite hollow barrels and lengthy rides if the banks are working. Best in clean, straight 4-8ft SW swell. V crowded. All standards of surfer.

VICTORIA

VICTORIA

Fairhaven

West from Anglesea on Grt Ocean Rd into Fairhaven. Look L.
Several L & R beach breaks work up & down the 6k beach in 3-6ft S-SW swell. Quality depends on sand banks (rare!). Great novices wave. Of note, in front of and slightly E of the surf club at E end, is **The Spot** (reef-break) and about 250 m further E is **Moggs Creek** (Some quality lefts off Table Rock). Heading west , the end of Spout Creek is good for beach-break fun if winds are westerly and there's enough swell.

Sleep: Surf Coast Backpackers Cowan Ave 0419 351 149

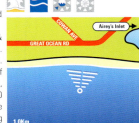

Cathedral Rock

Head W on Hwy, between Spout Creek & Lorne to the overlooking car park. You'll spot it if it's working.

Premier point for Lorne area. R over sand & rock bottom. Best in 6ft+ clean SW swells. Winter break, protected from SW winds. Jacking take-off & long, hollow, barreling sections. Gnarly inside reef. Paddle out in the channel to W of the peak. If you're coming from Fairhaven you may have spotted **Hunters** on the way (Shark Alley), a sometimes good right off Cinema Point.

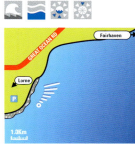

Lorne

You'll see the point if its on. everything else is round the corner.

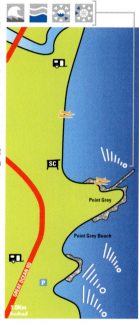

The Point is a R over sandy bottom. In 6ft plus swells & a W wind, can be really good 4-500m ride from second point (outside). Normally works from the inside point. Often you'll arrive to see the potential as lines wrap in and line up but, infuriatingly, don't actually break.

The micro-beach round the point (Point Grey Beach) has a right-hand reef with a good rip; **Vera Lynn** (as named by the old dudes of the day). You can buy great fresh fish near here.

Right next door, off Shelly Beach is **Barrels** - short peaky R reef break over sandy reef bottom. It's heavier than other waves in the area but needs a good S swell. Can be a jacking wave with steep takeoff and quick barreling sections. Beware the rocks.

Weeds, right next door in front of the carpark is similar to Barrels, with a bit more of a wall and usually more weight. Good barrel section at the end of the wave. Can get rippy.

Point Grey

Point Grey Beach

GREAT OCEAN RD

1.0Km

VICTORIA

VICTORIA

St George River

Heading W on G.O.Rd. out of Lorne, go
for a few kms to the car park.

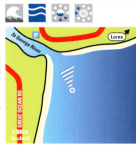

Nice R reef / point break can work
here, with a steep takeoff but fattens
out after that. Best in 4-8ft SW swells.
Shifting banks. In smaller conditions,
the odd glassy, clean wave here. Good,
safe novice, rarely crowded wave.

Cumberland River

Heading W on G.O.Rd, out of Lorne a
few kms to the caravan site.

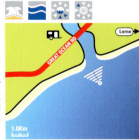

3-4ft beach / rivermouth breaks working
best in 6ft SE swells. Pretty fickle as
the beach is open to prevailing W
winds. Also a R point can be good at
low tide in W-NW winds. In a good
S swell, try **Jamieson Rivermouth**
nearby.

Wye River

Heading W on G.O.Rd. out of Lorne go for 10kms to the car park at Wye River.

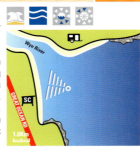

The rivermouth sometimes turns on good L & R beach breaks, breaking gently on sand. Best in 4-6ft plus south swells. A bit of a fickle wave, denendent on sand banks. All abilities. Show respect to the locals here. South of the mouth is the rare Baldy Rock right-hand reef.

Sleep: Wye River Valley Caravan Pk, Great Ocean Rd, 03 5289 0241

Sawmills

Heading West on Great Ocean Road. from Lorne, just before you get to Kennett Rivermouth, by the old sawmills.

Fickle, long Right hand reef break, breaking over sandy rock slab. Needs big SW swell. Mellow wave with hollow end section. Unlike most in the area, protected from SW winds. It handles some of the biggest swells so a good check when elswhere is too wild. Good winter break. Intermediate surfers.

VICTORIA

Kennett River

Head West from Lorne on Great Ocean Rd. Signed after Wye River.

Rivermouth: Peaky L & R sandbar held in shape by rock ledge in the rivermouth but breaking over the sand. Needs good deposits from up-river.

Kennett Point: Small but long R point over shallow rocky bottom, south of the mouth. Both are best in 3-6ft SW swells. Point definitely only works at low tide and is a Longboard spot. Always crowded if wind is southwest.

Sleep: Kennett River Caravan Pk, Grt Ocean Rd, 03 5289 0272

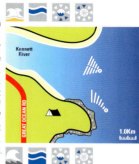

Boneyards

Heading W on G.O.Rd out of Kennett River, a couple of kms to the car park. Its off San Jose Beach.

A consistent R breaks on the shallow reef in straight 6ft plus SW swells. Steep takeoff. Short but punchy, hollow barreling section. Beware the shallow reef as it's a low-mid tide wave. Experienced surfers only. Next door you may spot **Juniors**, also worth a little look!

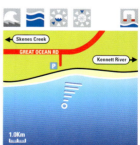

Apollo Bay

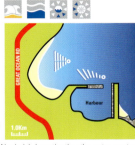

Heading W on G.O.Rd go into Apollo Bay and head W to the harbour.

A rare small R breaks along the harbour break wall here over sandy and rocky bottom in very big SW swells. Quite a clean barrel if its on, and protected from sea breezes. Holds some size but needs huge swell. In town, small beachies for beginners only, slightly increasing in size as you head north towards **Skenes Creek** (nice beach-break near caravan park there on smaller days and N to W winds). Investigating the outer, eastern side of the Harbour can pay off. *Sleep: Surfside Backpackers Gambier St Apollo Bay 03 5237 7263*

Marengo

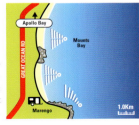

Continue W on G.O.Rd from Apollo Bay until you come to Point Bunbury. Head to the beach in town.

The point is a ledgey R over reef. Also 2 reefs nr the point - one a heavy barrelling L, the other L & R. All work in up to 12ft S-SW swells. Fickle beachies work and an ok sandbar best in 3-6ft SW swells. Something for everyone. Rocks everywhere, and a sewer pipe.

 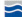 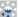 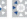

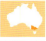

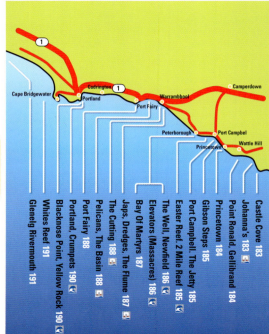

VICTORIA

Camperdown

Cape Bridgewater
Codrington
Portland
Port Fairy
Warrambool
Peterborough
Port Campbel
Princetown
Wattle Hill

Castle Cove 183
Johanna's 183
Point Ronald, Gellibrand 184
Princetown 184
Gibson Steps 185
Port Campbell, The Jetty 185
Easter Reef, 2 Mile Reef 185
The Well, Newfield 186
Elevators (Massacres) 186
Bay Of Martyrs 187
Japs, Dredges, The Flume 187
The Cutting 188
Pelicans, The Basin 188
Port Fairy 188
Portland, Crumpets 190
Blacknose Point, Yellow Rock 190
Whites Reef 191
Glenelg Rivermouth 191

Castle Cove

From Apollo Bay, follow Gt Ocean Rd round Cape Otway till you first meet the coast again. You can pull up above the break and walk down the steps.

Good but fickle R breaks on an offshore reef over sand & reef bottom. Jacking, barreling in best conditions. Further E is a longer peeling L. The bay holds a lot of swell. Plenty of beachies of varying quality in all swells. Strong currents.

VICTORIA

Johanna's

West from Apollo Bay on Gt Ocean Rd approx 10kms further on from Castle Cove.

L breaks off E point of the bay, over sand & rock bottom. Also several beach peaks, dependent on the banks. Best in 4-6ft S swells. A heavy wave that gets very crowded when Torquay is flat because it's known to be the most consistent break on the coast.. Holds a lot of swell so beware the rips.

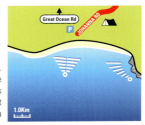

Pt Ronald & Princetown

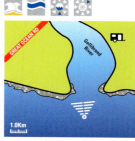

Going W from Apollo Bay, Turn L off Gt Ocean Rd to Pt Ronald. After the point, take track for Princetown.

Heavy beachies break at the rivermouth at Pt Ronald. Good after heavy rains but sharks like the same conditions. Holds heaps of swell, so beware rips. Princeton has sand-bank-dependent L&Rs. Both very powerful and best in 4-6ft SW swells. Intermediate plus waves. Adventurers can go east to check **Gellibrand Beach** and its extensive, quality beach-break peaks, as well as further on for **Pebble Point** for a quality, hard to access reef-break. Both these areas are rich in mysto spots best kept quiet.

Gibson Steps

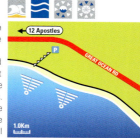

Heading W on Gt Ocean Rd from Princetown, take the steps down to the beach, just before 12 Apostles.

Heavy L & R beachies over sand & patchy rock bottom. Best in 4-8ft S swells. Heavy paddle-out. Some protection from N/NW winds. Big rips. Look L if nothing out front. Experience needed here. This gateway to the 12 Apostles is an awesome natural wonder regardless of the surf, but intimidating and not to be surfed alone. Reef options about as well.

Sleep: Princetown Camping Reserve, Old Coach Rd, 03 5598 8103

VICTORIA

The Jetty

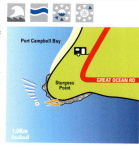

Take Gt Ocean Rd to Port Campbell. Head for the Jetty to the South of the port.

Fickle but sometimes very good L breaks over a shallow rock ledge south from the Jetty. Jacking takeoff, then short-medium bowl section. Can be a bit fat in bigger waves. Works in all swells & some protection from on-shores by Easter Reef. All standards.

Sleep: Port Campbell Caravan Park, Morris St 03 5998 6493

Easter (Two Mile) Reef

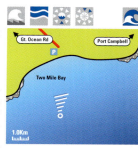

Head W on Gt Ocean Rd to Port Campbell. Head to 2 Mile Bay. 800m offshore.

In the heart of big-wave reef territory lies a serious bombie breaking on sand-covered rocky reef. Premier big wave spot. Needs massive straight S-SW swells to crank. Severe takeoff, followed by long, thick walling barrels. Handles more size than just about anywhere. If you're bored with the Rifle Range, then London Bridge area running west has plenty of off-shore reefs that handle size, although not always accessible.

VICTORIA

The Well

West from Peterborough. Carpark at the Falls of Halladale wreck site overlooks the small beach.

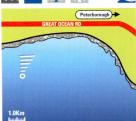

The Well: A gnarly, pumping Right breaking over sandy reef bottom. Best in big 5-8ft S swells. Entry is via a high jump off rocks, and dangerous. Scary trying to get back in on the rocks in big swells. Narrow take-off point. Pretty dangerous place. On the west side of the point is **Boneys**, another reef. If you need a beach-break, the **Newfield Bay** Car-park overlooks some sand sanity on smaller days and northeast morning breezes, east side of town. GreatOcean Rd tourist Park, 03 5598 5477

Massacres (Elevators)

Head West on Greatt Ocean Road to Peterborough. Off Massacre Hill beach, next to The Well.

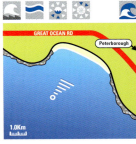

A massive, intense R breaking over reef in a small bay. Works in up to 10-15ft S swells, creating a free-fall take-off (hence the name) then a thick-walled bowling barrel. Currents. Psychotics only. On sizey days, the left-hander named after **Wayne Lynch** starts to work. The Bay of Islands coastal park is 20km of partly accessible reefs for experienced surfers. In most places these reefs block out the beach-break so this isn't the best beginners area.

Bay of Martyrs

From Peterborough, keep heading W a couple of kms to the bay.

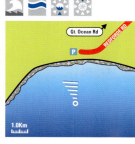

A spitting, gnarly L breaking on a reef 400m out front of the bay. The takeoff can be pretty intense. Best in bigger S swells. The bay is exposed so it can be fickle. A heavy paddle out and beware powerful currents.

There are many inaccessible but quality reefs around here.

Sleep:Warrnambool Beach Backpackers 17 Stanley St 5562 4874

Japs & Dredges

Off the Gt Ocean Road West past Peterborough. Take Hopkins Point Rd to Logans beach.

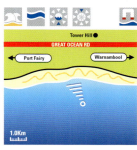

Long, deep, pitching L & R barreling beachies. Good in smaller 4-6ft SE-SW swell days. Novices check Lady Bay. Go W to Hopkins Rivermouth for fast sandbar L called **Dredges**. The best beginners spot in the area is **The Flume**, a beach-break just west across the creek in town at Warrnambool.

Adventurers can head further east and seek out **Backyards**, a left-hand reef requiring a polite dash across private property on Lake Gillear Rd.

The Cutting

Gt Ocean Rd between Port Fairy & Warrnambool. 15km to Tower Hill, then 200m S.

Quality beach-break with good consistent lefts. Best in 3-5ft straight S swells. Surprisingly powerful, but can switch itself off if conditions aren't right. Crowded if it's going off. Intermediate standard. A few ks east you can find Levy Beach if it is small and northerly winds are on.

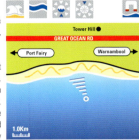

Pelicans

From The Cutting, head 250m out to the reef.

A massive R bombie with breakneck takeoff breaks offshore. Challenging, thick-walled barrel sections to follow. Works in big S swells. Pretty exposed. Very strong currents. To avoid the heavy paddle-out, take a boat. Only for the very experienced surfer. If its big and southwest winds are ruining the day, go west & check **The Basin** for protected inconsistent beach-break in the lee of sisters Point.

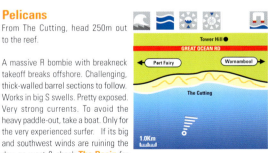

VICTORIA

Oigle's, The Passage & Gabbo's

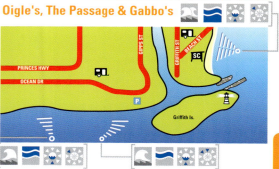

VICTORIA

Heading W on the Gt Ocean Rd from Warrnambool, go fro 20kms till you reach **Port Fairy**. Take the road to the surf club. The passage is in front of Griffiths Island. Gabbo's is 1km further on.

Oigle's is situated at East beach in town. A L & R reef break, breaking over a sand-covered wreck. Can create some great, peeling Rs. Really needs 8ft plus S swell since the beach is protected by the headland.

The Passage is a serious, heavy R breaking at the point in the boat channel. In 6-8ft swells it turns into a steep takeoff, clean & thick-walling power wave. Plenty of rock and weed add to the fear factor here.

Gabbo's is a walk further down the road. It's a good quality L breaking on sandy reef bottom. Works best in 4-6ft S swells. Tends not to be as crowded as the other breaks although pretty consistent.

For the advanced, check out the E end of Griffiths Island for a powerful fickle peak near the jetties in large S swells and SW winds.

Port Fairy Youth Hostel 8 Cox St Port Fairy 03 5568 2468

Portland

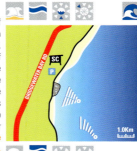

Take rd SW out of Portland for a couple of kms till you reach the beach car park. In front of the surf club in Bridgewater Bay, you may sniff out some good options if wind is west to north. **Bombers** off the rocks, and **Boatshed** out the back are both worth a look...) Also, in town, a rare but good right-hander, **Crumpets**, breaks off the harbour wall. Needs big S swells to get going. Hollow barrels with real power if you're lucky. Also look for the **Rifle Range, Crayfish Bay & Watertowers.**
Sleep: Claremont Holiday Village, 37 Percy St, 03 5521 7567

Blacknose Point

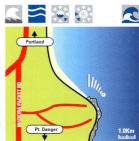

Portland past the smelter on Madeira Packet Rd. Yellow Rock is 2kms S.

Blacknose is a very long peeling R point over shallow sand & rock, just north of Point Danger. Needs huge S-SW swells. Can be a 500m ride. Heavy locals. Try **Yellow Rock** - exposed beach below the cliffs. Peaky L&R beachies on sand in 4-6ft plus S swells. Very rippy.

Whites Reef (Discovery Bay)

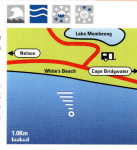

From Portland, head W to Cape Bridgewater then on to the bay. 4WD useful.

White's has a good L reef break, breaking on shallow and patchy rock bottom. Needs a big S swell. Also good beachies up and down the bay, sand-bank dependent. Exposed and rippy. Go exploring Bridgewater, Blowholes & Shelly Beach.

Glenelg Rivermouth

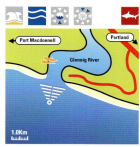

On the Princes Hwy, just before the border with SA, by Nelson, at Glenelg Rivermouth.

Good, if inconsistent L&R beachies, breaking over sandbanks at the mouth of the river. Best in 4-6ft S swells. On its day, clean peeling 3-4" tubes. Heavy currents and the odd powerful rip. Experienced surfers only. Sharky as...

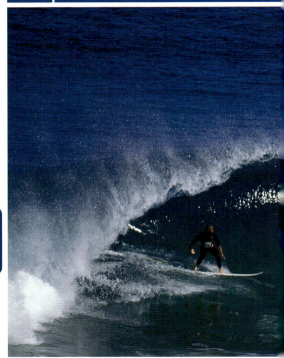

Yorke Peninsula / *Sean Davey*

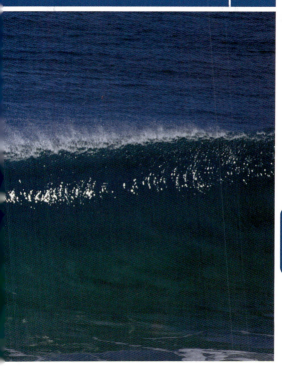

Adelaide

Christies 195
Triggs 195
N. Moana 196
Maslin 196
Aldinga 197
Sellicks 197
Myponga 198
Rapid Bay 198

Port Noarlunga

Goolwa

Rapid Bay

Victor
Harbour

Parsons Beach 199
Waitpinga Beach 199
Victor Harbour 200
Boomer Beach 200
Middleton Bay 201
Surfers(Goolwa) 201

SOUTH AUSTRALIA

Christies Reef

Head South from Adelaide, look for the Esplanade just north of Port Noarlunga.

A number of small L & R reef breaks, breaking on sand & reef bottom. Needs big Southwesterly swells to work. Lacking in consistency. Other than the shark concern, a pretty good place for improvers to get to grips with reef breaks.

Sleep:Glenelg Beach Resort1 -7 Moseley St Glenelg1800 066 422

Triggs Beach

You'll sniff it out in the Port Noarlunga area.

Beach breaks (Triggs 1 & 2), breaking R over sand & reef bottom. Need big 8ft plus SW swells but can turn on a reasonable, fun wave in 3ft offshore conditions. All standards. Attracts city crowds. If lucky, you might catch **Onkaparinga Rivermouth** (up at Southport) on v big swells only.

Sleep: Christies Beach Tourist Park, Sydney Cresc, 08 8326 0311

SOUTH AUSTRALIA

North Moana Beach

Signposts just S of Port Noarlunga.

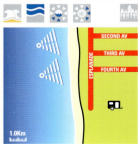

As with other Adelaide beaches, various small, but in good conditions, hollow & barrelling L & R beach breaks. Needs big 8ft plus S-SW swells to turn on. Often crowded due to better wave consistency.

Sleep: Moana Beach Tourist Park Nashwauk Crs 08 8327 0677

Maslin Beach

North around Blanche Point from Port Wilunga.

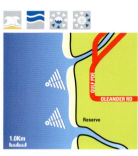

Better known as one of Australia's first nudist beaches, there's a selection of small, inconsistent, peaky L & R beachies. Needs very big 8ft plus SW storm swells to get through. Head to the N of the beach for a good reef, breaking L & R over reef bottom in same conditions.

Aldinga Beach

South from Port Wilunga. In Aldinga, turn R on Aldinga Beach Rd.

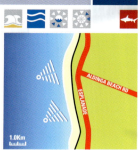

Selection of small, peaky L & R beachies, breaking on sand bottom. Can be a reef option too. Quality depends on size of swell (best in big 8ft plus SW swells) & banks. Shark threat (of course!). Attracts the Adelaide crowds.

Sleep: Aldinga Hol Pk, 08 8556 3444

Sellicks Beach

Head S to Aldinga from Adelaide via Port Wilunga. Take a right at Sellicks Hill to the beach.

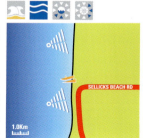

Various L & R beach & reef breaks, breaking on sand & reef bottom. Needs big SW swells to work. Varying consistency. Reefs are a way out in deep water, so beware the obvious threat! Beachies for all standards. Adelaide crowds.

Myponga Beach

Head S through Myponga on Main South Road.

Variety of L mostly reef breaks, that only work properly if there's a big westerly storm swell. Gets crowded. All standards. For a quieter, but good L in same conditions, try **Carrickalinga Beach.**

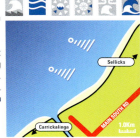

Rapid Bay

Head S from Adelaide on Main S Rd. Turn R at Delamare to Rapid Bay.

A selection of inconsistent L & R beachies on sand bottom. As with the breaks S of Adelaide, it'll be flat unless huge SW-W swells. Then, the peaks are shifting all the time. Beware strong currents & sharks. Experienced surfers only.

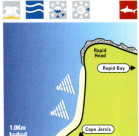

SOUTH AUSTRALIA

Parsons Beach

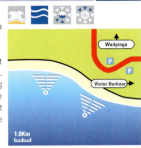

Take the same directions as for Waitpinga beach. It's a couple of kms W.

Parsons and Waitpinga are the best surf options in the Adelaide area. L & R beachies & reef breaks working best in 3-5ft plus S-SW swells. The reef can be serious quality in best conditions. Isolated, sharky & for the experienced only.

Shaper: Cutloose, 4 Piping Lane Lonsdale, 08 8326 0939

Waitpinga Beach

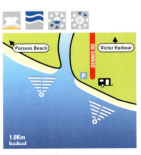

From Victor Harbour, take Range rd. Waitpinga Beach Rd, then L on Dennis Rd.

Good, fickle peaky L & R beachies & reef breaks, on sand & rock bottom work in 6ft plus S or bigger SW swells. Pretty isolated, big currents & sharks, so for experienced surfers only. Could try heading E to **Waits Beach** & Point.

Sleep: Adare Caravan Pk, Victor Harbour, 08 8552 1657
Shaper: Cutloose, 4 Pipping Lone Lonsdale, 08 8326 0939

SOUTH AUSTRALIA

Victor Harbour

Go 20kms W of Goolwa. Head through town.

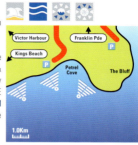

Plenty of secret spots W along the coast from here with L & R reef & beach breaks, in SE-SW swells. Try exploring W to **Knights Beach**, or E to **Petrel Cove** or **Kings Headland** for something different and more isolated.

Sleep: Anchorage At Victor Harbor 21 Flinders Pde 08 8552 1970 and 3 local caravan parks

Boomer Beach

Head W from Goolwa towards Port Elliot for 15kms. Turn L off Pt Elliot Rd Nth on Carfax St.

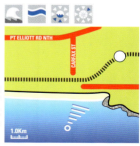

Gnarly R reef break, breaking on shallow reef bottom has a serious reputation. Terrifying steep takeoff & very hollow barrel section in 4-10ft S-SW swells. Heavy tides & watch the currents. Boogie heaven.

Sleep: Arnella By The Sea North Tce 08 8554 3611

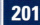

Day Street & Middleton Bay

Head to Middleton, then follow Surfers Pde 1K East of the main beach. This stretch is South Autralia's most popular/consistent area. **Day Street** has a number of good peaks. Also try cruising West back past Middleton Main, **Middleton Point** (Nice long mellow R on sand/reef). Then West to **Middleton Bay** (Hollow Ls) and finally **Suicides** (!).

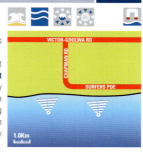

Sleep: Royal Family Hotel 32 North Tce Port Elliot 08 8554 2219
Shaper: Cutloose, 4 Piping Lane Lonsdale, 08 8326 0939

Goolwa

Head south from Adelaide to Goolwa. On Victor-Goolwa Road, Left on Chapmans Rd.

Selection of L & R beachies on sand bottom. Sandbanks (& break quality) are affected by big Murray River tides. Best in 3-6ft SW swells. Peaks are always shifting, & heavy paddle-out. Other than rips, good novice waves.

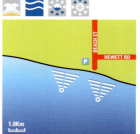

SOUTH AUSTRALIA

Sleep: Goolwa Caravan Pk, Noble Ave, 08 8555 2737

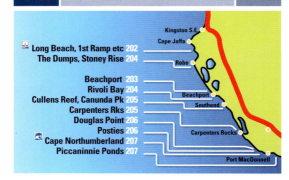

Long Beach

Long Beach runs north for 9km from the town of Robe. Depending on your level there are numerous beach-break options. **First Ramp**, in the southern end, is the least likely to have any size, and offers beach-break fun for beginners. Further up is **2nd Ramp**... quality peaks and well known. Still further up the Kingston road and accessed via a track (or hike it up the beach) is **3rd Ramp**, which is more consistent and obviously tends to be bigger. The beach faces more and more southwest as you go up, so wind protection decreases incrementally.

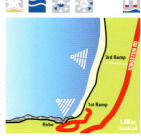

3rd Ramp
KINGSTON RD
1st Ramp
Robe
1.0Km

Beachport

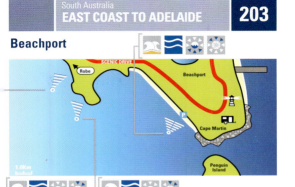

Head into Beachport from the Princes Hwy, look for Scenic Dr.

A good variety of breaks in the area. **Surf Beach**, just before the centre of town, has a selection of L & R s breaking over sand bottom. Works in 3-6ft SE-SW swells. Can et hollow.

A well-known L, **Kelps**, just outside of town heading W, breaks just off the beach hover sandy reef bottom in S-SW swells. Short, power-packed, peaky waves. Good intermediate spot.

Just around the corner is **Suicides**, a fast, heavy R working in bigger 6ft plus S-SW swells. Breaks over shallow reef bottom. Steep takeoff, then straight into a hollow, fast barrel section. Beware the rocks at the end. Intermediate to expert wave.

Just inside Cape Martin, are **Ringwoods Reef** & **Sherbert Bombie** - gnarly L & R. Both need massive SW swells to work. Only accessible by boat. Very isolated. Lunatics only.

Sleep: Beachport Backpackers 1 Beach Rd 08 8735 8197

Stoney Rise & The Dumps

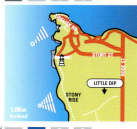

In Robe. **Stoney Rise**: Array of mostly beach-break peaks accessed by taking Robe street S and then 4WD tracks, just North of Little Dip National Park. Powerful peaks in any Easterly wind, pretty consistent, with good rips. A trek south (permit & 4WD required) into Little Dip Nat Park itself will reward the explorer. **The Dumps**: Short, steep, shallow and hollow. Intermediates plus. Likes any east wind, and solid SW swell. Sleep: Lakeside Tourist Park, 24 Main Rd, 8768 2193

Rivoli Bay

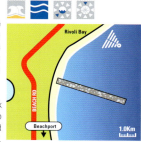

Rivoli Bay starts on the eastern side of Beachport and bends round all the way south to Southend. The bay faces from east to north west, so offers protection from a large range of wind directions.

In town itself, there are beach-break peaks around the pier, liking west to norwest winds. Gets a little crowded and can be a grom-fest after school.

Open beach-break abounds for the small days, heading east around the bay. Access becomes scant but exploration can pay off.

Canunda National Park

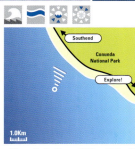

Turn off Princes Hwy at Millicent, for Southend. The Canunda Nat'l Park is 40ks of isolated beaches, odd birds, wombats and the spectacular Kyber Pass dune system. 4WD recommended. In northern end, you will find Cullens Reef : A powerful L over reef bottom in up to 10ft S-SW swells. Steep, jacking takeoff, followed by short hollow barrel section. Sometimes pretty long. Gets crowded. Plenty more secret spots between the lighthoue at Cape Buffon, and Boozy Gully. Sleep: Millicent Lakeside Caravan Ok, 12 Park Tce, 08 8733 3947

Carpenter's Rocks

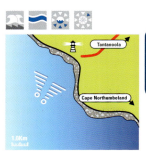

From Mt Gambier, its at the southern end of the Canunda National Park.

Good, hollow L & R reef breaks over reef bottom work best in 4-8ft S-SW swells. Further out, a bombie goes off when its bigger (forget the mission of a paddle-out). Experienced surfers only, this is hard-core.

SOUTH AUSTRALIA

Douglas Point

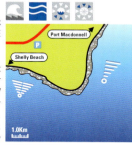

From Port Mac go W to the carpark at Douglas Point lighthouse. Walk E down the cliffs.

R breaks on E side of the point in 4-6ft S-SW swells, over reef. On bigger days, other reef breaks on the W side. Isolated and sharky. In bigger conditions, beware the currents. Intermediate / experienced surfers.
Sleep: Port Macdonnell Harbour View Caravan Pk, 59 Sea Pde Port Macdonnell, 08 8738 2085

Posties

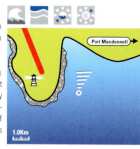

Head W from Port Macdonnell on Scenic Drive to old lighthouse. 20min walk E.

Highly-rated R reef break, breaking on shallow reef. Best in bigger (5-8ft but can handle more) SW swells. Very steep, fast take-off. Challenging sucking, barrelling section over sharp reef - booties a must. Gets rippy when it's big. Experts only.

Sleep: Woolwash Caravan Pk, Sea Pde, 08 8738 2095

Cape Northumberland

From Port Mac, take Sea Pde to Cape Northumberland lighthouse then a walk.

An outside reef which works in huge S-SW swells to produce L & R's breaking over reef bottom. Very steep takeoff, followed by intense barrel section when working. Nasty paddleout when it's big. Experienced surfers only.

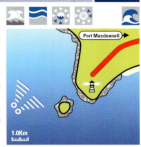

Piccaninnie Point

From Mt Gambier, take the Nelson rd. Wye turnoff to the beach. 4WD essential.

Peaky L & R s, breaking over sand bottom. Banks shift a fair bit. In good conditions (needs 4-6ft SE-SW swells), powerful, punchy waves. Gets rippy & the currents can be a problem, not to mention the sharks!

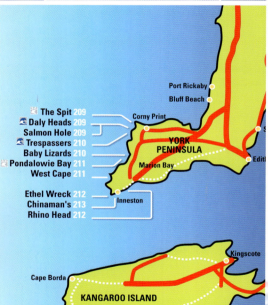

Port Rickaby

Bluff Beach

Corny Print

YORK PENINSULA

The Spit 209
Daly Heads 209
Salmon Hole 209
Trespassers 210
Baby Lizards 210
Pondalowie Bay 211
West Cape 211

Marion Bay

Edith

Ethel Wreck 212
Chinaman's 213
Rhino Head 212

Inneston

Kingscote

Cape Borda

KANGAROO ISLAND

Con
Park

SOUTH AUSTRALIA

The Spit

Turn off Corny Point Rd to Little Lizard Bay. It's just N of Point Margaret.

A sometimes excellent L point break breaks at the N side of the point. Works best in 3-6ft S-SW swells. Can be a long-walled, spitting barrel lasting for 2-300m in best conditions. Isolated break for advanced surfers. Gets rippy.

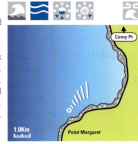

Corny Pt

1.0Km

Point Margaret

Sleep: Corny Point Caravan Park, Main Rd, 08 8855 3368

Daly Heads & Salmon Hole

Turn off from Corny Point Rd to Daly Heads.

Salmon Hole is a R semi-point over shallow rock. In 3-8ft S-SW swells, a short, fast, jacking wave for advanced surfers. At **Daly Heads** itself, is a good L & rare R reef break over shallow reef bottom in big S-SW swells. Expert surfers only.

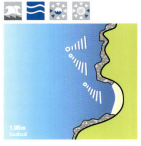

1.0Km

SOUTH AUSTRALIA

Trespassers

Same directions as for The Spit.
Head N of car park & scramble down
the cliff.

Named because access is via private
property. Very heavy, powerful long R
reef break, breaking over shallow rocky
reef bottom. In big 8-10ft S-SW swells,
gets very big & hollow. Isolated spot.
Experienced surfers.

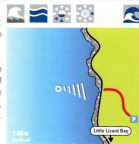

Baby Lizards Beach

Take Corny Park Rd out of Innes Nat Pk
to Baby Lizard Beach.

Right hand reef break, breaking over
shallow rocky reef bottom. Short,
sometimes hollow in 3-5ft S-SW
swells. Use the rip at the point to
paddle out. Intermediate wave. Try
exploring nearby beaches & look for
Rock Pools in big N-NW swells.

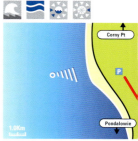

Pondalowie Bay

Take the road into Innes Nat Pk, then take signs to surfers campsite.

Right and left break up from campsite over sand and rock bottom. Best in summer 6ft+ W-SW swells. Can be powerful, heavy & hollow. Big summer crowds & sharks. Class spot. Head 250m up the beach for R, **Richards**, if Pondie L is working.

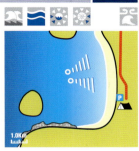

West Cape

Turn off to the Cape from Stenhouse Bay. It's as far W as you can go.

Directly off the Cape, is a L & R peaky reef break, breaking over reef bottom. Works best in 3-6ft S-SW swells. The long beach is open to all available swell so can get rippy. Isolated. All standards of surfer. Go explore for other options.

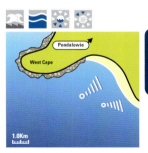

Ethel Wreck

Take the main road into Innes Nat Pk. Then a 10min scramble down the cliff.

Left & Right reef break, over reefy rock bottom. In 6ft plus S-SW swells forms short, intense, ledgey waves. A bit inconsistent. When conditions are right, a summer wave for experienced surfers. Beware rips and freaky clean-up sets.

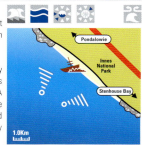

Rhino Head

On the main road to Pondalowie between Marion Bay & Stenhouse Bay.

Left reef break, breaking over rocky reef bottom. The break is quite well protected from prevailing winds. Best in 3-6ft S-SW swells. Quite a hike to get there, and really only for when all else is blown out but good for novices.

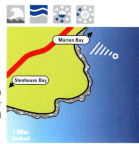

Chinaman's & Baby Chinaman's

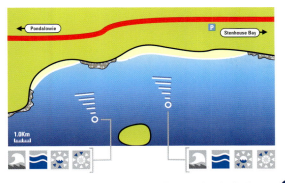

Head into Innes National Park via Stenhouse Bay, head W to the first bay you come across. You will see Baby Chinaman's first, then the big one is about a K further.

A classic South Australian wave. **Chinamans** is a L (does break R too) hand reef break, breaking over rocky reef bottom. In 4-8ft S-SW swells, this wave can have a very fast, jacking beast of a takeoff over shallow bottom. It then moves immediately into a fast, barreling wall section over a shallow rocky ledge. Can deliver a 100m ride in perfect conditions. Advanced surfers only.

To the East of the break is **Baby Chinamans** - a smaller L reef break, breaking over rocky reef in 3-6ft S-SW swells. Good break for improvers.

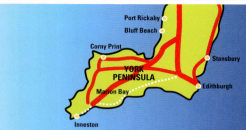

Port Rickaby

Bluff Beach

Corny Print

YORK PENINSULA

Stansbury

Marion Bay

Edithburgh

Inneston

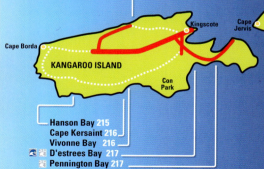

Stockes Bay **215**

Kingscote

Cape Jervis

Cape Borda

KANGAROO ISLAND

Con Park

Hanson Bay **215**
Cape Kersaint **216**
Vivonne Bay **216**
D'estrees Bay **217**
Pennington Bay **217**

Stokes Bay

Ferry from Cape Jervis to Penneshaw. Head through Parndana on Playford Hwy. Turn R & go through Amen Corner to the bay.

Mainly L, but sometimes good R reef breaks, breaking over shallow sand & reef bottom. Needs a massive plus W swell. Heavy currents. Experienced surfers only. Go explore round here.

Sleep: Kangaroo Island Central Backpackers Murray St Kingscote 08 8553 2711

Cape Younghusband / Hanson Bay

Ferry from Cape Jervis to Penneshaw. From Vivonne Bay, head W on South Coast Road. Turn L to Hanson Bay.

Powerful L point break, breaking over rocky reef bottom. Best in 8-10ft plus S-SW swells. Possibility of steep takeoffs, followed by long hollow barrels. However, catches a lot of swell so the currents can be dangerous. Experienced only.

Sleep: Western KI Caravan Pk, South Cst Rd, 08 8559 7201

SOUTH AUSTRALIA

Cape Kersaint

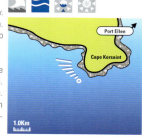

Ferry from Cape Jervis to Penneshaw. Turn off Playford Hwy at Parndana. R on Sth Coast Rd. L at Port Ellen to the Cape.

A really good L breaks off the R side of the point, over rocky reef bottom. Needs huge S-SW swells to turn on. Steep, hollow & spitting barrels in perfect conditions. Only for the experienced surfer.

Vivonne Bay

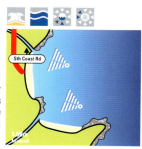

Ferry from Cape Jervis to Penneshaw. Turn off Playford Hwy at Parndana. R on Sth Coast Rd, then L to Vivonne Bay.

Good L & Rs break over sandbars formed by sand deposited from the two river mouths at either end of the bay. Needs large 6-8ft plus S-SW swells to produce punchy, sometimes great quality, waves. Good for all standards.

Sleep: Kingscote Nepean Bay Tourist Pk, Brownlow, 08 8553 2394

D'Estrees Bay

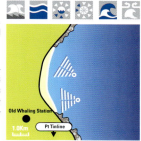

Ferry from Cape Jervis to Penneshaw.
From Pennington, head W on Playford
Hwy. Turn off L to the bay.

A selection of reef breaks, breaking L
& R over shallow reef bottom. Needs
massive S-SW swells to turn on. Gets
very gnarly, steep takeoffs, very hollow
waves & shallow, sharp reef. Only for
the very experienced.

Pennington Bay

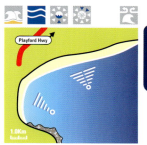

Ferry from Cape Jervis to Penneshaw.
Head South West on Hwy for 30kms
to the bay.

Selection of peaky L & R beach breaks
at this protected beach, breaking on
shallow sand bottom. Best in 3-6ft
S swells. Gets crowded, due to it's
proximity to Penneshaw & Kingscote.
All standards of surfer.

Sleep: Penneshaw Caravan & Camping Pk, Talinga Tce, 8553 1075

SOUTH AUSTRALIA

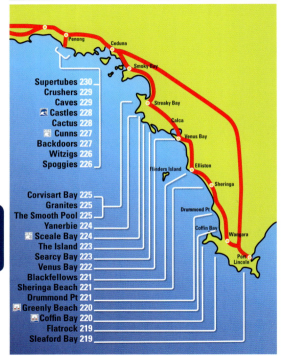

Sleaford Bay

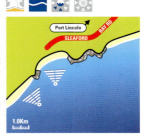

From Port Lincoln, head S on Sleaford Bay Rd. Take the rd to the beach.

Various L & R beachies, breaking over sand & reef bottom. Work best in 3-6ft South swells. In best conditions, peaky A-frames with fast, hollow barrel sections. Head R up the beach for empty peaks. Intermediate waves. Search for **Barrel Beach** & **Fishery Bay**.

Flatrock

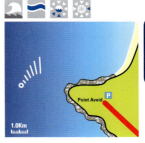

Head W from Port Lincoln to Coffin Bay. W 30kms to the car park at Point Avoid.

Seriously gnarly L breaking over very shallow reef bottom. Steepest takeoff, then fast into a total power, top-to-bottom barrel section. Best in 6-8ft SW swells. Experts only. 4WD to explore empty reef spots or go S for **Almonta Beach**.

SOUTH AUSTRALIA

Coffin Bay Peninsula

Head W from Port Lincoln to Coffin Bay. Follow signs to the Nat Park. 4WD.

The various 4WD tracks will lead to many different reef & beach breaks, breaking over reef or sand. High chance of empty, quality breaks. Best to explore in W-SW swells. Very remote so only for the experienced surfer. Beware sharks.

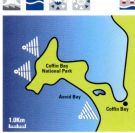

Sleep: Coffin Bay Carvn & Campg Pk, The Esplanade, 8685 4410

Greenly Beach

Head NW on Flinders Hwy. L at signs between Warrow & Coulta. 4WD recommended.

V long, open beach. Wide variety of beachies over sand or reef bottom. Best in 6ft plus South -SW swells. All standards. At best, empty punchy A-frames. Beware strong currents & sharks. Head S to check **Coles Point**.

Drumond Point

Head NW on Flinders Hwy. Turn L just S of Mt Hope. 4WD recommended.

L & R beachies, reef & point breaks for all surfing standards. Best in 3-6ft S-SW swells, as the point catches more swell than most spots in the area. Go explore and you'll find. V isolated, rips & sharks. Experienced surfers only.

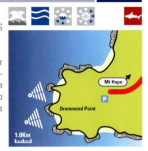

Sheringa Beach

Head NW on Flinders Hwy towards Elliston. Turn L at Sheringa to the beach area. 4WD recommended.

Variety of L & R beach & reef breaks, breaking over sand & reef bottom. In 3-8ft S-W swells there are real quality, punchy A-frame waves to be had. Isolated. Experienced surf explorers will love it here.

Sleep: Elliston Waterloo Bay Caravan Pk, Beach Tce, 08 8687 9076

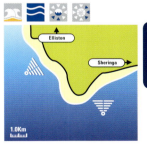

SOUTH AUSTRALIA

Blackfellows

Head N of Elliston on coast rd to Cape Finiss car park.

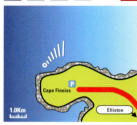

V powerful L point break, breaking over rocky reef bottom. Best in 3-6ft SW swells. Freefall 100% commitment takeoff, even in 3ft. Thick-lipped, knockout barrels for experts only. A true beast. Hairy paddle-out & very sharky! For real adventure try Flinders Island.

Sleep: Elliston Caravan Pk & Camping, Flinders Hwy, 08 8687 9061

Venus Bay

N of Elliston on Flinders Hwy, turn off 10kms S of Port Kenny to the bay.

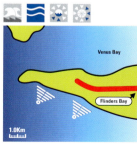

Just N of the township, a variety of L & Rs on secluded beaches & reef breaks below the cliffs, breaking over sand & reef bottom. Best in 3-6ft plus S-SW swells. Generally safe spots for all standards. Surf explorer heaven.

Sleep: Venus Bay Caravan Pk, Matson Tce, 08 8625 5073

Searcy Bay & Point Labatt

NW of Port Kenny, take Baird Bay signs then L on 4WD tracks to bay & point.

Various beach & reef breaks, breaking over sand & reef bottom. Best in 3-6ft plus S-SW swells. Similar to Venus Bay - an isolated spot for experienced surf explorers of all standards. All the usual dangers (& that means sharks!).

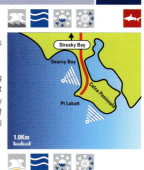

The Island

Head N from Port Kenny on Flinders Hwy to Streaky Bay. Take signs to Sceale Bay.

10min dune walk to a heavy R reef break, breaking over sand bottom. Handles big 8ft plus S-SW swells to form a short, intense, very hollow barreling beast for experts only. Heavy currents, sharks & locals! Explore S for empty waves.

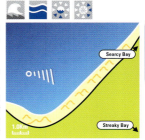

Sceale Bay

Head N from Port Kenny on Flinders Hwy to Streaky Bay. Take signs to the bay.

S end of the bay along the north shore of Cape Blanche, a quality L breaks over reef bottom in solid 6ft plus SW swells. Various L & R beachies, mainly over sand in S-SW swells. V remote spot for explorers. All the usual dangers. Sleep:Sceale Bay Caravan Pk, Government Rd, 08 8626 5099

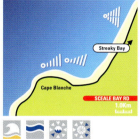

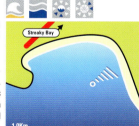

Yanerbie

Take the same directions for Sceale Bay, then go to the N end. 4WD preferable.

Inconsistent R reef break, breaking over shallow rocky reef bottom. Needs solid 8-10ft plus S-SW swells to get going. In perfect conditions, a powerful, hollow wave for advanced surfers only. Beware currents & (obviously) noahs.

Corvisart Bay & Granites

Head N on Flinders Hwy from Elliston. Streaky Bay is 50kms. Wells St to Back Beach.

At Back Beach carpark, a L breaks over shallow reef in 3-6ft S-SW swells. Small but clean 150-200m barrels. Improvers & locals. Head S to Pt Westall car park. Head down the cliff to the legendary **Granites** - long, powerful L over shallow rocky reef in big 6-8ft plus S-SW swells. Steep takeoff, fast walling bowl sections. L & R when smaller. Huge paddle-out in deep water! Experts only.

Further along the point is **Indicators** - similar to Granites, though not as intense & handles 8ft S-SW swells. Experts only.

Further down is The **Smooth Pool** - nice L over totally shallow rock bottom (often break the surface) in 6-8ft plus SW swells. Remote psycho spot only for the best.

Sleep: Streaky Bay Foreshore Tourist Pk, 32 Wells St, 8626 1666

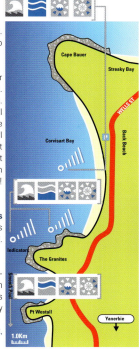

SOUTH AUSTRALIA

Spoggies

From Penong, head 21k to Point Sinclair and Cactus. Turn off R at the sign to the beach.

Powerful, hollow-barreling L & R reef break over reef & sand bottom. Gets going in 3ft but holds 8ft plus S swell. Pretty heavy so experienced surfers only. Very isolated spot. Give locals some room.

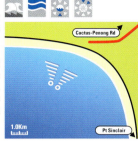

Witzigs

Head N from Streaky Bay to Penong on Hwy. Turn off to Point Sinclair, 21k.

S end of the point beyond the car park, a powerful L reef break, on v shallow sand-covered reef bottom. Best in 6-8ft S-SW swells. Turns on cover-up barrels & 3-400m rides in best conditions. Advanced surfers only. Isolated spot.

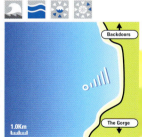

Backdoors

From the car park at Witzigs, head N along the coast to the next break.

Big & powerful R reef break, breaking over shallow rocky reef bottom. A little inconsistent but can turn on jacking steep takeoffs & thick-lipped double-peak in 6-8ft W-S swells. Usual Cactus warnings: sharks, locals & reef.

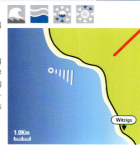

Cunns

From Backdoors, North round the point past the shop. Scramble down the cliff.

Powerful L reef break, breaking over rocky reef bottom just inside the point. Needs 6-8ft W-SW swells to turn it on. Steep takeoff over shallow reef. Hairy jump-in entry in bigger conditions. Advanced surfers only.

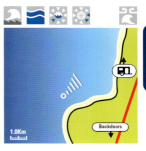

SOUTH AUSTRALIA

Cactus

From Penong head 22K to Point Sinclair. Just N of Cunns, out in front of the car park.

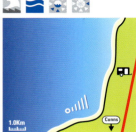

The break that made the region famous. A Left reef break breaking over sand-covered reef. Best in 3-6ft W-S swells. Straight forward takeoff & fairly mellow ride. One of the more approachable waves in the area. Look out for noahs.

Sleep: Penong Hotel, 08 8625 1050. Or camping grounds at Cactus

Castles

Just 200m N of Cactus.

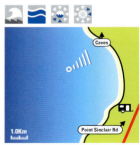

Powerful, grinding L reef break, over shallow reef bottom. Best in 8ft plus W-SW swells, when it forms a jacking takeoff & a thick-walled hollow barrel section follows. In under 6ft, a reform L inside the reef forms a surprisingly fast, small barrel. Heavy paddle-out & currents. Sharks.

SOUTH AUSTRALIA

Caves

Just 200m N of Castles.

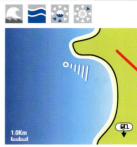

All-time classic Right reef break over shallow rocky ledge. Best in 8-10ft S-SW swells. Turns on a seriously steep takeoff, hollow top-to-bottom barrel of awesome quality & power. Experts only. Sharks in the deep channel just S. Show respect to the locals and you'll be fine. Razor reef!

Crushers

Just N of Caves, round the prominent headland.

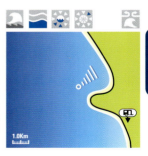

Yet another powerful, grinding Left reef break, breaking over shallow reef bottom. Best in 6-10ft W-S swells. All the usual attributes of a L in Cactus, except that it tends to be a bit less crowded, being a little further to walk. Advanced surfers only.

Supertubes
Just 200m North of Crushers.

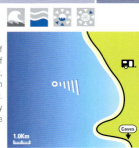

A powerful offshore Right reef break, breaking over very shallow reef bottom. Best in 6-8ft W-S swells. Fast, hollow & thick-walled long barrels. In bigger conditions a heavy paddle-out. Advanced surfers only. Can get really crowded when it's going off. All the usual Cactus warnings.

Sleep: Caravan Park nearby

Caves

1.0Km

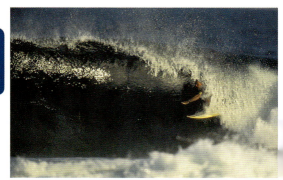

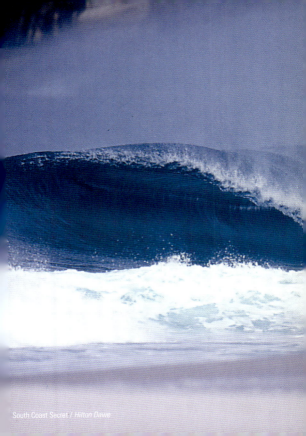

South Coast Secret / Hilton Dawe

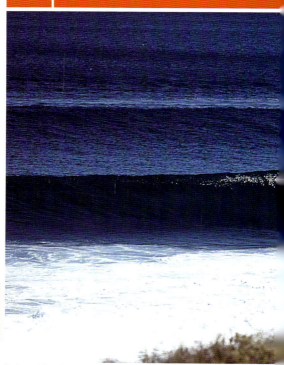

Northwest / *Sean Davey*

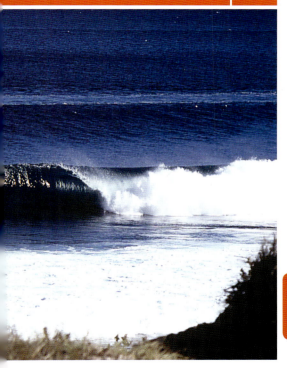

Cape Arid 235
Wylie Bay 235
Wests, 2nds, Chapmans Pt 236
Salmon Bay 237
Fourth Beach 237
Twilight Beach 238
Nine Mile Beach 238
12 Mile Beach 239
Crazies 239
Mylies Beach 240
West Beach 240
Dillon, & Bremer Bays 241
Long Beach, Cheyne Bay 241
Nanarup Beach 242
Middleton Beach 242
Salmon Holes Reef 243
Sand Patch Beach 243
Mutton Bird Beach 244
Lowlands Beach 244
Wilsons Inlet, Ocean Beach 245
Lights Beach, Back beach 245
Peaceful Bay 246
Conspicuous Beach 246
Rocky Head, Normalup Inlet 247
Hush Hush Beach 247
Mandalay Beach 247
Windy Harbour 248
Augusta Rivermouth 249
Deepdene 249

Cape Arid

From Esperance, head 110K East on Fisheries Rd to Cape Arid National Park. 4WD.

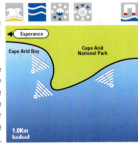

The Nat Park is a major wildlife refuge with over 160 bird species. It is frankly awesome surf or no surf, and the waters are mostly a striking turquoise blue. It boasts a variety of breaks for the adventurous with a 4WD. Be nice to the locals in Esperance for advice, and contact CALM on 08 9075 0055 for some detailed itineraries etc. Most spots work on S-SW swells. Waves can be huge, and there is a threat of big fish. Experienced surfers only.

Wylie Bay

From Esperance, take Fisheries Road East towards Cape Le Grand then Bandy Creek Road & follow signs. 4WD essential.

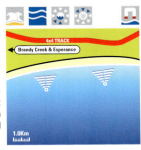

Long sandy beach with heavy, shifting-peaked L & R-breaking beachies. Best in bigger 4ft plus swells. The beach holds a lot of swell. Beware rips and strong currents.

Isolated too so experienced only. Beautiful spot.

Wests & Seconds

Just out of Esperance southwest on Twilight Beach Rd. Both have a carpark so you'll spot them.

Two busy little beaches good if you don't have time for a major adventure. Mostly beach-breaks, consistent on lower tides, N winds and SW swell. There's a reef break option visible on bigger days. Crowds at the usual times, but scenic and cruisy atmosphere so you will not lose out.

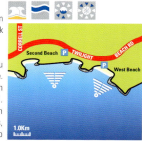

Chapman's Point

From Esperance, head SW on Twilight Beach Rd. Top end of Bluehaven Beach just past Seconds.

A powerful, lippy Right breaks off the point over sand and patchy reef bottom. Entry and exit is pretty nasty over slippery rocks. Rips are very strong here so watch the locals to get into the line-up. Experienced surfers only.

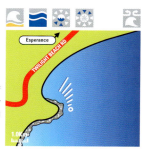

Sleep: Pink Lake Tourist Pk, Pink Lake Rd 08 9071 2424

Salmon Bay

From Esperance, take Twilight Beach Rd. Go past Chapmans and Bluehaven Beach, next bay.

Short, steep, spitting R works off the reef, breaking on shallow reef & sand bottom. The beach is very rippy with evil currents. Best in up to 6ft swells. Experienced surfers only. It gets ripped up by the southwest sea breeze, so if there's enough swell check Bluehaven just north for varies options out of the wind.

Sleep: Esperance Bay Caravan Pk, Dempster St, 08 9071 2237

Fourth Beach

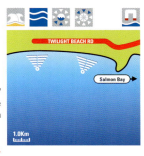

Head W from Salmon Bay round the headland to the next bay.

Consistent, quality L & R s with shifting peaks, breaking on sandy and patchy reef bottom. Best in up to 6ft S-SW swells. As with many beaches in the area, can get rippy & keep an eye on the currents. Solid local scene.

Sleep: Esperance Bay Caravan Pk, Dempster St, 08 9071 2237

Twilight Beach

From Esperance, take Twilight Beach Rd west. Its just after and joined to Fourth Beach.

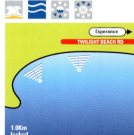

Another impossibly beautiful white sand beach with staggeringly turquoise blue clear water, and a rocky outcrop at its western edge. Several L & R beachies with shifting peaks, breaking on sandy bottom. Quality is dependent on the banks. Best in up to 6ft S-SW swells. Does have a couple of rips. Often attracts the crowds as the western end is slightly out of the wind.

Nine Mile beach

Head W from Salmon Bay Its the next bay round from Fourth Beach.

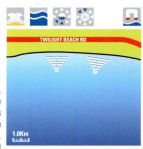

Various L & R s with shifting peaks, breaking on sandy and patchy reef bottom. Best in up to 6ft S-SW swells. Beware the rips & currents, particularly in bigger swells. Can often be less crowded than other beaches in the area as just that bit further to get to. Further still is Eleven Mile, which will be your best bet to avoid people!

WEST AUSTRALIA

Twelve Mile Beach

From Ravensthorpe, take the Hopetoun Rd to Hopetoun. Coast rd 20kms E to Jerdacuttup Lake.

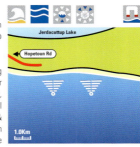

Smaller L & R beachies with shifting peaks. Fairly fickle. Best in smaller S swells (tends to max out at 4-5ft, particularly when it's windy). You'll often find uncrowded peaks up & down the beach. On the way you can check out Two Mile Beach for more accessible options.

Crazies

At Ravensthorpe heading East on Hwy, turn off to Hopetoun. Head for the jetty.

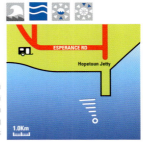

Fast, shallow left-hand reef break off Hopetoun Jetty. Currents and a considerable paddle separate the men from the boys here, but the wave can be quality, with square sections reeling down the line making goofy-footers tumescent. Advanced plus.

Mylies Beach

Heading W from Hopetoun, follow rd 20kms to the beach. Its a couple of kms past Barrens Beach.

More popular & consistent than West Beach & offering more power. L & R s with shifting peaks, breaking over sand. More protected in the SW near Caves Point. Handles up to 8ft of swell.

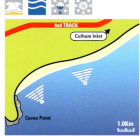

West Beach

Head W from Hopetoun past Culham Inlet into Fitzgerald Nat Park. It's just past Mylies. 4WD essential.

Good little L & R beach breaks with shifting peaks, quality dependent on the banks. Works best in smaller 3-6ft S swells. Bit of a trek to get there through the Nat Park. Can be a great explorer day.

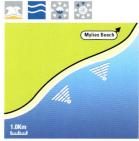

Bremer Bay

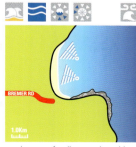

Head to Bremer Bay, E of Albany. A selection of fickle but sometimes very good L & R beach breaks. **Bremer Bay** (East of town) is the most protected from the SW breezes, and **Dillon Bay** (S of town) is also a good bet. Best in 3-6ft S swells and offshore in N-W. North of Bremer, on Tooregullup Beach is **Gordon Inlet**: Hard to access creek mouth action that's offshore in the south-westerlies. Between here and Hopetoun lies the FitzGerald River National Park. This is a massive zone of undiscovered, semi-inaccessible surf. For some info on how to get in and out, call 08 9835 5043.

Long Beach / Cheyne Bay

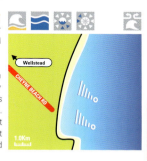

Go East on Hwy from Albany for approx 120K. Turn off at Wellstead for 20kms.

A powerful, barreling R works in 6ft S-SE swells. Works in slightly different conditions to most beaches in the area so seems inconsistent. **Pallinup Beach** to the north an east can offer point and beach options out of the southwest breeze in an isolated setting.

Sleep: Cheyne Beach Caravan Pk, Cheyne Beach Rd, 9846 1247

WEST AUSTRALIA

Nanarup Beach

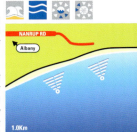

Take Lower King Rd E from Albany. Approx 25kms from town centre to the beach. 4WD on the beach or long walk.

Beach-break peaks from 1-6ft, slightly blocked from southwest swell. Popular Albany spot that can offer quality, with the sheer extent of it absorbing any number of surfers. About 5k further are the amazing, crystal clear Little and Waterfall Beaches in Two Peoples Bay. If flat, head here for a swim.

Middleton Beach

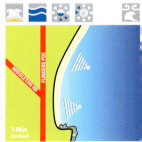

Take Middleton Rd out of Albany. After 3kms take Flinders Pde to the beach.

L & R beachies breaking over sand. Needs bigger S-SE swells. As a result, pretty inconsistent, but protected from afternoon sea-breeze. Despite all of this, can get crowded due to it's proximity to the town. Good place for novice surfers.

Sleep: Middleton Beach Caravan Pk, Flinders Pde, 08 9841 3593

Salmon Holes Reef

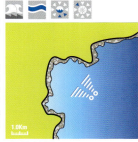

Head out of Albany on Frenchman Bay Rd. Turn off at the signs for the beach.

Salmon Holes is a small bay where a R & L breaks over a reef. Best in 6ft S swells. Very dangerous in big swells as entry is via slippery rocks. Really a bodyboard break. There are always better options. The beach and rockpool however, are spectacular.

Sleep: YHA Of WA 49 Duke St Albany 08 9842 3388

Sand Patch Beach

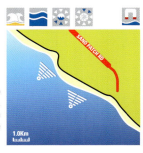

Take Frenchman Bay Rd out of Albany. Take Sand Patch Rd to the cliffs - big hike down. 4WD is good!

Many Left & Right breaking beachies off this sandy beach, below steep cliffs. Maxes out in 6ft S-SW swells. Varying consistency. Wide open beach gets pretty rippy. Sharks feed on the salmon here.

Sleep: By the Sea B&B, 7 Griffiths St Albany 08 9844 1135

WEST AUSTRALIA

Mutton Bird Beach

Take Lower Denmark Road out of Albany. Turn off to the beach. 4WD if you can.

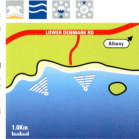

With a good 4ft+ S swell, this long open beach holds sometimes excellent, long L & R s, breaking mainly over sand. Best in up to 6ft S-SE swells. Steep takeoffs, long bowling sections and power. What more do you need?

Lowlands Beach

Heading out of Albany on Lower Denmark Rd, turn off on Tennessee Sth Rd to the beach.

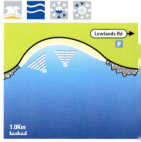

Consistent L breaks off the rocky point of the second bay. Beachies in the middle of this small bay, breaking over sandbar. Needs 4-6ft S-SE swells. Holds plenty of swell, so gets rippy with strong currents.

Wilsons Inlet & Ocean Beach

Take Ocean Beach Road south from Denmark & follow signs. There's a sealed road to the surf club on the point.

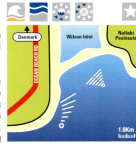

Powerful, long peeling Rs break at the inlet mouth, when it's opened to the sea every July by the council. Needs big 8ft plus S-SW swell. The beach has some quality peaks all year though. 4WD/long walk up the beach for good beachies (best & most crowded is **Anvils** on E headland). This spot is quality.

Sleep: Ocean Beach Caravan Park, Ocean Bch Rd, 08 9848 1105

Lights Beach

Head W from Denmark on the highway and take Lights Rd. Signs to beach. 4WD only. William Bay area.

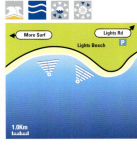

West of Ocean Beach is Lights Beach, accessed via Lights Beach Rd. It's more exposed to wind and swell so best surfed early morning. When OB isn't big enough, head here. Nearby is the amazing Greens Pool/Madfish Bay area, where , if its flat, you can head off and inspect some truly staggering beaches with awesome rock pools and boulder formations. Sleep: Rivermouth Caravan Pk, Inlet Dr, 08 9848 1262

WEST AUSTRALIA

Peaceful Bay

South Coast Hwy east from Walpole. Take Right at Bow Bridge on Peaceful Bay Road.

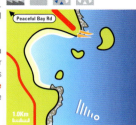

Peaceful Bay Rd

1.0Km

Just past the bay, 200m out is a powerful, hollow R breaking over shallow sandy reef. Needs 8ft plus S-SE swells to crank. Nearby, **Rame Head** is hardcore 4WD only. Explore for real gems in the area.

Sleep: Peaceful Bay Caravan Pk, 08 9840 8060

Conspicuous Beach

East about 12k from Walpole on south Coast Hwy. Turn off right Before Bow Bridge on Conspicuous Beach Rd.

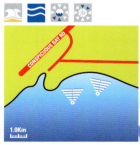

CONSPICUOUS BAY RD

1.0Km

Protected sandy beach which holds a lot of swell, produces shifting, sometimes heavy L & R beachies, breaking on shifting sand. Works in 3-10ft S-SW swells at either end of the bay. Look for the bombies off East point in big conditions.

Sleep: Crystal Springs Camp, South West Hwy, 08 9840 1027

Rocky Head

Heading W from Walpole on Hwy, turn off into Nat Park. Really only accessible by boat.

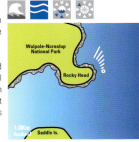

Big, gnarly R point break at Rocky Head breaking over rock is sizey, powerful and only for the experienced. Best in 6ft plus S-SW swells. Just off the coast is **Saddle Island** for the explorers amongst us.

Sleep: Valley of the Giants Ecopark, South Coast Hwy, 9840 1313

Hush Hush Beach

Turn off Sth Western Hwy at Crystal Springs on Mandalay Beach Rd. Take Long Point Track.

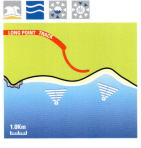

An isolated beach, accessible by 4WD. Lovely little L & R beachies over sand and rock. Best in 6ft W-S swells. Quality depends on the banks and the ideal is a WSW swell to make it work. Its exposed to wind and swell, so best surfed when small or early morning.

Mandalay Beach

Turn off Sth Western Hwy at Crystal Springs on Mandalay Beach Rd.

Long, sandy beach producing good quality beachies, over sand & rock. The banks here tend to be pretty consistent. Catches most S-SE swell. Best in 6-8ft. Great spot. Look for **Lost Beach** & **Circus Beach.**

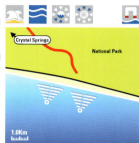

Windy Harbour

Take the Sth Western Hwy from Augusta to Northcliff. Head South on Northcliff Rd to Pt D'Entrecasteaux.

Spectacular spot, below the steep headland. Very open to the swells, so an unreliable place with heavy rips. If things are on, there's a series of beach breaks, breaking over sand & patchy rock in smaller S-SW swells.

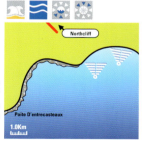

Augusta Rivermouth

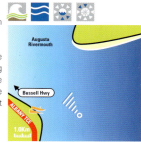

Head S on Bussell Hwy 100kms from Busselton to Augusta.

Inconsistent but good R works at the rivermouth, breaking over a shifting sandbank. Quality depends on the amount of sand deposited out of the rivermouth. Best in 6 ft S-SE swells. It being a rivermouth...Watch out.

Sleep: Doonbanks Caravan Pk, Blackwood Ave 08 9758 1517

Deepene

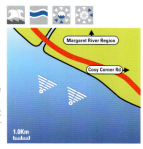

Heading N on Bussell Hwy from Augusta, take Caves Rd. Turn on Cosy Corner Rd. 4WD track S 2 kms.

Isolated and beautiful spot where you'll find L &R reef breaks off the fishing beach. Best in big S-SW swells. Real power-packed waves straight from the Southern Ocean. Breaks for advanced surfers.

Sleep: Flinders Bay Caravan Pk, Albany Tce, 08 9758 1380

WEST AUSTRALIA

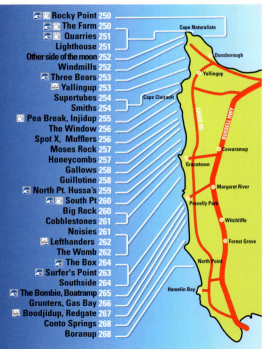

WEST AUSTRALIA

Rocky Point

West from Dunsborough on Cape Naturaliste Rd, take Eagle Bay Rd to end, long trek NW.

L reef break breaks on sand-covered reef just off the point. Needs big SW-W swells to really happen. The forms an ideal novice wave with a good bowling section after takeoff. Maxes out at 6ft. Normally uncrowded.

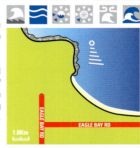

yahoo

s u r f b o a r d s

Unit 3/I Clark St. Dunsborough. WA 628I. PO Box 210
Ph/Fax (08) 9756 8336 email: yahoo@wn.com.au

The Farm

Turn off Cape Naturaliste Rd into Bunker Bay Rd Carpark at west end of beach. North of Rocky Pt.
Inconsistent, smaller, mainly R beachies. Need 8-10ft plus SW-W swells to work. Uncrowded novice waves on the whole. Can also check **Boneyards** to the E for similar stuff.

Sleep: Dunsborough 3 Pines Beach YHA, 201-5 Geographe Bay Rd, Quindalup, 08 9755 3107

WEST AUSTRALIA

The Quarries

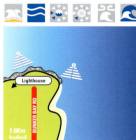

Head Northwest from Dunsborough on Cape Naturaliste Rd. R on Bunker Bay Rd to end.

There's a small L here breaking on reef off the rocky point. Needs a big 8-10ft plus SW-W swell to Get around the head and push into the bay. Also an OK beachie; The Farm. Beautiful spot.

Sleep: Dunsborough 3 Pines Beach YHA, 201-5 Geographe Bay Rd, Quindalup, 08 9755 3107

Lighthouse

From Dunbsborough, take Cape Naturaliste Rd all the way to lighthouse. Head west. This spot was formerly known as "other side of the moon" and still is by some (see after).

Consistent, mainly L reef/beach break over sand and reef bottom. Small beachies stretch for 2-3kms from the lighthouse S to the Wedge. Best in 4-6ft SW-W swells. Can get crowded particularly in the summer. All standards.

Other Side of the Moon

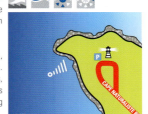

From Dunsborough, take Cape Naturaliste Rd all the way to lighthouse. 20 min hike West.

Small Left reef and sand break, producing peaky, punchy A-frames. More consistent in summer conditions, and best in 4-6ft SW-W swells. Gets v crowded in summer when it's going off. Waves for all standards.

Windmills

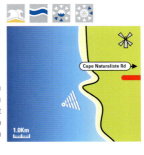

From Dunsborough, North on Cape Naturaliste Rd, turn L on Sugarloaf Rd. Head N on 4WD track 3kms. Or Walk S from Lighthouse.

Small L & R reef breaks, breaking on sandy & patchy reef bottom. Best in 4-6ft SW-W swells. A pretty good spot for novices to learn & intermediates to improve. Gets surprisingly crowded in good conditions.

Sleep: Canal Rocks Caravan Pk, Smiths Beach Rd, 08 9755 2116

WEST AUSTRALIA

The Three Bears

Turn off Sugarloaf Rd onto 4WD track. Head south.

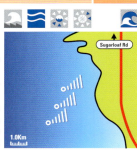

3 long Left reefs to surf in all sizes of SW swell. Classic WA reef breaks: jacking takeoffs & square sucky barrels. On small days surf **Baby Bear**. If 5ft plus, surf **Mama Bear**. When it's big, eat your porridge and go deal with **Papa Bear** who awaits you furthest out. You need E winds. Trek south and investigate Shivery Rock.

Sleep: Yallingup Beach Caravan Pk, 08 9755 2164

Yallingup Beach

Turn off Caves Rd to Yallingup. Go through town & North to the beach.

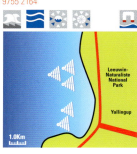

Bubble, Cove and **Main Break** are quality reef-breaks offering hollow lefts and rights on southwest swells. More south in the swell makes the lefts fire and line up. Southeast winds perfect. Big swells handled with ease, and in fact over 6ft is best. Tide no problem. Further up at **Rabbit hill, Shallows** and **Mousetrap**, mainly right-handers get hollow in any east wind, south west to west swell, and 4-6ft plus of juice.

Supertubes

Turn off Caves Rd to Yallingup. It's just N of Smiths.

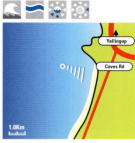

Small but very long and hollow R breaking over shallow reef bottom in 3-6ft SW-W swells. As with many reef breaks here, a jacking takeoff, followed by a fast barrel section. Small but power-packed. Great intermediate / advanced wave. Chill out at Cafe Laguna after.

Sleep: Caves Caravan Park, Yallingup Beach Rd, 08 9755 2196

Smiths Point & Beach

S on Caves Rd from Yallingup, turn off R on Canal Rocks Rd, 1st R to the beach.

A reasonable L breaks over sand-covered reef off the rocks at the S end of the beach. Needs 8ft plus SW-W swell, SE wind. Good Beachies further up, and sucky R over sand and reef in SE winds. Get into Save Smiths Beach campaign! Some SW wind protection.

Sleep: Dunsborough 3 Pines Beach YHA, 201-5 Geographe Bay Rd, Quindalup, 08 9755 3107

Injidup Carpark & Pea Break

S from Yallingup on Caves Rd. Take Wydabup Rd to the end. Left at end to car park (for CarPark; Pea Break is 200m N).

A good couple of good right handers break over shallow reef. It starts cranking in solid SW-W swells, when there is surprising power. Takeoffs are steep, followed by a long peeling sections. Crowds.

Sleep: Wydabup Brook Cottages, Wydabup Rd, 08 9755 2294

Injidup Point

As above then long walk. to the Southern point.

A long L breaks along the rock shore at the end of the sandy point on reef/rock. Needs bigger SW swells (6-8ft plus) to get cranking. When it does, it offers a refreshingly mellow alternative to most of its more intimidating neighbours.

The Window

Trek / 4WD South from Injidup Point.

A series of Right & Left reef breaks, breaking over shallow reef. Very steep takeoff, with hollow cover-up barrels. Working best in 4-6ft SW-W swells. Isolated spot for experienced surfers. Try **Wildcat** 2kms N.

Spot X & Mufflers

Just S of Yallingup, turn off Caves Rd to Injidup. Its about 4K S of The Window. 4WD needed.

An excellent quality R breaks over shallow reef bottom. Steep takeoff, then the classic, intense barrel. Works best in smaller 4-6ft SW-W swells.

A very barren spot for the adventurous.

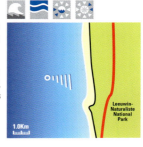

Sleep: Yallingup Beach Caravan Pk, 08 9755 2164

WEST AUSTRALIA

Moses Rock

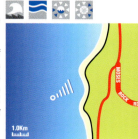

Heading S from Yallingup on Caves Rd, take Moses Rock Rd to the beach.

A quality L breaking over shallow reef bottom. As is common in these parts, a jacking takeoff, followed by a sucky, hollow barrel of a wave. Surprise, surprise, works best in SW-W swells! Isolated spot. The odd rip & heavy current.

Honeycombs

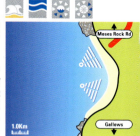

Turn off Caves Rd 15kms S of Yallingup on Moses Rock Rd. 1km S on 4WD track. Its S of Moses Rock.

Good L & R breaking in a small bay over sandy bottom. Best in 3-5ft S-SW swells. Does get good but a fickle set up. Good, safe summer wave spot. All standards. Not normally too crowded. If it is, check **Goannas** to the N.

Sleep: Taunton Farm Caravan Park, Cowaramup, 08 9755 5334

The Gallows

Take the same directions as for Guillotine.
4WD is essential.

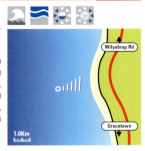

A powerful, peaky L breaks off an outside bombie, 2-300m out. Sucks up over a shallow reef to form a hollow, intense cover-up barrel. Best in up to 10ft SW-NW swells. As at Guillotine, totally isolated, so experienced surfers only. A few clicks N is **Classics**.

The Guillotine

Go S on Caves Rd approx 15kms from Yallingup. Turn off right after Wilyabrup to end, and take the tracks S. 4WD only.

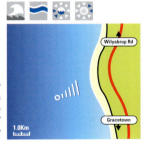

A hollow, reeling L breaks over shallow reef bottom. Cranks up quickly & forms some challenging sections before closing out. Best in up to 10ft S-SW swells. A really isolated break, only for experienced surfers.

WEST AUSTRALIA

North Point (Cowaramup Bay)

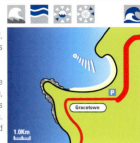

Western end of Cowaramup Bay Road, due west of Cowaramup. Follow signs to Gracetown.

Heavy, spitting R beast of a wave with a v long barrel (4-500m rides), in huge S-SW swells . Still breaks small in 4ft swells, but fires at 8ft plus. Breaks over shallow reef. Experienced surfers only.

Sleep: Taunton Farm Caravan Park, Cowaramup, 08 9755 5334

Hussa's

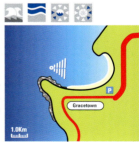

Close to the car park between Cowaramup North Pt & South Pt.

One of the few breaks in this area to be really good for novice & small wave surfers. Good quality L & Rs break over sand-covered reef. Needs 6ft plus S-SW swells to get into the bay. Can be strong current action. Great fun.

South Point (Cowaramup Bay)

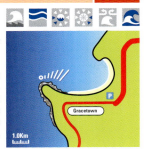

Same directions as for North Point. It is across the bay by the car park.

A long, clean L breaking along the point over shallow rock bottom. Needs big 8ft plus SW-W swells to break. A quality wave with some testing cut-back sections. Go there when other spots are out of control. Intermediate/expert.

Sleep: Gracetown Caravan Pk, Cowaramup Bay Rd, 08 9755 5301

Big Rock

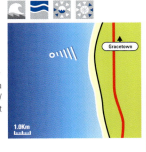

From Gracetown, Go S out of town on the dirt tracks for a K, then R. 4WD needed.

Another trademark R breaking over shallow reef bottom. Tends to be a smaller wave location in 2-6ft S-SW swells. Worth the hike but does get crowded. Good surfers only.

Cobblestones

Cobblestones and Noisies are pretty much at the same place as Big Rock, but don't turn right at the end; head to the carpark and walk just a bit S.

A smaller R breaking over reef bottom in 4-8ft S-SW swells. On its day, a clean, peeling barrel of length and surprising power considering it's relative size. Gets shallow and sucky. Experienced surfers only.

Sleep: Taunton Farm Caravan Pk, 08 9755 5334

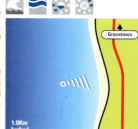

Noisies

Same directions as Cobblestones, a bit South.

Powerful, fast L & R peak over rocky reef bottom. Gets really hollow. Works in the same conditions as Lefties - best in smaller 4-6ft S-SW swells. Again, hardcore local scene and does get crowded.

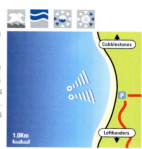

Lefthanders

Drive to Gracetown (The Bay). Go S
from Town. Take gravel track past Big
Rock S to carpark.

Grinding, hollow Left breaking over
shallow reef. Forms a long & fast,
thick-walled barreling wave of some
quality. Best in smaller 4-6ft W-SW
swell days. Get's v crowded as it's pos-
sibly the biggest swell magnet on the
coast. Right next door is Nowheres.

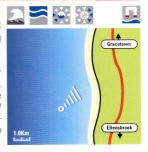

Sleep: Old Bakehouse B&B, Peake St Cowaramup, 08 9755 5462

The Womb

Heading South on Caves Rd, take
Ellensbrook Rd 5kms S of Gracetown.
Walk N of the homestead.

Sucky, hollow L breaking over shallow
reef bottom. Steep takeoff, followed by
long, thick-walled, cover-up barrels.
Some short rights too. Works best in
6-8ft S-SW swells. Heavy paddle-out
& big currents. Isolated spot for good
surfers. Sleep: Gracetown Caravan
Park, Caves Rd, 08 9755 5301

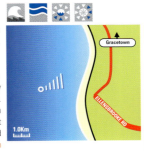

WEST AUSTRALIA

Margaret River: Surfers Point

Take Wallcliffe Rd to Prevelly Park. Head for the car park at the river mouth.

Most (in) famous big wave break on the WA coast. Surfer's Point is a L & R peeling either side of a shallow ledge reef. Holds up to 25ft. Tricky paddle-out & shifting peak in bigger swells. The Left can be a vertical drop takeoff, followed by long sucky bowl section, then a great long whackable wall.

The **Rivermouth** just North is an occasional beach style option.

From the car park you can see **South-side** (Suicides!) just South - see opposite.

Goes without saying that you need to be expert to survive here on big days. Quite apart from the wave itself, there's also hold-downs, being caught inside, broken boards & strong currents to think about.

Sleep: Prevelly Park Beach Resort, Mitchell Dr, 08 9757 2374

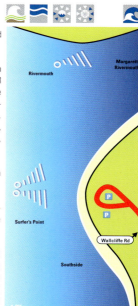

Margaret River: The Box

N of The Point at Margaret River, by Cape Mentelle.

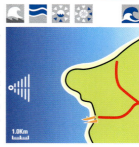

Probably the gnarliest of the lot. A horror-story R, breaking over suck-dry rock ledge. Very fast takeoff. Also a pile-driving lip to contend with. Works in 4-10ft and bigger SW swells... Again, the clinically insane only need apply!

Sleep: Inne Town Backpackers 93 Bussell Hwy Margaret River 1800 244 115

Margaret River: Southside

Take Wallcliffe Rd to Prevelly Park. It is 2-300m S of Surfers Point.

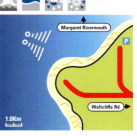

Margaret Rivermouth

Wallcliffe Rd

A long gnarly L & R reef break 200m out. Works in 4-10ft SW-W swells, creating a steep takeoff over a very shallow reef! The Left can be the gnarliest and hollowest - but also longer. The R is more forgiving once you make the drop.

Sleep: Margaret River Lodge 220 Railway Tce Margaret River 08 9757 9532

WEST AUSTRALIA

The Bombie

Take the same directions as for Boat Ramp. The Bombie is just N.

One of the spectacular WA all-time big waves. A L (& lesser R) breaks way out on an outer reef. Massive is the only way to describe it. Works in 10-12ft plus huge S-SW swells. Goes without saying that its for experts / the clinically insane.

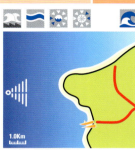

Sleep: Riverview Caravan Pk, 8-10 Wilmott Ave, 08 9757 2270

Boat Ramps (Gnarabup Beach)

Turn off Caves Road on Wallcliffe Rd to Prevelly Pk. Take Gnarabup Beach Rd.

A L hand outer reef-break of all-time quality. Big, heavy and hollow, packing all the power of the Southern Ocean. Holds up to 15ft of W-SW swell. Expert surfers only (have you seen the paddle-out?).

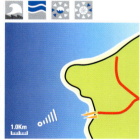

Sleep: Margaret River Tourist Park, 36 Station Rd, 08 9757 2180

WEST AUSTRALIA

Grunters

Take Wallcliffe Road to Prevelly. Drive S through Gnarabup. First turn to Grunters carpark.

Seriously power-packed R breaks 300m out on the outer reef. Big paddle-out. Even bigger freefall takeoff, forming a sucky, hollow cover-up barrel. Holds up to 12ft. Beware just about everything here! Only expert surfers.

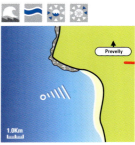

Sleep: Surfpoint Lodge, Riedle Dr, Gnarabup Beach, 08 9757 1777

Gas Bay

Same directions for Grunters, but go through Gnarabup to Gas Bay carpark. 4WD if possible.

Long, powerful, grinding Right hand barrel, breaking over shallow sand & reef bottom. Best in 4-6ft S-SW swells. Can get pretty crowded (quite a hardcore local scene) when it's on. Gets rippy. Advanced surfers.

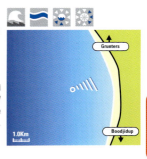

Boodjidup Beach

30 min walk N from Redgate Beach or
S from Gas Bay.

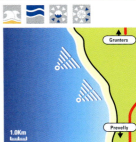

A grinding, heavy selection of beach
breaks, breaking Left & Right over sand
bottom. The waves suck up very hollow
to provide an intense ride in small 4-8ft
S-SW swells. There are big outer reefs
but whether they are surfable...?

Sleep: Surfpoint Lodge, Riedle Dr,
Gnarabup Beach, 08 9757 1777

Redgate

Turn off Caves Rd onto Redgate Rd
approx 5kms S of Prevelly Pk.

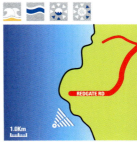

Really powerful shifting Left & Right
A-frame beach breaks, becoming
hollow barrels. Mainly break over
sand & sand-covered reef bottom.
Works best in 4-6ft S-SW swells.
Can get rippy, particularly when bigger
swells come in.

Conto Springs

Turn off Caves Rd about 20kms S of Prevelly Pk, on Conto Rd. To end.

Conti's is a long, fast, peeling Left breaking over sand & rocky bottom. Has a jacking takeoff, followed by a challenging wall section. Best in 6-8ft S-SW swells. Great goofy-footers wave in beautiful, isolated scenery.

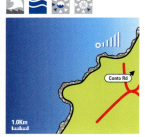

Boranup Beach

N of Augusta, take Caves Rd 15kms. Turn to Hamelin Bay. 4WD N 6-7kms.

Long, sandy beach with a variety of testing, A-frame L & R beach breaks, breaking over sandbars. Watch out for the powerful rips & currents all along the beach. Best in big (10ft plus) S-W swells. Isolated intermediate spot.

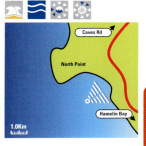

Sleep: Hamelin Bay Caravan Pk, Hamelin Bay Rd, 08 9758 5540

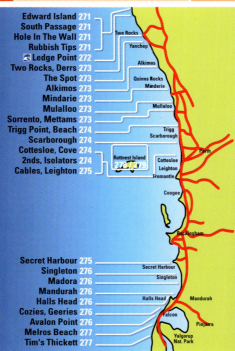

Two Rocks
Yanchep
Alkimos
Quinns Rocks
Mindarie
Mullaloo
Trigg
Scarborough
Perth
Rottnest Island
Cottesloe
Leighton
Fremantle
Coogee
Rockingham
Secret Harbour
Singleton
Halls Head
Mandurah
Falcon
Pinjara
Yalgorup
Nat. Park

Lancelin

80k north of Perth. A range of brilliant and varied surf options in Lancelin.

Back Beach and **Rubbish Tips** south of town = quality lined up beach-break with azure blue water. Likes 2-6ft SW-NW swell, & E to NE wind.

Eddie Island, past the caravan park in town and 500m off-shore, has a mainly R reef best in 4-6ft.

End of Cunlliffe St, but over a KM off-shore is **Hole in the Wall**; right-hand reef break from 3-10ft, awesome, lined up, shallow and square with tapering shoulder. Boat in.

North of this, 2k off-shore is **South Passage**; reef left just about visible from harbour. Outside works to 10ft +.

Finally **Lancelin** Island hosts a pair of awesome R reef-breaks if you have a boat.

Ledge Point

On the South side of Lancelin, down Wanneroo Road, follow signs.

L & R reeef breaks work a boat trip out form the point. Need sizey (6ft plus) S or SW swells to get going. Don't even think of the paddle out (you won't) Not a place for the inexperienced. Sharks are often sighted.

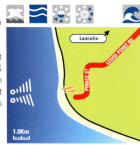

The Spot

North from **Yanchep** on Two Rocks Rd, bumpy track to left. L on shallow reef, best in 5-8ft SW swells. When big swells come in, gets v crowded. Big boulders. Just 6k N up **Two Rocks** Rd is Two Rocks, where you may find a wave in similar conditions. **Derrs**, through the grassy dunes by the Marina is a legendary beach with quality reef setup. Access is officially illegal now thanks to some anal regulations so be careful driving the track. Do not forget **Alkimos**, a right left reef setup about 12k south of Yanchep (via dirt track off Pipidinny Dr). It likes E to NE winds and can hold some size. The outside break is a legend in these parts.

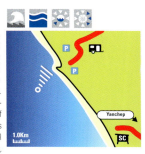

Mullaloo

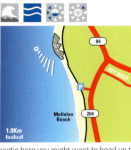

Mullaloo beach is at the top end of Hillarys, and top of the beach is the point. Access to the beach is straight of the coast highway, but the point requires a walk. Some typical Perth beach-break, but off the point, a right over sand and a bit of rock, that can be perfect, lined up and hollow. Rarely threatening, sometimes a beauty. Likes E to NE winds, Rare NW swell from 3-8ft would be perfect if only! Gets totally destroyed on summer afternoons. If its hectic here you might want to head up to **Mindarie** and try to find a gap in the crowd.

Mettams

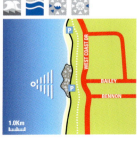

Just north of Trigg by about 1.5K, you will spot some reefs off the coast rd. Right left reef break that gets good if the wind will stay off-shore while a decent size, 3-6ft southwest to west swell comes in. Lower tides. Rarely threatening, all levels. Of note there's a good LR reef up at **North Beach**, and also further up at **Waterman's Beach**. You can check the lot in 1 quick drive. You may also spot **Toms**, and **Grabbers**, which breaks often but not always good, and sometimes dumping. **Sorrento Groyne** is also known to create short wedgy rights on north to east winds, SW-W swell.

Triggs Beach & Point

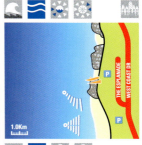

In Perth, head to Scarborough and up West Coast Dr to Trigg. The Point has a pretty good R breaking over sand / rock & working in bigger SW-NW swells. Beachbreak can be fun, but the whole strip is best in winter. Needs a bit of size. For a bit of variation, **Floreat** has a wedgy left-hander off the groyne. It's a little protected from the SW winds but needs some swell. SE winds best. **City Beach** further down also has a groyne worth a look; both sides work depending on the wind. **Swanbourne** has plenty of beach-break peaks too.

Cottesloe Beach

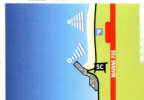

In Perth, head N on West Coast Hwy. Take Eric Av to Cottesloe Beach. L at end of the groyne can get good in big SW swells. Also a R breaks off the Pylon. **Cove** (gentle, long R Reef), **Seconds**, (short sucky L reef, hollow take-off) and **Isolators** (L&R reef, good for mals, the left being shorter and suckier, the right better for long rides, drawn out turns & the occasional barrel) are a good check to the South, if swell 2m+ on Cottesloe wave buoy. The setup is incredibly crowded so, be nice!

Sleep: Scarborough Starhaven Caravan Pk, 18 Pearl Pd, 9341 1770

Leighton Beach
Just south of Cottesloe.

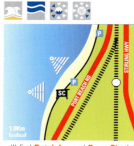

A selection of shifting peaked R & L beachies. Needs a good SW or NW swell before it works, and there's a surfboard ban in summer. Can be a real gem in bigger swells, if banks are right. **Cables**, the artificial R reef at N end, can be good too. It was only laid down in 2000 but is now a well established, busy spot best surfed low to mid tide in any east wind. Nearby, you'll find **Dutch Inn** and **Deep Six**; left and right reefs/groynes on lower or mid tides, any E wind and most swell to 6ft (Deep six holds a bit more).

Secret Harbour
Head S on the Old Coast Rd towards Mandurah. Secret Harbour sign leads to beach.

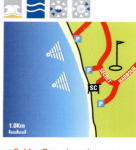

Just about the best swell puller in the Perth Metro area, with approach-able beach-break peaks working on smaller swells. Higher tides tend to be fatter and good for mals. Anything large tends to close out. Probably your best chance of a wave when in Perth. There's more beach-break options down at **Golden Bay**, where there are some mellow peaks. It works on SW-NW swells with east or northeast winds best.

WEST AUSTRALIA

Singleton

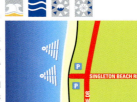

13kms N of Mandurah on the Fremantle Rd. Turn off to Singleton to the beach. Left & Right beachies with shifting peaks breaking on sand bottom. Needs a fairly large SW or NW swell to get going. A good novice beach, with ENE winds best. 2-6ft. Just south in **Madora** you will find similar beach-break action for all levels in the 2-5ft range. **Stewart Street** in Mandurah is a known beach-break in large SW-W swells, SE-E winds. If theres enough swell and southwest winds are ruining life, **Halls Head** is rare but worth investigating, if not the **Esturey Mouth** is also deserving on SE winds.

Cozies & Geeries

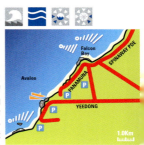

South on the Mandurah to Bunbury Coast Rd into Mercedes Ave, L on Soinaway Pde, & park on Panamuna Dr. Walk to beach lookout.

1st spot N is **Cozies**, a small left hand reef working into the bay. Further out and south is **Geeries**, another left reef requiring a bit more swell and holding more size on the big days. Both like low to mid tide, southeast winds and southwest to west swell preferably over 6ft on the buoy. **Avalon Point** next up south, is a quality right-hand reef point at the bottom end of Avalon Beach in Falcon Bay. SE winds, solid WSW swell and most tides will see it firing.

Melros

From Mandurah south on Coast Rd, turn right a few k after the Dawesville Cut on Dawesville Rd. Stop where the road bends north. Clamber and check!

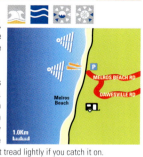

Left and right beach-break peaks on any tide can be fun and shapely. there's also a left and right reef option here that gets good on its day. South a few minutes is **Tims Thickett**. A now renowned reef break that used to be shrouded in mystique. Easy to find but tread lightly if you catch it on.

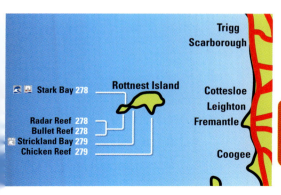

Trigg
Scarborough

Stark Bay 278
Rottnest Island
Cottesloe
Leighton
Fremantle
Radar Reef 278
Bullet Reef 278
Strickland Bay 279
Chicken Reef 279

Coogee

WEST AUSTRALIA

Stark Bay

Get the Rottnest Express from Fremantle or the ferry from Hilary's. Bike-ride to Stark Bay in the N.

Serious barreling L hand reef break, breaking a long way out on sucky shallow reef. Holds massive SW-NW swells. One of WA's premier big waves. It's a boat trip to get out. Definitely expert surfers only. Heading northeast from here towards Geordie Bay you may see **Parakeet Point**; left-hander good up to about 6ft on higher tides and SE wind. Even further E is **Transits**; fickle low tide R &L.

Sleep: Alison and Caroline Thompson Camping, 08 9432 9111

Radar & Bullet Reefs

Cape Vlamingh in the W. Follow the signs.

The most exposed & isolated breaks on the island. R reef breaks, breaking on shallow reef, holding over 12ft SW-W swells. Can get big, grinding with steep takeoffs & hollow barrels. Nasty paddle-out. Beware currents. Experts only. Check West End for **Cathedral Rock** - a monster left-hander by the shipwreck best on lower tide, SE wind.

Strickland Bay

Take the Starflyte ferry from Perth or Fremantle. Bike-ride from there.

Most consistent and popular break on the island. Mainly L, but also R reef break, breaking over shallow ledge. Can produce some heavy long rides through challenging sections. Best in 6ft plus S-SW swells but holds 10ft plus. Experienced surfers only. Next door, E in Mary cove is **Piss Head Point**, small left-hander on low to mid tide and ENE winds. In the same conditions you will see the right-hander **Bricks**, just E.

Chicken Reef

Head for Porpoise Bay. The most East breaks on the island. Follow the signs.

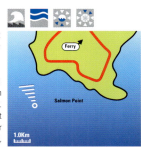

Off Salmon Pt is **Chicken Reef**: a powerful, hollow left breaking on shallow ledge on W side of the point. Best in 6ft S-SW swells and northeast through east winds. If this isn't your thing, pedal west to Fairbridge Bluff, where you'll see **Ducks**, a left-hander in the 2-5ft range in any north wind.

The Bluff / *Hilton Dawe*

Onslow
Exmouth
1
Coral Bay
Gnaraloo
Quobba
Carnarvon
Denham
1
Kalbarri
Horrocks
Geraldton
Dongara
Cervantes

1.0Km

WEST AUSTRALIA

Dunes

From Exmouth on Murat Rd to lighthouse. L on Mildura Wreck Rd to NW Cape.

Series of L & R reefs. Best in 6ft+ SW swells. Hollow, peeling waves. Can be intense long rides. Rippy between the reefs. Sharks. Intermediate / advanced. There are waves further north even as far as Broome (**Cable Beach**), but consistency starts to be a problem from here on up.

Sleep: Ningaloo caravan and holiday Res,murat Rd, 08 9949 2377

Lighthouse Bombie

Head N of Exmouth on Murat Rd. Turn L to lighthouse. It's out in the bay.

Monster, hollow classic L reef break, breaking over shallow sandy reef in huge S-SW swells. Freefall takeoff, followed by intense barrel section. Awesome power. Forget the paddle, boat it! Big rips & currents & sharks. Crazies only.

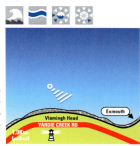

Sleep: Exmouth Cape Tourist Village, Murat Rd, 08 9949 1101

WEST AUSTRALIA

Gnaraloo

Head N from Carnarvon. Take Blow-holes turnoff, then take a right to go north past Quobba station. All up it's 75k of sealed road + 75k of track, in variable condition. 4WD best, and full surf trek supplies necessary.

The Gnaraloo area has a number of very serious long reef breaks, with lefts predominant. Just S of **Three Mile Camp**, are the 3 main waves, all left hand reef beasts over shallow coral. **Midgies**, way out the back, runs a few hundred metres towards **Centre Peak** or **Centipedes**. CP is a Square steep fast barrel. Then finally **Tombstones**; a hell paddle, triple suck takeoff and ledging freight train... Experts only, esp. at low tide when horrid steps appear in this last wave.

On smaller days, **Fencelines** offers a relatively relaxed session over patch sand and reef. It's right in front of 3 Mile Camp. **Gnaraloo Bay** offers some mellower options too, especially if there's a very big southwest swell running and the 3 Mile spots are huge.

Accommodation: Gnaraloo Station Homestead (beds), 08 9942 5927, or 3 Mile Camp (camping) 08 9948 5000. Bring supplies, a tent, and fishing gear. Plan this trip and call ahead.

Gnaraloo Bay

Shark Alley

Gnaraloo Homestead

Fenceline

Tombstones

CP

Midgies

Red Bluff

1.0Km

The Bluff & Turtles

From Gnaraloo (see previous) drive south down the track past 3 Mile Camp. Turtles is a walk right after the "No 4WD" sign, and The Bluff is 6k south of this, beyond the station fenceline. Also accessible via Quobba Station in the south.

One of Australia's all-time waves - **The Bluff**, or **Red Bluff**, is a monster L hand reef/point break, and a well photographed icon of Western Australian surfing. Breaking over very shallow, urchin-infested sharp reef, it holds up to 10ft of southwest swell but is at it's most perfect in 5-6ft. Severe steep takeoff, followed by a long, thick-lipped barreling bowl section. It's powerful and hold-downs are severe. Helmets recommended. The wave shoulders out into a deep water area known for its sharks.

Heading N on the track towards 3 mile camp, by the dunes, is **Turtles**, a L & a fickle R breaking over shallow, sharp reef. Best in smaller 4ft SW swells. Both are for experienced surfers only.

Sleep: Gnaraloo Station or 3 Mile Camp, see previous page.

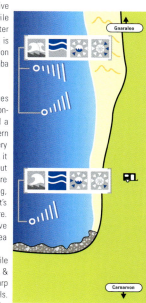

Surf Point (Dirk Hartog Island)

A boat trip or flight from Denham.

Dirk Hartog is a World Heritage Site, and a natural wonder. In season you'll see whales, whale sharks & turtles. Across from Steep Point, a R breaks over shallow reef. Best in solid SW swells. Long barrels but v dangerous - big rips & currents in the channel & very sharky. Other breaks on the islands for hardcore crew only, up north at **Hawks Nest** and **Turtle Bay**. For accom and travel help call 08 99481211 or see www.dirkhartogisland.com

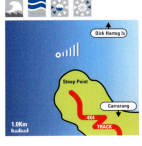

Steep Point

Serious adventure in 4WD. Take Denham turnoff from the NW coastal Hwy through Hamelin Station, then continue into Carrarang Station. It's at the northwest tip.

Serious L breaks over v shallow, sharp reef. Good in 6ft plus S-SW swells. Powerful long barrels which are suck-dry at takeoff. Expert surfers only. Very isolated & very sharky so beware. BYO supplies out here - it's barren. On the way you'll see the **Zuytdorp Cliffs**, which are a whole world of extreme surf adventure waiting for the hardy explorer.

WEST AUSTRALIA

Blue Holes

Just SW of **Kalbarri** on Red Bluff Rd, turn off the coast track at the signs.

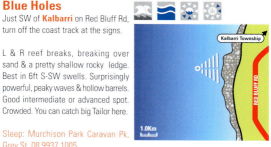

L & R reef breaks, breaking over sand & a pretty shallow rocky ledge. Best in 6ft S-SW swells. Surprisingly powerful, peaky waves & hollow barrels. Good intermediate or advanced spot. Crowded. You can catch big Tailor here.

Sleep: Murchison Park Caravan Pk, Grey St, 08 9937 1005

Jake's Point

Just a few clicks S of Blueholes off Red Bluff Rd.

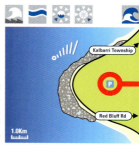

One of the best waves on the coast. Grinding, spitting L breaks off the point over very shallow reef. Best in 6ft plus SW swells. Takeoff is suck-dry & steep. Thick-lipped, powerful barrel section. Expert surfers only. Show maximum respect to locals who have it wired, and you'll snaffle a couple.

Sleep: Kalbarri Tudor Caravan Pk, Porter St, 08 9937 1077

Bowes Rivermouth

Turn off Brand Hwy at Northampton, to Horrocks. It's about 20kms W.

Several peaky L & Rs break over sand bottom. Best in 6ft SW-NW swells. If the sand banks are good, it can be a great place for punchy, hollow little waves. Head N as far as Port Gregory for similar, less crowded options.

Sleep: Horrocks Beach Caravan Pk, 1 North Court, 08 9934 3039

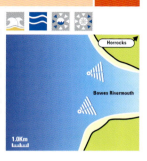

Coronation Beach

50 kms N of Geraldton on Brand Hwy, turn L for 10kms to the beach.

A series of L & R peaky beach breaks, breaking on sand. Best in 6ft S-SW swells. Can be good in smaller if banks are good. Punchy little A-frames. Gets surprisingly crowded if the conditions are right. All standards. Check out the R at Oakabella nearby.

Sleep: Backpackers (Batavia) Bayly St Geraldton 08 9964 3001

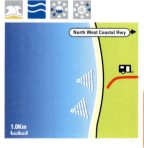

WEST AUSTRALIA

Drummonds

Head N on Brand Hwy out of Geraldton for 10kms. Take road to Drummond Cove.

A couple of small L & Rs break over sand-covered reef, best in 6ft SW-NW swells. Can be a bit inconsistent, due to the sand build-up, but if good, forms a nice, long peeling wave.
Good improver wave.

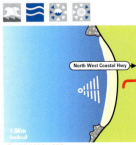

North West Coastal Hwy

1.0Km

Sleep: Sunset Beach Holiday Pk, Bosley St, 08 9938 1655

Hell's Gate

In Geraldton, head to Point Moore. The reef is about 800m W of the point.

Pretty serious R hand reef break, breaking over shallow reef. Works best in 6-8ft S-SW swells. Can be a long hollow peeling R. Forget paddling out there. Beware strong currents. NB: small L at Lighthouse in big swells called **Explosives**.

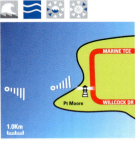

MARINE TCE

Pt Moore

WILLCOCK DR

1.0Km

Sleep: Belair Gardens Caravan Pk, Willcock Dr, 08 9921 1997
Shaper: Bruce Montgomery, 116 Northwest Coastal Hwy, 9964 4966

WEST AUSTRALIA

Flat Rocks & Headbutts

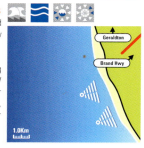

Head S from Geraldton on Brand Hwy. It's near 7 Mile Beach. Follow 4WD tracks.

L & R reef & beach breaks, breaking on sandy reef bottom. Needs W-SW swells but tends to max out in over 6ft. In 4-5ft you'll find uncrowded long, hollow barrels. Many peaks further N&S along the beach for adventure.

Port Denison

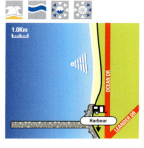

30kms S of Dongara on the Brand Hwy, take Leander Dr and turn into Ocean Dr. 4WD for explorers.

Just N of the harbour L & R beachies over sand bottom. Best in 6ft S-SW swells. Drive S along the coast for more isolated reefs & beachies. Probably smaller but also empty! Advanced surf explorers.

Sleep: Dongara/Denison Tourist Pk, 8 George St, 08 9927 1210

WEST AUSTRALIA

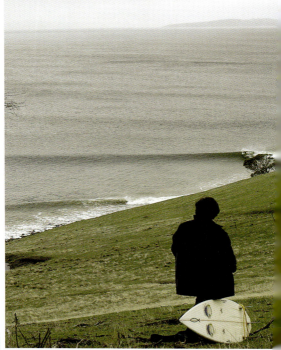

Secret Spot / *Sean Davey*

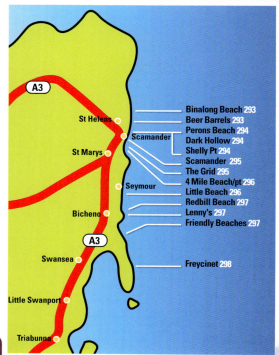

A3

St Helens

Scamander

St Marys

Seymour

Bicheno

A3

Swansea

Little Swanport

Triabunna

Binalong Beach 293
Beer Barrels 293
Perons Beach 294
Dark Hollow 294
Shelly Pt 294
Scamander 295
The Grid 295
4 Mile Beach/pt 296
Little Beach 296
Redbill Beach 297
Lenny's 297
Friendly Beaches 297

Freycinet 298

TASMANIA

Bilalong Beach

Head North East from St Helens on the Binalong Bay road.

A fairly consistent crowd-pleaser that is off-shore in the horrid southwest storm winds. The banks of this beach-break can get nicely sculpted by the lagoon outlet. Whilst it misses out on prevailing SW swells, any east coast low will feed it and a big S swell can just about make it in. All levels, has its own little crowd but there are enough peaks.

Beer Barrel Beach

Drive up St Helens Point Rd past Perons. Next beach up.

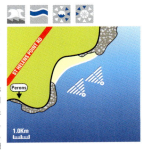

L & R beach-break, breaking over sand & patchy reef bottom. Works in NE-SE swells to form A-frame peaks with hollow barrels. Quality is sand bank dependent. Pretty isolated & uncrowded. Good intermediate spot. Offshore in any north to west wind, and a consistent spot that gets maxed out a lot.

Sleep: St Helens Caravan Pk, 2 Peneloop St, 03 6376 1290

TASMANIA

Perons beach

Drive up St Helens Point Rd from St Helens. Signs to Perons across the dunes.

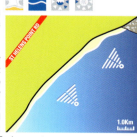

Punchy L & R beachies, breaking mostly over sand on this huge, consistent beach. Works in ENE-SE swells to form A-frame peaks with hollow barrels. Northern corner is protected from any north winds. Quality is sand bank dependent. Pretty isolated & uncrowded. Good intermediate spot. Seals, currents.

Sleep: St Helens Caravan Pk, 2 Peneloop St, 03 6376 1290

Dark Hollow

NE of Beaumaris, just a 10min walk NE of Shelly Point (the other Shelly Pt).

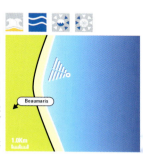

L & R beachies breaking over shallow sand & some rock bottom. Depends on banks for the quality but can be peaky, powerful A-frames. Holds quite a bit of swell - watch out for rips. Novice / intermediate spot.

Shelly Pt to the S is a pretty consistent right point worth checking.

Sleep: Scamander Kookaburra Caravan Pk, Scamander 6372 5121

Scamander Rivermouth

25kms S of St Helens on Tasman Hwy.

Peaky, surprisingly powerful L & Rs, breaking on sand & patchy reef bottom. Best in 6-8ft NE-SE swells. Quality can be excellent when the river deposits plenty of sand on the banks. Strong currents & gets rippy. Shark sightings. Experienced surfers only.

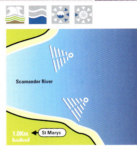

Sleep: Pelican Sands Holiday Units157 Scamander Ave Scamander 03 6372 5231

Cattle Grid

From St Mary's follow Hwy N then turn R to 4 Mile Creek. N end of the beach.

A powerful, good quality L breaks over shallow rocky reef bottom. Best in bigger NE swells. Pretty steep take-off & long-walled cover-up section to follow in best conditions. Attracts the crowds. Experienced surfers only.

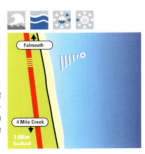

Four Mile Beach & Pt

From St Mary's follow Esk Hwy N. R to
4 Mile Creek.

A L works off the point, breaking on
sand-covered rock bottom, forming
classic hollow barrels. Needs 6-8ft
NE swell. In bigger swells (up to 15ft)
a R bombie breaks 200m further out.
Severe wave. Also, L & R beachies up
the beach. Gets rippy.

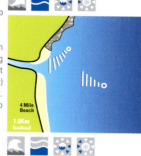

Little Beach

Head N on Tasman Hwy from Bicheno
approx 15kms. Take the signs.

A good, inconsistent L&R at the S end
of the beach, breaking on reef. Best in
6-8ft NE swells. Small A-frames break
up the beach. Best in smaller 3-6ft
conditions. Good novice / intermediate
spot. Check out **Denison Beach** too.

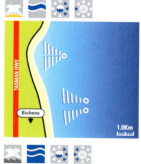

Sleep: St Marys Seaview Farm Germantown Rd St Marys 63722341

Redbill Beach

From Bicheno, head N on Tasman Hwy.
Turn R just out of town.

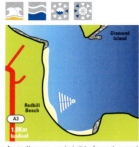

Small L & R beachy breaking on sand bottom. Best in 4-6ft E swell, and completely misses southern ocean pulses. A very good novice's wave when it works, and protected from southwest storms. Off the beach is **Diamond Island** where a R breaks off the point in bigger swells over rocky bottom. Nasty paddle-out for pros only. A stroll away, and visible from the road, is **Lennys**, a well frequented, average right-hand point-break.

Sleep: Bicheno Backpackers 11 Morrison St 03 6375 1651

Friendly Beaches

Take the C302 S from Llandaff! Ok down, take left. Road gets pretty rough. Then walk.

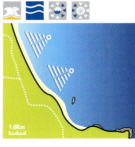

A 10km expanse of beach-break interspersed with reef formation that catches any available swell from N through S. Off-shore in S-westerlies. This is extremely remote and should never be surfed alone. Currents along some stretches are horrendous. Be prepared to hike, and take first aid kit. Beyond here is **Freycinet Peninsula**, a national park of staggering natural beauty and a few hidden gems for the most intrepid surf explorer.

TASMANIA

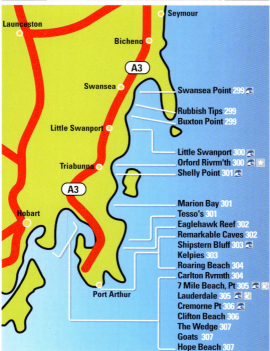

Seymour

Launceston

Bicheno

A3

Swansea

Swansea Point 299

Rubbish Tips 299
Buxton Point 299

Little Swanport

Little Swanport 300
Orford Rivrm'th 300 ⭐
Shelly Point 301

Triabunna

A3

Marion Bay 301
Tesso's 301
Eaglehawk Reef 302
Remarkable Caves 302
Shipstern Bluff 303
Kelpies 303
Roaring Beach 304
Carlton Rvrmth 304
7 Mile Beach, Pt 305
Lauderdale 305
Cremorne Pt 306
Clifton Beach 306
The Wedge 307
Goats 307
Hope Beach 307

Hobart

Port Arthur

Swansea Point

Take Tasman Hwy to Swansea. Go R on Esplanade just before town centre.

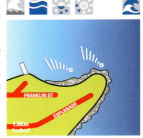

Big Rights break over sand & rocky bottom, just off the point. Needs massive S swells to work. These waves are jacking at takeoff, often revealing rocks, then powerful bowling barrel sections. Experienced surfers only. Just S is **Rubbish Tips**, similar wave, more protected from S winds.

Sleep: Swansea Holiday Pk, Shaw St, 03 6257 8177

Buxton Point

Head S from Swansea on Tasman Hwy. It's the S point of Mayfield Bay. Acess is through Lisdillon, which is a private property so it is essential you close gates, leave no trash and show respect.

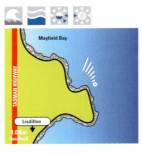

R off the point on a rocky reef. Needs big East -SE swells to work. In these conditions, it's a gnarly takeoff, leading to a heavy, walling barrel section. Watch rips & currents. Experienced surfers only.

Sleep: Swansea Kenmore Cabin & tourist Pk, 2 Bridge St, 6257 8148

Little Swanport

25kms N of Triabunna on Tasman Hwy.
R off onto Saltwater Works Rd.

Long L breaks at the rivermouth on a sandbar, which when good, forms a very fast 2-300m ride with a steep takeoff & cover-up barrels. Needs huge (15ft plus) SE cyclonic swells. There's also a R at the S point. Experts only.

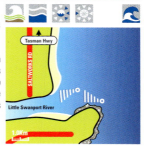

Oxford Rivermouth

10kms S of Triabunna. Go over the bridge and turn L.

Inconsistent, classic left-hander in the right conditions; only worth checking if everywhere is maxed out by a big 10ft+ SE swell. Long rides up to a minute are rumoured. If you luck out here, you will not forget it. Very very inconsistent so when its on there will be crew.

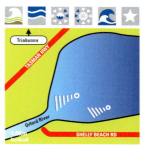

Sleep: Triabunna Caravan Pk, 4 Vicary St, 03 6257 3575

Shelly Point

Head SE from Orford for 3kms. Walk to the point.

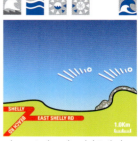

A R breaks over sandy reef bottom in big SE or NE swells. Outside section breaks in v deep water, sometimes linking with a long inside sec. Far Less consistent than its northern namesake, but classic when on. If it isn't quite doing it here because too small, then a trek into **Marion Bay** may pay off. This requires a drive down to Bream Creek and some tracks and roads into the bay. An expanse of beach-break taking swell from east to south in varying degrees as you head north. Remote.

Tessellated Pavements

Head 2kms N of Eaglehawk Neck, just before the point.

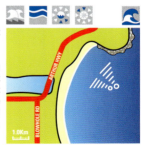

R & L reef break (mainly R), breaking over a very shallow kelp-covered rock ledge. Gets good in the bigger (10ft plus) SE swells. Be prepared for the dredging, followed by a fast, powerful barrel section. Big tides & currents. Experienced surfers only.

TASMANIA

Eaglehawk Reef

From Sorrell, take Arthur Hwy 75kms to the Peninsula. It's at the bay mouth.

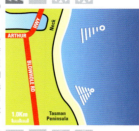

400m walk on from Tesso's, heavy L breaks on very shallow rocky reef in the bay mouth. Best in 6-10ft NE swells. Severe steep takeoff, followed by long, fast barrel section. Mistakes can be costly! Experienced surfers only. Theres the beach at Eaglehawk Neck for a scenic surf.

Sleep: Eaglehawk Neck Backpackers 94 Old Jetty Rd 6250 3248

Remarkable Caves

Head S from Port Arthur on Safety Cove Rd for 10kms to the caves. Paddle or walk through the caves at low tide.

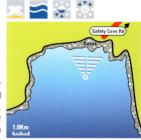

Ripper of a right. At 4 feet this is already a heavy wave, and at 6 it is for the pros only. Lefts too. Pretty isolated spot, so it's rare to find any crowds. Keep an eye on the currents in bigger swells. Experienced + spot, and known to be sharky. The entrance to the cave is a hazard in itself so go with a local, or watch locals negotiate it.

Sleep: Port Arthur Caravan Pk, Garden Pt, 03 6250 2340

Shipstern Bluff

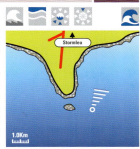

From Nubeena, take Port Arthur Rd, then Highcroft Rd to Stormlea. Long long walk along tracks and you'll come to the bluff above the break.

No longer a secret, and in fact marked on any road atlas, this hollow, barrelling R reef break, sucks and steps over a shallow rock shelf. Short, steep, intense ride with holes and stairs on take-off, and the bottom dropping out completely on many waves. Best in big SW-S swells.

Cold southern ocean water feels dense, and it can turn on some of the biggest heaviest (15ft+) waves in Australia. Experts and spectators only or stay away. Break taking swell from east to south in varying degrees as you head north. Remote.

Kelpies

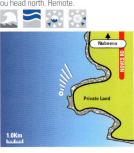

Head SW from Nubeena to White Beach. Take Noves Rd. 25 mn walk on track thro private farmland.

Good Left breaks off a point over rocky & sand bottom. Needs a solid 8ft plus SE swell to go off. In these conditions, expect a hollow tube quickly after takeoff, a long wall section, then shoulders out. Fickle spot requiring rare combination of conditions. Isolated so experienced surfers only. The channel between here and Wedge Island is notorious for sharks.

TASMANIA

Roaring Beach

Head out of Nubeena for 2-3kms. Turn L onto Roaring Beach Rd to the beach.

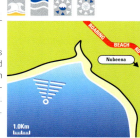

A selection of peaky L & R beachies work here, and a good fun rebound R. Breaking mostly over sand with some reef. Generally needs 4-6ft S-SW swells but can handle more size. Popular with locals from Nubeena. Intermediate level break.

Sleep: White Beach Caravan Pk, White Beach Rd, 03 6250 2142

Carlton Rivermouth

E from Sorrell on Arthur Hwy, turn R & go through Dodges Ferry to Carlton.

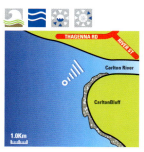

A long L works best in heavy SW-S swells, breaking over sand bottom. Quality depends on size of swell and the sand bar, deposited from the river. Good learner point break, but intermediate in bigger conditions. Sharks are possible.

Seven Mile Beach & Pt

Take road to 7 Mile Beach just before the airport on Tasman Hwy. Walk for 20 mins to the point.

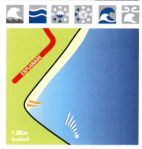

Expansive beach-break popular with Hobart surfers, needing straight south swell to break, unless a very large SW groundswell is powering up Storm Bay. Of note also, a long, smooth-walled R breaks at the point on extra large swells from the same direction. The point can be hollow when big, although generally is a fun wave. Crowds appear when the swell is on the up.

Lauderdale

Turn off Tasman Hwy on Sth Arm Rd to Lauderdale. Bayview Rd to the point. **Mays Point**: Long R point break over sand & patchy rock bottom. Needs huge 10ft plus SW-S swells to get going, but is off-shore in the accompanying SW winds. Takeoff leads quickly into a hollow, barrelling section. The best point for novices in the area. Beach-peaks up **Roches Beach** are more consistent, and good in southwest - west winds. At the top of the beach is **Lauderdale Point**, which works in similar swells with west winds, but gets extremely crowded.

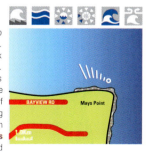

Cremorne Point

From Lauderdale, take South Arm Rd S for 5kms. Turn L on Cremorne Av. Vigorous paddle across inlet.

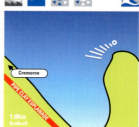

Another long R point break, breaking over sand & patchy rock bottom. Works in huge 10ft SW-S swells. OK takeoff, then a pretty mellow peeling wave with a long-walled mid-section. Crowded.

Clifton Beach

7-8kms S of Lauderdale on South Arm Rd, turn L to Clifton Beach.

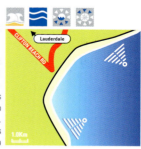

Expanse of beach-break that can get good if the winds are co-operating and banks are right. Straight south swell hits the spot best, with more angled swells needing to be progressively bigger to negotiate Cape Raoul or Tasman Head. It's one of the more consistent beaches within striking distance of Hobart, so crowds are on the increase here and weekends are busy. All levels.

Hope Beach & Goats

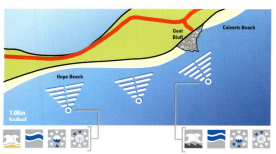

Head south from Lauderdale towards South Arm. The road takes a big right swing at Calverts Beach. At the western end of **Calverts Beach** you'll see Goats Bluff. A fickle reef break works in solid southwest to south swells here, a.k.a. The Wedge. It gets super hollow and pretty intense from 3 ft upwards, with steep take-offs and a concentrated peak. Not an easy place to surf. West along Hope Beach is a series of beach-break peaks that can get good. On solid south

Goats / Sean Davey

swells it thumps onto the banks here. There's plenty of room, with the eastern end of the beach getting the best shape most days (AKA **Goats**). North winds are the go, any tide. It's a bit swell-specific here, needing as much south as possible.

TASMANIA

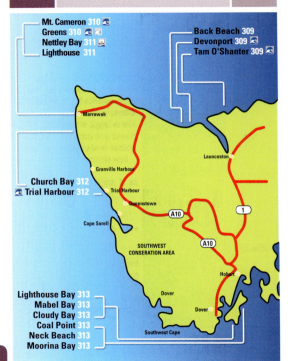

Marrawah

Launceston

Granville Harbour

Trial Harbour

Queenstown

A10

1

Cape Sorell

SOUTHWEST
CONSERATION AREA

A10

Hobart

Dover

Dover

Southwest Cape

Tam O'Shanter

NE from Launceston, between George-
town & Bridport at Lulworth.

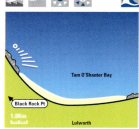

One of the few spots in the Launceston
area. Left hand point break breaking
over sharp rock bottom. Can get pretty
good but needs a rare straight west
swell through the Bass Strait to work.
These swells are usually the result of
sustained WNW Bass Straight storm
winds, and are often only surfable
when these stop. Trouble is, the wave usually stops about 5 minutes later! Gets
crowded because when its on it is a rare event, so local surfers are likely to be
desperate! Show respect here. Strong rips.

Devonport Rivermouth

Head N on Bass Hwy to Devonport. Go
R on Formby Rd to Victoria Pde.

A very long, fast L breaking at the
rivermouth off the point. Very dependent
on wind conditions. Needs W swells
from the Bass Strait to work. Can be
a really high quality wave in perfect
conditions. Very fickle. Busy when
its on. Feel free to investigate **Back
Beach**, west round the rocks.

Sleep:Tasman House Backpackers 114 Tasman St Devonport 6423 2335

TASMANIA

Mount Cameron

Head N out of Marrawah on Harcus River Rd. Take the track left to Mt Cameron.

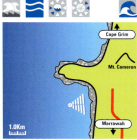

L & R reef breaks & beachies, including a long right, breaking over rocky & sandy bottoms. Often kelpy. Handles massive SW-W swells. Very isolated spot. Be prepared to walk. It is essential you ask permission from the owners of this aboriginal site, who you will usually see in or by a caravan parked on the road. If you are allowed to surf it, show the utmost respect.

Greens Point Beach

From Marrawah, Green Point Rd west to the beach.

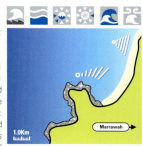

Greens Point itself hosts a fun, lined up left-hander that is protected from the southwest winds. It can be a good spot to check when beach-breaks are being pounded by Southern Ocean fury. The beach running north has varied but consistent beach-break peaks all the way up to Mount Cameron. All levels but remote.

Nettley Bay

From Marrawah, Head towards West Point but turn off right before the end. 4WD.

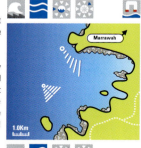

A R at N end breaks over rocky sandy bottom to produce a long-walled 6-second plus barrelling wave. Best in 6ft plus SW swells. Further S are powerful L & R rocky reef breaks off the headland. Heavy currents. Experienced surfers only. This is a hard-core spot.

Lighthouse Beach

Bass Hwy to Marrawah. Turn L on Arthur River Rd. R to West Point. 4WD. Just south of the point.

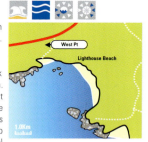

V good L & couple of good Rs break over sand & patchy rock bottom. Holds up to 15ft SW-W swells. Best in 6ft. Paddle-out using the rip by the rocks. Lots of kelp in big swells adds to the fun. Experienced surfers only. Go explore. Hard core spot on aboriginal lands, so show respect.

Church Bay

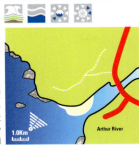

Take the road south from Marrawah to the bridge at Arthur River. Right just before river, then walk along the coast through the dunes.

A rivermouth break with all the baggage these types of spot can have; abundant marine life, current (surf dead low to minimize the rip), and shifting peaks. However, this is a consistent spot with excellent shape on its day and barrels both left and right. A solid south swell fires up the lefts which are fast and powerful. More west and the rights are good. Will work from 2 to 10 feet. Advanced unless small.

Trial Harbour

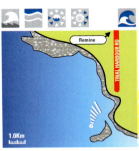

From Queenstown, take Hwy for 30kms. Turn L at Zeehan to Remine.

Quality, hard-core, big wave arena. Massive L point, breaking over weedy rock. Best in 6-12ft SW swells. Heart-stopping take-off leads to suck-dry, hollow barrel section. Awesome power for insane big-wave freaks only! Beware powerful rips. There's a heavy and huge right-hander on the other side of the channel that is a true kamikaze spot, working best on west southwest swells. The whole setup is for hell-men. Perhaps the fact that there have been 3 major ship wrecks here should be a hint.

Coal Point

On Bruny Island, head north about 3k from the town of Adventure Bay on the coast road.

In the south end of the Adventure Bay, is **Coal Point**, a hollow L breaking over kelpy reef bottom. In big SE swells, a steep takeoff & suck-dry barrelling beast. Experienced only. **Neck Beach**, which runs north, is a consistent and expansive beach-break option if winds are west to north, on most tides. All

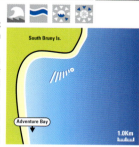

levels but exposed to swell and currents. Go N to explore **Moorina Bay** for uncrowded breaks, and some point action in north to east winds.

Cloudy Bay

Take the ferry from Kettering to Bruny Island. Head S 5kms to the bay. All-time long & barrelling L & R beachies, breaking over deep-channelled sand banks. Best in 3-6ft SE-SW swells. Mood can change from fun to hollow. This spot picks up power south swells but has a maximum size after which it is close-outs. The creek mouth can provide the best banks. All levels. The hard-core adventurers will try **Mabel Bay** on the way to Cape Bruny. It is protected from southwest winds and

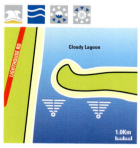

can provide good banks. **Lighthouse Bay** picks up the most swell of the lot, east of the Cape. Rocky beach with good potential if small elsewhere.

Northern beaches / *Sean Davey*

Surf like a pro with this book

Step by step instructional sequences

Key moves: the pros tell you how

Insider tips from the very best, Rasta, Parko, Andy Irons, Mike Fanning, Kelly Slater, Shane Dorian...

Australia
BREAK INDEX

317